APPROACH TO GREEK ART

APPROACH TO GREEK ART

By
CHARLES SELTMAN
Fellow of Queens' College, Cambridge

A Dutton *Paperback*

Everyman

NEW YORK
E. P. DUTTON & CO., INC.
1960

This paperback edition of
"Approach to Greek Art"
Published 1960 by E. P. Dutton & Co., Inc.
All rights reserved. Printed in the U.S.A.

Reprinted by special arrangement
with Studio Publications.

CVI DONO LEPIDVM NOVVM LIBELLVM
IACLINE, TIBI : NAMQVE TV SOLEBAS
MEAS ESSE ALIQVID PUTARE NVGAS

CONTENTS

PREFACE

AS a new approach to Greek art—and by inference to all Western art—these chapters are not an attempt to go a little further than other studies of the subject, but an attempt to start the study somewhere else.

Limitations have been accepted.

The creative activities of mankind are rooted in simple beginnings. Men hewed rocky hollows to make more comfortable caves; they built huts, then houses and greater buildings. But that is another story. This book is not about architecture. At first there are just two materials man uses to create—mud and wood. Women sometimes work with these things too, but more often with grass and hair; and that is not part of our story. Man models with mud; and with coloured mud he starts to paint on skin or wood. Wood itself he carves; and so learns to carve harder things: bone, ivory and stone. Then man discovers metal and creates with that; but still, in effect, treats it either as mud or wood; for he either casts it, which is modelling, or he forges it, which means hammering and carving. He may make useless things with these materials in part because he enjoys it, in part because he finds others to enjoy his creations and it does him good to be appreciated. From this springs criticism, whereby distinction is made between what is fine and non-fine; and so with experience there grows good taste, a virtue of which the Greeks came to possess a very large share. It is this—good taste—which provides the golden thread that runs through the art of Greece from 1600 B.C. to A.D. 1200, and perhaps beyond.

There are paragraphs in this book which seem to be phrased in dogmatic fashion, but the constructive side of what has been written is not intended to be dogmatic. I could have loaded my sentences with the oft-repeated "possibly" and "perhaps", and might have reiterated that nothing more than a personal opinion

was being expressed. Instead I prefer to preface the whole by stating that, the evidence being what it is, I personally am inclined to hold as a provisional hypothesis that fine art is either in the nature of poetry or in the nature of prose. Yet I am aware that my attitude to the evidence must be influenced by disturbing elements of the emotions or of tradition, and that these elements may exist unobserved. In any aesthetic problem it is always doubtful whether we can ever reach a hypothesis that is more than provisional, for the problem must be, like the world of Heraclitus, in continual flux. Every aesthetic question is an open question.

The destructive side of this book is another matter, for it is far easier to undermine outworn beliefs than to build certainties. It is, and must be worth the attempt to overthrow some of the more lingering heresies which have promoted theories about the Greek cult of Beauty, the Growth and Decay of art, the "Minor" status of certain arts, the ineptness of formalism, and the meretriciousness of representational art. In combating these theories I am prepared to be dogmatic, while admitting that it is easier to perceive where others now in the past were wrong, than to know when you yourself are right.

A great number of my pictures is entirely new or has never before appeared in a popular work on art. I am indebted for photographs, and for leave to publish to the following:

The Trustees of the British Museum, the Victoria and Albert Museum and the Royal Ontario Museum of Archaeology; the Directors of the Museums in Brussels and Copenhagen; the Librarian of the Vatican; the late Mr. D. L. Caskey in Boston, Massachusetts; Mr. A. E. Austin of Hartford, Connecticut; Monsieur Babelon and Monsieur Charbonneaux in Paris, and especially Miss G. M. A. Richter in New York for numerous photographs. Also to Mr. Leigh Ashton, Professor Beazley, Count Chandon de Briailles, Professor A. B. Cook, Mr. D. L. Davis, The Duke of Devonshire, Dr. Winifred Lamb, Mr. E. A. Lane, Mr. R. C. Lockett, Professor Persson, Mrs. Leonard Russell, Captain E. G. Spencer-Churchill and Mr. G. M. Young.

Most of this book was begun a good many years ago, and what was then written has been remodelled, while the last chapter is a

recent addition. During the years in which I have thought and talked on the subject of Greek art I have received many helpful ideas from many friends in the agreeable process of discussion and argument. There are five among them to whom I feel a special debt of gratitude alike for wisdom in criticism and acuteness in suggestion. Martin Charlesworth, President of St. John's College, Cambridge, Alan Wace, now Professor in Alexandria, Professor Arthur Darby Nock of Harvard, and W. L. Cuttle, Tutor of Downing College, have all given me encouragement. The same is true of Jacqueline Chittenden, sometime Fellow of Newnham College, who has also read the whole of my script. To her I dedicate this book, and pray the shade of Catullus to condone some lifted lines.

Cambridge, 1948. C. S.

CHAPTER I

THE CRADLE OF EUROPEAN ART

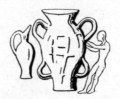

AS the grey breath of illusion drifted away from the anxious soul of mediaeval man he began to know himself as an individual, even as the Greek had known himself long centuries before. And so in Italy the rebirth of humanism came to pass, ushering in the modern world. Men turned to the glory of the ancients in literature as in the arts, and dwelt enraptured with their discoveries. A social world had arisen "which felt the want of culture, and had the leisure and means to obtain it. But culture, as soon as it freed itself from the fantastic bonds of the Middle Ages, could not at once find its way to the understanding of the physical and intellectual world. It needed a guide, and found one in the ancient civilisation with its wealth of truth and knowledge in every spiritual interest".[1]

Men began not only to study the writings of the Greeks and Romans on art but also eagerly to collect such works as could be found, and under Pope Alexander VI (1492–1503) the Apollo Belvedere was unearthed in Rome, while under Pope Julius II (1503–1513) there were made the memorable discoveries of the Laocoon and the Vatican Venus. The palaces of nobles and cardinals and the studios of artists began to be filled with ancient statues and fragments of marble.

From this time onwards collectors sought for works of marble to which they gave pride of place; and, when a second renaissance

[1] J. Burckhardt, *The Civilisation of the Renaissance in Italy*, Phaidon ed., 1944, p. 107.

came to Europe, inspiring the nobles of England and France to collect the antique, it was once more the gallery of ancient marbles which was held to enshrine the most glorious tokens of Greek genius. With the nineteenth century there came fresh emphasis by way of the Elgin marbles, the Aegina marbles, and marbles unearthed by excavators' spades.

For more than four centuries men have been instructed that the very best things which the Greeks ever made were of marble, and that is why you may read in a book on Greek art written little more than a score of years ago that "sculpture was in many ways the most characteristic art of Greece ; . . . it achieved the highest attainments".[1] Such has been the usual approach to Greek art. The prize must go to sculpture in stone, with which large works cast in bronze were often associated : next came painting, which is now represented mainly by drawings made on the surfaces of ancient vases : third came the so-called "minor arts", under which label were grouped with condescension and convenience the work of die-cutters, gem-engravers, jewellers and celators (or metal-chasers). But does such "classing" in any way correspond with the ideas which the Greeks themselves held about artists and art?

It is certain that they had very different views.

Even in the distant age of bronze the inhabitants of Greece and the islands held the skilled worker in metal in very high regard. His art was both a mystery and a delight, and he was thought to owe his gifts to supernatural beings around whom many legends grew. There were creatures called Dactyls, smelters of bronze ; Curetes and Corybantes, armourers ; Cabeiroi, who were skilful smiths ; Telchines, gifted workers in gold, silver and bronze who made weapons for gods and the earliest statues ; and lastly the mighty Cyclopes forging the bolts of Zeus. All these are vague giants, goblins and godlings—patron saints of the workshop and the forge whom you might do well to appease and some of whose names just meant "Fingers", "Hammer", "Tongs" and "Anvil". Then, by the time that the Homeric epic began to take form, one of these beings seems to have grown in stature until he attained Olympian rank. Men said he was a lame god because his mother, Hera, had once hurled him to the earth,

[1] E. A. Gardner, *The Art of Greece*, 1925.

but this is just a story to explain the fact that smiths constantly at work at the anvil tend to have powerful arms and weak legs. In the Homeric world blind men would become minstrels and lame men smiths. An artist's god must resemble the artist. The Olympian smith was named Hephaistos, a name of great antiquity belonging to some language spoken before ever the Greek-speakers came to Greece.[1]

The artist, dreaming his dreams of what wonders he would like to make, attributed to his god the power to create just such things of surpassing fineness, and the minstrel set them in epic form. And so, in the eighteenth book of the Iliad, Homer told of the wonderful shield of Achilles made by the famous god. Centuries later came the description by an unknown poet of the shield of Herakles likewise wrought by the god, while an early Hymn to Hephaistos told how he taught men glorious works throughout the world. The Boeotian poet, Hesiod, set in his *Theogony* a tale of how the very famous limping god formed of clay the likeness of a shy maiden, Pandora, whom Athena clothed in fine raiment. Here he may turn his hands for once to modelling in clay, but he is a divine artificer because he is so great an artist in metal and ivory and precious stones. The mortal smith worked, as he thought his god worked, with his delicate moulds engraved by his own hand, and employed drills, chisels, punches and flats. There is no lack of evidence from the prehistoric bronze age of the fineness of such work.

There was a comprehensive Greek word, *toreutiké*, to describe it; meaning carving, chasing and engraving on gold, silver, bronze, ivory or gems. The artist who practised this was a *toreutés*, in Latin called *caelator*. The Latin term for his art was *caelatura*, from which came an English word "celature" used in the seventeenth century and before, but grown obsolete, though it will be found in the big dictionaries. We shall do well to revive this word; to call this art of engraving-embossing-chasing-carving *celature*, and to english the artist as a *celator*.

Many fine examples of Minoan and Mycenaean celature dating from the Bronze Age still survive. There is simple line-engraving, intaglio work, embossed work made in moulds and

[1] W. R. Halliday in *C.A.H.*, ii, p. 616.

afterwards chased, elegant carving in ivory—everything, in fact, which comes under the heading of celature.

Fine Art as such began in Europe with celature and painting—not with sculpture and modelling—and attained a very high level of excellence by about 1650 B.C. A thousand years or more before that date a phenomenal art had existed among a group of islands in the Aegean Sea known as the Cyclades, of which the chief were Paros, Naxos and Amorgos. With simple tools of copper, saws, chisels and tubular drills which were worked with the aid of plentiful corundum-dust, the islanders cut, ground and polished their local marble. They made attractive stone vessels and enchanting figurines, generally of women. Since such things have been found in tombs they will have been made to serve the needs of the dead in some manner or other.[1] However much they may delight us now in their strength and simplicity, they were made with a magical-practical end in view by groups of peasant fisher-folk. Such works are accordingly classed as peasant art, not as fine art.

Art which is the product of the artist's own creative love for fineness, which is produced for a social world that appreciates this, art which gives delight to people who have some leisure in life, be they kings or nobles, townsmen or farmers, scholars or soldiers—this is what may be termed Fine Art. And this began in Europe with celature and painting.

If we were to discourse at length on what survives from the Bronze-Age civilisations of Crete and of Greece (known respectively as the Minoan and the Helladic cultures) in these two branches of fine art, and in these alone, we could fill a volume. But, since our concern is to be with Greek art proper, we may only select a few typical examples of celature such as may display engraving, intaglio work, inlay, embossing, chasing and the carving of ivory adorned with gold. Two fine examples of painting will suffice. All these works are products of two brilliant centuries between about 1600 and 1400 B.C.

Good engraving appears on a Minoan bronze double-axe with a recumbent lion resting upon rocks (Plate 1a), an admirable example of early drawing with a hard point which cut fairly

[1] D. G. Hogarth in *Essays in Aegean Archaeology*, pp. 55 ff.

deeply into the bronze. There is a golden signet ring from a royal tomb at Mycenae engraved with a ferocious battle-scene in which a king wearing a tasselled bonnet fells three antagonists (Plate 1b). The artist who made this employed punches, a drill, a wheel and a graver: all tools which he would use on hard stones like chalcedony or agate. One such (Plate 1c) depicts a lion which has leapt on the back of a rushing bull and bites it in the neck. Some Minoan and Helladic artists were masters of damascene or inlay work, a kind of celature hard to illustrate with good effect.[1] A dagger found at Mycenae has a blade of bronze into which are inlaid three golden lions in a flying gallop, while above them are cloud-like shapes made of silver and gold alloy (Plate 1d).

Embossing and chasing was a favoured art in this age and hundreds of examples have been found. Such work was hammered over a die or matrix either of bronze or stone. The process was as follows: the design was first cut into the matrix with chisels, borers and punches; then a sheet of gold or silver or bronze was laid over the matrix and held in position probably by a leather thong; by means of a punch of hard wood or horn the metal sheet was then hammered into all the crevices of the design.[2] An embossed piece of metal, after release from its matrix, could be turned over and chased on its face, a process which was usual for the finer kinds of celature. Minoan stone matrices have been found. One such (Plate 2a) has moulds for making three different metal objects: on the left a little figure holding a disk; next to this a larger female—in a hat, sleeved jacket which leaves the breasts bare, and a flared skirt mostly hidden by a large apron—who holds up flowers; on the right is a large, toothed, wheel-like ornament. No actual products of this matrix have been discovered but it is instructive to compare with it two objects derived from kindred moulds (Plate 2b, c); a thin golden figure of a woman or goddess, and a gold ornament, both from Mycenae.

[1] It is best to avoid using pictures of *reproductions* of objects from Mycenae, etc. Such smooth modern copies are unfairly and too frequently figured as samples of ancient art, though they really show the skill of modern copyists.

[2] See the clear description of the art by Gisela M. A. Richter in *American Journal of Archaeology*, 1941, pp. 375 ff. Matrices of granite and basalt were found by Schliemann at Mycenae.

The golden signet, the agate sealstone and the dagger-blade surpass the arts of any other land in the seventeenth and sixteenth centuries before our era. Yet they in their turn are surpassed by the famous embossed and chased vessels of gold and silver found in various royal Helladic tombs, like the king's golden cup from Dendra (Plate 3) with its four great octopods among rocks and seaweed and diving dolphins. The same king owned a second cup (Plate 4) of silver, which has an inner layer or lining of sheet gold. On the outside are embossed and chased figures of charging bulls.

To the Greeks of a much later age the highest achievement in the fine arts was always embodied in the "Chryselephantine" statue, that is to say, the figure made of gold and ivory. It was owing to their creation of such things that Pheidias and Polycleitus acquired immortal fame. Behind this art lay a tradition running back to the Bronze Age, for of all the Minoan works that have survived the finest are their chryselephantine statuettes. The most famous of these is the little ivory snake goddess (Plates 5, 6): her belt and armlets, the hem and flounce-borders of her skirt, of gold; and her nipples two little golden studs. Her arms are held out stiffly and each hand holds a golden snake. They have called her "goddess", but she may well be a young priestess holding sacred serpents, for this is not so much a type as an individual girl, the expression of whose face is sweet and yet grave. Another Minoan girl of the same epoch, made of ivory richly decorated with embossed and chased gold, is the lovely girl toreador. Her face is tense as though she waits to catch another girl or boy who vaults from a charging bull. A golden apron protects the groin and belly and a corsage covers the ribs, but the breasts are bare following the regular Minoan fashion (Plates 7, 8). What she is about may best be learned from a fresco[1] found in the royal palace at Knossos and depicting a Minoan *rodeo* (Plate 10a). Facing the charging bull one athlete seizes a horn, and, as the beast flings up its head, the toreador gets enough spring to land on the bull's back, to grip its flanks and turn a back-somersault. Both movements are combined in the fresco. As the athlete leaves the bull a comrade catches him to break his fall. For this the ivory girl

[1] This was found in fragments but is convincingly and correctly restored.

16

toreador is waiting. Young boys must have started to train for acrobatic feats by practising with young steers, and it is such a one who is represented in a third lovely ivory figure clad only in a little gold apron, his arms raised waiting a young bull's charge (Plate 9). It is likely that these two—the girl and boy toreadors— each formed part of a set of ivory figures grouped round a bull, which may have been carved in some other material. The central bull from another such group, this time made of solid bronze, survives. The artist who cast this finished it by careful chasing of certain details (Plate 10b). Here the acrobat upon the bull rests for a mere moment back to back upon the beast before he leaps off. This little bronze is the work of a great artist.

It has been necessary to dwell with some emphasis on this early art of celature because its fame and high repute were passed through the Homeric epic to Greeks of the classical age. Thus the taste for things of especial fineness, and respect for the kind of artist who could make such things, became an integral part of Greek civilisation. Here was something that, despite the long interval that was to follow, permanently affected the whole Greek attitude to fine art.

Men competent to make such works as these were able to draw and to paint with skill, and they have left some evidence of their art in the form of many frescoes on the walls of palaces. But the brittleness of plaster is such that almost all the frescoes are in a very fragmentary state[1] with two notable exceptions. One was painted in the seventeenth century before our era when the painter had already full command of his medium. This landscape with life-size figures of animals comes from the wall of a palace in southern Crete and has a background of ivy-clad rocks, crocus and lilies. A lithe cat, big-eared like all Mediterranean cats, stalks a pheasant-like bird which seems to tremble, fearing something it cannot see (Plate 11a). The second fresco comes from Melos, once under Cretan domination, and shows a group of flying fish, some swimming in water over shells and sponges, some leaping from the water with spread fins (Plate 11b). This is a study in blues, whites and yellows full of delight and life.

[1] The Minoan and Helladic paintings shown in most books are masterpieces of ingenuity on the part of the restorer, but they inspire little confidence.

With the gradual passing of the Bronze Age and the Minoan and Helladic civilisations, the art of painting seems also to have passed, and the Greeks of a half-millennium later had to find it out again and learn its skill anew.

Such was not the case with celature, for this greatest of the arts, best beloved by the Greeks, went right on through the sombre centuries which came with the Dorian invasion of Greece and the age of the iron-smelting men.

They were turbulent years in comparison with the past era of golden Mycenae and the bright life to come in the city-states of Greece. But chieftains still honoured the smith for the splendid armour he could make, sailors and adventurers admired him for the luxurious merchandise which his art could furnish, and farmers loved him because the warm forge was the village club.

Hephaistos, the divine artist, made armour for gods and for godlike Achilles, but it was some mortal smith who created the panoply of King Agamemnon so vividly described in the opening passages of the eleventh book of the Iliad. And in the twenty-third book the first prizes given at the funeral games were tripods and cauldrons, vases, and bowls of silver and of bronze, such as merchants carried overseas.

Yet men less daring and adventurous than those soldiers and traders were kept in constant touch with the friendly smith who made not only ploughshares and reaping-hooks, but delicate works of art. Hesiod, in canny mood, cries a warning against the delights and temptations of haunting the smithy. "Pass by the smithy and its crowded lounge in winter time when the cold keeps men from the fields." Go home, he says, when jobs need doing—no good can come of the lounge.[1] It is easy to imagine the rough and noisy good company in the forge, when they pass round and admire the new helmet ordered for the laird, and a fine brooch made for his lady with bronze pin and ivory panel set with bosses of amber and dark blue glass. It was in some such way that almost every Greek through these years kept alive his admiration for fine art.

And the laird would turn his hand to celature, too, at times,

[1] *Works and Days*, 493 ff. My attention was drawn to this important passage by Jacqueline Chittenden.

for the great Odysseus was no mean artist himself. In the twenty-third book of the *Odyssey* the hero tells how he once constructed his marriage bed "and made it fair with inlay work of gold and of silver and of ivory".[1]

All this is in the spirit of the early Iron Age of Greece—the so-called geometric age, from which great quantities of pottery survive, but not very much else. The pottery cannot truly be classed as fine art and so falls outside our sphere. A few fine, though often sadly damaged works in bronze and in ivory shall serve to show that the celator did not lose his skill and retained a choice sense of good design.

The smith's own creative love for fineness of design, within formal limitations, sometimes comes through during the ninth and eighth centuries B.C. in the bronze animals he made for men to give as offerings to their gods. Horses, bulls (Plate 12a, b) and birds were made for a small, austere, social world in which people did have some leisure to take pleasure in such things. A good shape, helped by very simple ornamentations, is the strong attraction of the bronzes, as it is of ivory brooch-slabs found at Sparta (Plate 13a, b). But the most attractive by far is a little naked ivory girl wearing a crown ringed with a geometric meander design (Plate 14). The date of this and of the ivory brooches is about 820 B.C.

While such things were being made on the Greek mainland there were other influences at work from across the water. Many people—individuals and families—had been emigrating for about two centuries and establishing new and prosperous settlements in the large eastern islands and on the coast of Asia Minor, just as later on like settlements were to take place in Sicily and on the coast of Southern Italy. The great Greek Asiatic states, Miletus, Ephesus, Samos, Chios, Lesbos, Rhodes and many others, soon proved to be new centres of Greek art. The men who founded these states developed an outlook somewhat different from that of the men who stayed behind, for the emigrants, uprooting

[1] A view, put forward by B. Schweitzer (*der Bildende Künstler, etc.*, Heidelberg, 1925, p. 38), that the author of the *Odyssey* did not really think his hero could have been an artist because this would be an improper employment for "a prince", is somewhat insensitive. If it were true the whole Recognition Scene would be spoilt and the climax of the *Odyssey* would fall flat.

themselves, could take with them neither the ancient shrines and oracles of their tribal and earthbound gods, nor the tombs and holy bones of their ancestors. In consequence, a people who had never, even in Greece, been heavily shackled by priestly authority, found themselves in a new country free of all superstitious sanctions, and able to indulge in the most precious thing in the world—fearless freedom of thought.

On the contemplative side, this condition made possible the genius of Thales, who could set everyday experiences above ancient myths, and other practical men who were also brilliant and profound thinkers, like Anaximander, Anaximenes and Heraclitus. On the technical and artistic side, this condition caused celators and painters to abandon any thought of pious adherence to paternal tradition and to seek eagerly for novelty and experiment. This meant finding out what other workmen in other parts of the world were up to, assessing their products critically, adopting designs and ideas, or discarding what was not in good taste.

Now the most industrious of all ancient workmen in those days —and for long afterwards—were the Phoenicians. They were in their day an astonishing phenomenon. Acutely they observed what the artists of Egypt and Assyria were making, what was popular in the bazaars of Philistia and Arabia, in Cappadocia, Syria, Cyprus and Eastern Crete. They noted the lot, copied the lot, mixed the lot, and served up articles mass-produced and cheap, for any taste. The Greek smith and celator both really seem to have worked for the fun of making fine things—sometimes sententiously called "the creative impulse"—but the Greek's contemporary in the Phoenician cities and factories worked for the fun of making money. Cyprus, where Phoenicians were plentiful, became a kind of stew-pot for the arts and crafts of the Middle East and the *olla podrida* which came out of it was, with a few exceptions, not too good. Yet the same Phoenicians who manufactured cheap wares for export also carried in their ships from one country to another some of their more fine and expensive products of art, and they will have been the middlemen who introduced to the Greeks of Asia, and presently to the older Greek states, the fine ivories and worked metals of Syria and Egypt. In this way

Greeks could handle, examine and assess the work of other artists to their own benefit and delight.

The effect varied somewhat in different regions. In Crete the celator who made, about 700 B.C., the pleasing figures, engraved and cut from a sheet of bronze, of two hunters with a wild goat (Plate 15), was still strongly influenced by some surviving and familiar Minoan work. Half a century later, another Cretan artist made a charming small-waisted boy in bronze, wearing nothing but a belt, for dedication to Apollo at Delphi where he was found (Plate 16a, b). In neither of these examples had oriental influence as big a rôle to play as it had in a group of enchanting ivories from Ephesus of about the same date as the bronze boy. The face of the big-headed girl priestess (Plate 17a, b) is not Greek, though her garment is; the grinning Eunuch priest with heavy rosary (Plate 16c) is an Asiatic. The curly Sphinx (Plate 17c) is a new motif, product of an eastern imagination soon to be taken up and enlivened all over the Greek world.

Sphinxes, gorgons, harpies, eagle-griffins, lion-griffins, centaurs, winged bulls human-headed, pegasus and dread chimaera, and the lurid creatures of Ezekiel's vision, these were mostly sprung from oriental minds prone to imagine such horrid and mighty ministers dancing attendance on sinister and vindictive gods. But the gay, sceptical Greek adopted these creations mainly for their entertainment value and for the fun you might get from playing artistically with monsters. Later on, in the fifth century, a brilliant physicist-philosopher, Empedocles, of Sicilian Agrigentum—which Rhodes helped to found about 582 B.C.— even went so far as to rationalise the monsters, suggesting that Chance, mixing inappropriate heads, limbs and bodies, may have thrown up such creatures which failed to outlive the law of the survival of the fittest.[1] Thus, the mighty Bogies of the Orient turned for the Greek into objects of mere curiosity or amusement.

It has already been noted that with the gradual passing of the Bronze Age and the Minoan and Helladic civilisations, the art of painting seems also to have passed, and that the Greeks much later were to find it out again, and to discover and to learn the skill

[1] See F. M. Cornford, *C.A.H.* iv, p. 568.

anew. But before they learned this they had to acquire a fresh skill in draughtsmanship. The highly-stylised simplicity of the drawing which exists on geometric pots may tempt one to think that nobody could draw with competence during the geometric age, but of this we cannot be sure, since the archaeological evidence is still too slight, and by the time we get to about 700 B.C. we may already note a certain competence of line-engraving in the figures of the two hunters cut from a sheet of bronze (Plate 15). In any case, familiarity with fine drawing on metal objects of Egyptian and Syrian origin must have inspired the Greeks to emulate; and drawing of considerable competence began to appear on pottery made in Rhodes. Yet, to find the masterpiece of seventh-century draughtsmanship, eked out with gay colours, we have to turn to the work of a Corinthian painter. Here, on a clay jug made and decorated about 640 B.C. (Plate 18) is a most brilliant battle-scene. Two opposing regiments of heavily-armed Greek hoplites meet in combat; the front ranks already attack with their spears, and the rear ranks on either side come up at the double to join in the fray. With the army on the left—all of whose shields we see from the inside—is a boy flute-player blowing hard into his double flutes some wild tune to excite the soldiers. The army on the right is a brave array and on the overlapping shields of its soldiers we see a splendid series of coats-of-arms, lions, hawks, eagles, bulls' heads, a gorgon and a wild boar. This picture, cramped though it is by its position on the ovoid body of a vase, is none the less a very remarkable achievement. Despite certain artistic conventions of the time, with which we are not entirely familiar, we are impressed both by the liveliness of the scene and the lightness of the drawing.

Apart from its charm as a work of art, this little scene of battle appearing at this time has a great historical significance. Changes were taking place in the Middle East. The power of Assyria was on the wane; Egypt was rising; Lydia was dominant in Asia Minor; and tough, adventurous Greeks were seeking employment as mercenaries in the service of the rulers of these lands. Gyges, King of Lydia, sent to Pharaoh Psammetichus a body of "brazen men", Ionian mercenaries who helped him to throw off the Assyrian yoke. So it came about that Greek soldiers settled

for the first time in the land of Egypt. The merchant tends to follow the army, and not many years later—about 650 B.C.—the rich settlement and trading factory of Naucratis was established in the delta by traders from Ionian and other Greek states. This meant that in a very short time enterprising and artistic Greeks came into close contact with the unfamiliar phenomenon of Egyptian monumental art. The effect of this on Greek art was surprising, for there can be no doubt that the meeting of Greek and Egyptian art which ensued was one of the greatest events in the art history of the world.

CHAPTER II

POETRY AND PROSE IN ART

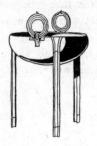

UP to this point twenty-seven works of art ranging in time between about 1650 and 640 B.C. have been illustrated and briefly discussed in the preceding chapter. All these works have really only two things in common: they were made by Greeks; and they are fine. But they stand for very diverse kinds of aesthetic expression and artistic presentation, since some of them, like the Toronto Ivory Girl and the Oxford Ivory Boy (Plates 7, 8, 9), are fully representational and naturalistic; others, like the geometric horse and bull (Plate 12) are purely formal and pattern-like.

In fact, we have already found ourselves in the presence of two very different kinds of Greek art, which, in the terminology favoured by Roger Fry, would be called formal and representative.

Now these two artistic moods express two kinds of thought. They do not express two kinds of technique; neither do they express two kinds of efficiency.

This is a fact which must be grasped for the clear understanding of any art, and quite specially for the understanding of Greek art; and an aid to its comprehension will come from a frequent and studied comparison between literature and the fine arts. In a volume which appeared as the fruit of a lifetime's thought, Professor Samuel Alexander[1] reached the conclusion that the

[1] S. Alexander, O.M., *Beauty and Other Forms of Value*, 1933.

essential difference between poetry and prose that exists in literature is likewise present in all the arts.

First, it must be emphasised that by poetry regular metrical poetry is meant. "Metre", said Hegel,[1] "is the first and only condition absolutely demanded by poetry." In the most precise sense poetry has been defined as "the concrete and artistic expression of the human mind in emotional and rhythmical language", and the poet as "simply the man who by instinct chooses for his concrete forms metrical language".[2] Metre as an essential is also insisted on by Alexander, who holds that "the reason why the poet in general expresses himself in metre as well as rhythm is not that he chooses to do so, but that he must" "The difference of prose and poetry is not merely one of form, but of kind. They are not merely two styles of saying the same thing; what is said is different."[3]

The absolute difference between poetry and prose is defined as follows: poetry is organic and concrete; prose is descriptive and analytic. The poet works from within outwards; the prosaist describes from without. Poetry's "nature is to be not a part, nor yet a copy of the real world, but to be a world by itself, independent, complete, autonomous".[4] Prose must narrate; and, though it invent, its inventions must be copies of the real world or related to an invented world because it has to be descriptive. It is convenient so to define prose and poetry that the essential difference between them is as follows:

Prose implies the imitation of the ordinary or natural form of spoken language, without metrical structure.

Poetry implies the use of a metrical, that is, patterned arrangement of language, and poetry employs words and figurative uses differing more or less from those of ordinary or natural speech.

This difference is possibly present in all the arts, and clearly apparent in the fine arts of celature, sculpture and painting, for we can transfer our definitions to these with a very slight change, italicising the altered words.

[1] *Aesthetik*, iii, p. 289.
[2] T. Watts-Dunton, *Poetry and the Renascence of Wonder*, 1916, p. 8 *f.*
[3] S. Alexander, *op. cit.*, p. 99.
[4] A. C. Bradley, *Oxford Lectures on Poetry*, 1909, p. 5.

Art prose implies the imitation of the ordinary or natural form of *seen objects*, without metrical structure.

Art poetry implies the use of a metrical, that is, patterned arrangement of *objects*, and *art* poetry employs *forms* and figurative uses differing from those of ordinary or natural *phenomena*.

Prose art is descriptive and analytic: poetic art, organic and concrete.

The prosaist, literary or plastic, employs natural form because, even when he selects, he wishes to inform his readers or spectators of happenings within the bounds of nature.

The poet, literary or plastic, departs from natural form because the poet considers himself superior to nature. Just as the literary poet "operates with words as words and not as mere instruments"[1] of speech, so the poet-artist operates with forms as forms and not as mere instruments of representation.

It appears that this distinction between prose and poetry is really an elementary distinction in art. If it happens that attempts are made to treat prose art poetically in a romantic movement, or to treat poetic art prosaically in a classic movement, these are perhaps generally misguided attempts, springing not from a compromise, but from a conflict between the analytic and the concrete. Yet the normal difference between prose and poetry in the arts is one towards which many thinkers and critics have appeared to feel their way. It was Kant who wrote of the perceptual approach, and the conceptual approach to art; and it is surely clear that the perceptual is the way of prose artists; the conceptual the way of poet-artists. The former narrate or illustrate, the latter decorate. As civilisation advances the former show their activity through that which Herbert Read calls constructive expression, the latter through creative expression; for Clive Bell and Wilenski the first are descriptive artists, the second formal artists; for Roger Fry they are representative and formal. According to Ogden and Richards there is symbolic use and emotive use. In fine there is in the plastic arts what Alexander has termed prose—descriptive and analytic—and poetry—organic and concrete. This concurrence of views from minds of such different types is sufficiently

[1] S. Alexander, *op. cit.*, p. 33.

remarkable to deserve a tabulation of the key-words in separate columns:

PROSE	POETRY
perceptual approach	conceptual approach
narration (illustration)	decoration
constructive expression	creative expression
representative art	formal art
symbolic use	emotive use
descriptive art	organic art
analytic art	concrete art

If we are prepared to accept the view that the arts, and in particular the plastic arts, are either poetic or prose-like, we must follow up this parallelism between literature and art in one more detail, for we must take into account the question of Value. In literature prose and poetry each has its inferior versions. Prose usage started with the first coherent utterances from the lips of savages; poetry will have begun with the simple rhythmical jingle of some peasant at work. From their simple beginnings both progressed till they became the elaborate vehicles of description and of concrete emotion.

But prose as an art has its inferiorities ranging through rhetoric to journalese, and poetry as an art has its vulgarisations ranging through versification to doggerel.

To this there is a real parallelism in the other arts; thus, the Aphrodite of Melos is competent prose, the Medici Venus a piece of rhetoric, Canova's Venus in Florence, journalese. Or again to take the work of a single artist, Epstein's Night is poetry, his Genesis versification, his Day a jingling medley. The same might be said of poems picked from the works of many a literary poet.

It is generally when critics fail to observe both the essential difference between prose art and poetic art and also the varying degrees of excellence within those arts that their criticisms tend to become embittered. "The advocates of formalism sharpen their diatribes against representation. But those diatribes are not relevant to representation as such, but only to inartistic representation."[1] In like fashion the advocates of representation may attack

[1] S. Alexander, *op. cit.*, p. 83.

formalism, and their attacks are not relevant to formalism as such, but only to inferior formalism.

You have every right to prefer fine poetry in literature or art to the finest possible prose, or to prefer fine prose to the finest possible poetry, for that is ultimately a matter of taste, not of values. But you must not condemn Thucydides because he is unlike Aeschylus, nor Parthenonic sculpture because it is different from Olympian, nor Tintoretto because he is not Duccio. You can admire Herodotus without apologising for Homer's lack of historical narrative, you may delight in Praxiteles if you do not call Antenor "childish", you may revel in Canaletto provided you do not dismiss Cézanne for a fool.

Preference and taste are personal things. Value, in the philosophic sense, appears to have an almost universal validity. If a student of art would attain a proper sense of Value it would seem that he ought to begin by discovering whether the art that he is studying is poetic or prose-like. Having arrived at a decision he must next use his judgment about the quality of the art. Is it true poetry or prose; is it merely the artistic counterpart of versification or of rhetoric; is it no better than a kind of plastic doggerel or journalese?

If it is not distinctively poetic or prose-like, then it will be found to spring either from compromise or conflict, and if such be the case then training in the sense of Value will prove an aid to the understanding of Art.

He who is eager to understand Greek art in its fullness must, however, be warned of two considerable stumbling-blocks which the older schools of art-critics have tumbled into the roadway and left lying around. One of these is the strange, false assumption about the "Greek cult of Beauty".

It is one of the most healthy signs in modern thought that the wretched word "Beauty"—the most ill-defined and indefinite word in the language—is being sternly discarded. Ogden and Richards,[1] for example, pour merited scorn upon it, providing a list of sixteen traditional and incompatible uses of "Beautiful". Clive Bell is equally emphatic in its rejection,[2] proving that

[1] C. K. Ogden and I. A. Richards, *The Meaning of Meaning*, 1923, ch. VII, p. 387 f. [2] *Art*, 1928, pp. 12 ff.

between the aesthetic implication contained in a phrase like "beautiful cathedral" on the one hand and the loose slang of a phrase like "beautiful shootin'" on the other, there is the common and normal use of the word which means simply "sexually attractive".

The Greeks, whose thinking was both clear and simple, had no such confused concepts as Beauty and Beautiful. Employed to translate *kallos* or *to kalon* the word Beauty is weak, just as Beautiful is a misleading rendering of *kalos*. We can perhaps get nearest to the meaning by using Fine and Fineness, for these may be employed in most of the senses of the Greek words.

To say that for the Greeks Beauty and Goodness were one and the same is an error. But put it, that to the Greeks Fineness automatically included excellence, because what is fine must be fitted to its purpose and therefore Good, and we are on the right track. *To kalon* or Fineness could become the ultimate Value by which all other Values could be measured.[1]

To speak of Beauty as the main quality of Greek art is exceptionally misleading because the word's first suggestion to our minds is sexual attractiveness, and this suggestion receives apparent reinforcement from the nudity of many Greek statues. Here, however, we are misled by our own heritage of prudery which the Greeks lacked. Just as we can look at a naked dog or horse without instantly thinking of the kennels or the stud, so the normal Greek could see the naked human figure without sex-obsession.[2] His emotion could be stirred by the fineness of a fine form for its own sake whether animal or human, and his art was no less competent to make a bronze horse than a bronze athlete. We can fairly apply the word "fine" to such ancient master-pieces as the Corfu Gorgon pediment, the New York Kouros (Plates 31–33), the head of Claudius II (Plates 99, 100) and the bronze Valentinian of Barletta (Plate 101), and those who first saw these things would have called them *kala*. But if we term them "beautiful" we must begin by some clumsy definition of what in

[1] In modern Greek the ethical force in *kalos*, which means primarily "good", has been retained. "Beautiful" is in modern Greek properly rendered by *orayos*, "nice to look at".

[2] This is not to say that he always *did* see it thus. But nakedness did not make him snigger.

29

each particular instance we are meaning by the word. It is a stumbling-block, and should be avoided.

The other great stumbling-block in our approach to ancient art is quite as serious: it is the theory of growth and decay. As long as this theory is held the study of art is forced into a rigid framework because it is confined by a piece of anthropomorphic jargon.

It was not so long ago customary to assume a definite process of growth and decay in Ancient Art.[1] Pliny assumed it. Part of his account of ancient sculpture (based at second hand on the work of an earlier writer called Xenocrates of Sicyon) implies a steady development of merit up to the year 296 B.C., when, says Pliny, "Art stopped". "It began again," he declares, "in 156 B.C." In fact, art for him seemed to have grown like a human being from childhood to maturity, to have fallen into a coma for one hundred and forty years, then to have recovered and continued in vigorous life. He anthropomorphised art history, and in another place even foretold its end when he wrote of painting as "a dying art".

Greeks before the Hellenistic Age held no such views of continuous development in art, for such a notion is part of the concept of human Progress—with a capital P—foreign to earlier Greek thought. If you are descended from Piltdown man or from the simple savage of Lucretius, you think you are on the upgrade and Progressing. Not so if you are of the seed of Herakles or Ion and you believe the Golden Age is behind you.

Once upon a time the anthropomorphising of art history combining with modern adulation of Progress was apt to dominate men's conceptions, and so they thought of the archaic Greek period as a kind of childhood, of the early fifth century as an adolescence, of the later fifth and fourth centuries as the full vigour and of the Hellenistic period as the ageing of an art which passed into presumed paralysis with the advent of Byzantinism. It was simple, the theory of Growth and Decay; but it is not a theory which readily fits in with the ascertained facts of history; it is not a phenomenon observable in another and parallel form of

[1] The following paragraphs are taken from a paper which I read to the Royal Society of Arts (see *Journal of the R.S.A.*, Vol. XCIV (April 12th, 1946), p. 325 f.).

expression, literature. Homer cannot be described as more childish than Aeschylus, but as a different kind of poet; Plato is not called a riper stylist than Thucydides, but a different kind of writer with a different theme; St. Paul's letters are not more decadent than Cicero's, merely different. For the literature of the ancient world this Growth and Decay Formula will not work. Are we justified in applying it to Fine Art?

"Well," you may say, "why worry if people have this harmless illusion about Growth and Decay?" But it happens not to be so harmless, because it implies another doctrine. Implicit in the formula is the dogma that earlier Greek artists must have been striving all the while to attain a naturalism, to achieve a life-like imitation that was beyond their powers. Yet, reverting to literary comparison, it is not generally claimed that in dramatic presentation, Aeschylus, to take an example, was struggling to be as true to life as Menander; or Shakespeare as true to life as Shaw. It is even conceivable—rather probable—that Aeschylus would have disapproved of the New Comedy, and Shakespeare of Shaw.

Is it not perhaps equally mistaken to suppose that the sculptor who made the *Kouros* in New York was trying hard to make an exact imitation of man, but failing? Did he give his youth an ear like some strange shell, and a wig like half a beehive (Plate 33) because he was too immature and helpless to be able to carve stone into a semblance of a human ear and head of hair? Was he more stupid than the palaeolithic cave-man of Altamira? Or was it not rather because he loved formality and enjoyed pattern? If he could have been confronted suddenly with the Praxitelean Hermes I believe he would not have hammered his own handiwork to pieces in despair. It is rather probable that the sixth-century Greek would have been partly mystified, partly annoyed, not by his own production, but by the *hubris* of a man who made an imitation of something that the gods could obviously make better in the original.

"The view has been abandoned," wrote Gerhard Rodenwaldt,[1] "that the merit of a work of art depends on its fidelity to nature, and that the development of art consists in a steadily growing capacity for imitation. When the primitive or archaic artist

[1] *Die Kunst der Antike*, 1927, p. 33.

shows a departure from nature he does not do so from inadequacy of vision or incompetence of hand, but because the subconscious inclination within himself and his age demands a kind of 'inner truth' of form, which is not necessarily evident in nature." The early artist, says Rodenwaldt, is inclined to this inevitably, "not from any lack of ability to imitate had he wished to, but from a positive craving for form and expression. There is something that drives all genuine and unaffected primitive art away from the copying of nature".

It is evident that in the earlier periods Greek celature, sculpture, drawing, drama and poetry were executed under absolute authority of opinion imposed by the particular conventions of their day. The themes which art handled had a certain detachment from everyday life, for they were usually superhuman or heroic themes. And even on a lower plane, even when the poet treated of field labour or of love, when the sculptor made a marble girl for dedication to Athena, when the vase-painter drew the olive yard, these themes had to be deliberately limited within fixed conventions.

The conventions of an age, the themes, the interests and fashions of a period *change* to those of another. Thought, literature, architecture and the plastic arts likewise *change*, but they do not rise and mature, nor decline and fall. Let such anthropomorphic jargon be consigned to limbo.

If it is possible to be rid of these two stumbling-blocks—the theory of the Greek cult of Beauty and the theory of Growth and Decay—then the road will be clear for a study of ancient art along the fresh lines of poetic and prose expression.

FORMAL ART IN GREECE

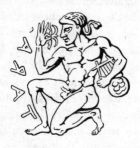

IT is now time to resume the story of the changes which Greek art underwent as a result of contacts with another culture. The establishment of the rich settlement at Naucratis in Egypt about 650 B.C. brought Greek artists face to face with the phenomenon of Egyptian monumental sculpture. Countless stone statues mainly life-size, some smaller, some gigantic, were there to view, hieratically posed in a few simple attitudes. Men stood, hands to sides, left foot advanced, women with feet together; men and women sat, frontal, rigid, hands on knees or held close to the body. There were variants on these themes, but not many. Yet, on these bodies there were very often splendid portrait heads, for there can be no doubt that an element existed in Egypt which craved for patterned formalism and, as a result, the monumental sculptor produced figures which combined naturalistic descriptive portraiture with formal bodily structure. A prose head on a poetic body. The astonishing degree of success that he obtained in this compromise is the more evident when his productions are seen separately. Many of these stone statues were gaily-coloured, the men's flesh with a red-brown, sunburnt hue, the women's a pale gold-olive-brown, or at times a deeper tone.

These visions impressed and delighted the Greeks, who were quick to realise that in their fine island marbles they possessed a material far better for such work than the stones of Egypt, and

after a few experiments they were able, by about 620 B.C., to produce in marble, statues of naked youths and of girls, almost always draped, the two types known as the *kouros* and the *kore* (Plates 24, 31–33, 43, 44, 50, 53a). Yet these figures were not mere copies of Egyptian figures; for, in the first place, they did not have portrait-like faces, but features quite as formal and patterned as were the bodies. Secondly, they were un-Egyptian in build, following some other scale of proportions. Thirdly, the youths, being athletic, were naked, a condition which to an Egyptian would have seemed unsuitable for a man of distinction.

The Greek statues, like the Egyptian, were painted in bright formal colours. Here, if ever, was a departure from nature when an artist gave a man or girl rich orange or deep-blue hair, carmined their lips, and patterned their garments with scarlet, ultramarine and emerald green.[1] But the artist left areas of the marble to display the fineness of its surface and texture, for the flesh parts of the statues were not painted, but stained and thereafter treated with hot wax to prevent the stain washing off in rainy weather,[2] and the lovely surface of marble was not hidden by this skilful technique.

The time may yet come when a modern formal sculptor will throw off the last and heaviest shackle of the pseudo-classical "beauty-tradition" and dare to apply colour—but not illusionistic colour—to sculpture. The Sumerians used colour on their statues, the Egyptians painted theirs, the Greeks did likewise—at first formally and then almost imitatively—and the Romans followed suit. The mediaeval sculptor delighted in brightly painted statues and the splendour of gold-leaf with powdered lapis and malachite. Then came the Renaissance and men began to dig up old Roman copies of Greek Hellenistic Apollos and Aphrodites; and before the mid-fifteenth century the industrious Francesco Squarcione (1394–1474) of Padua had travelled to collect remains of antique sculptures which he gathered into his popular art-school. There great numbers of pupils assembled to

[1] The archaic Greek palette was as follows: black, white, red, blue, green and yellow (see Gisela M. A. Richter and Lindsey F. Hall, *A.J.A.*, 1944, p. 322); the Egyptian colours were black, white, blue, emerald-green, olive-green, brick-red, vermilion, yellow (see J. D. S. Pendlebury, *Tell el-Amarna*, p. 139).
[2] See G. M. A. Richter and L. F. Hall, *loc. cit.*

draw and study these marbles, all white and naked because time had worn the ancient colour from them. Thus, apparently, the belief was fostered that antique statuary was never painted, and the coloured sculpture of Europe was scorned as but another example of Gothic "barbarism".[1] So strong was this conviction that, when an excavator found a number of ancient coloured stone statues in Cyprus during the nineteenth century, he did not dare to offer them for sale to a great museum until he had caused each figure to be coated with a film of powdered stone to hide the colours which, he feared, would cause doubts about the genuineness of his finds. It was the excavation in 1885 on the Athenian Acropolis of many examples of ancient painted statues which supplied the first clear evidence of the colouring of sculpture by the Greeks. The modern sculptor may claim that his desire is to use and display the full fineness of his material's texture. This he could still do, as the sixth-century Greek did, and yet use formal colour in unbroken masses on selected portions of surfaces in such a way as to enhance the value of the stone or marble and to give new emotional significance to curves and planes; for colour is one of the qualities of form through which rhythm gains fuller effect. That even the most advanced artists like Henry Moore and John Skeaping have not yet ventured on this is merely a sign that they have still some subconscious attachment to the sham-classical "beauty-tradition" of the late Renaissance and the nineteenth century.

There are among the many surviving *kouroi* two statues of young men which have an especially marked poetic quality: the New York *kouros* (Plates 31-33), and the *kouros* from Tenea now in Munich (Plate 24). The former is Attic and was made about 615 B.C., the second a Corinthian work of about 570 to 560 B.C. Only one completely naked *kore* survives, made about 550 B.C. of Parian marble by an island sculptor,[2] and she is sufficiently well-carved to attest the artist's familiarity with his subject. Other such figures must have existed and may one day be found. Rather later, about 540 B.C., comes the first of the draped marble girls on

[1] But pottery and terracotta figures continued to be coloured after the Renaissance, which knew no ancient terracottas.

[2] She belonged to the "Melos Group", cf. G. M. A. Richter, *Kouroi*, no. 101, and is illustrated in *Jahrbuch arch. Inst.*, 1906, p. 194, fig. 6.

the Acropolis, a figure of exquisite simplicity (Plates 43, 44). But most of these girls in marble are about a quarter of a century later again (Plate 50), and the last of them, the *kore* of Euthydikos (Plate 53a), was made shortly before the Persians sacked Athens in 480 B.C.

There are in the *Hymn to Aphrodite*,[1] written probably in the seventh century B.C., verses about the goddess which seem to give a word-picture of one of these brightly painted statues:

"She was clad in a robe outshining the brightness of fire,
 A fine robe of gold enriched with many colours
 Shimmering like the moon over her tender breasts, a marvel to
 see.
 And she had twisted brooches and shining earrings flower-
 shaped:
 And round her soft throat were lovely necklaces."

But though this passage may create for us the same impression as a statue, the balance and rhythm of any of these sixth-century figures is perhaps better to be compared with the balance and rhythm of a fragment of Sappho's:

"Like the sweet apple which reddens upon the topmost bough,
 Atop of the topmost twig,—which the pluckers forgot, somehow—
 Forgot it, nay, but got it not, for none could get it till now." [2]

Excitement and emotion controlled by metre and balance; it is there in the verses and there in the archaic marble.

The statement has sometimes been made that these early Greek four-square figures have only four proper view-points: front, side, back, and side. If the older opinion is held and such figures are regarded as the childish attempts of men striving after naturalism, then it might be said that the unnaturalness of these figures is often rather less startling in a frontal or profile view than in an angle view. But if we are prepared to take them frankly as poetic and therefore unnatural we can enjoy them from any angle (Plate 33). Nevertheless, the frontal or side-view, or the back is in most cases to be preferred simply because it impresses us most with the work's metrical quality.

Along with the creation of these great numbers of marble statues, made for the delectation of gods and men in a society

[1] Lines 86 *ff*.
[2] Translation by D. G. Rossetti.

which was growing ever more prosperous and venturesome, we look for the emergence of personalities in the world of art.

The Greek attitude to fine art, it must not be forgotten, was affected by the Greek respect for the celator [1] and the painter. The stone-cutter and marble-carver did not win the same regard, unless he did fine work in metal as well. Yet here was a great rush of marble-carving and it may well be asked who organised it all, and how? It appears most probable that certain well-established artist celators, persons of wealth and position, took the whole thing over. Their families were ready for partnership, since a son generally followed the profession of his father, apprentices could be acquired and masons hired, and a whole concern like a guild could grow up and travel about the Greek world.[2] Later tradition, if carefully examined, will reveal the existence of several such associations, or firms. One of the earliest seems to have been founded by Melas of Chios, who flourished about 630 B.C., and carried on by his son Mikkiades (about 600), his grandson Archermos (about 570), and two great-grandsons, Athenis and Boupalos, working about 540 B.C. The last man is known to have been a celator, and his forebears probably were also, though they designed and caused to be made many figures in marble.

The island of Samos was the home of a similar firm: Telekles I about 580 B.C., his sons Theodoros and Rhoikos (550–520 B.C.) and the latter's son, Telekles II. These brilliant people were architects, celators, engravers, bronze workers and carvers; they certainly employed a large staff and accepted contracts in various lands.

A certain Bathykles from Ionian Magnesia travelled with his staff all the way to Sparta to set up a throne decorated with celature for Apollo. In every case "it is undoubtedly more correct to speak of the influence of metal-work on marble . . . than to say that marble-cutters taught silversmiths".[3]

But the biggest concern of all, which ramified and presently split up into various organisations, was the one started by the

[1] See p. 17 above.
[2] See Gisela M. A. Richter, *Kouroi*, p. 10 *f.*
[3] Dorothy Thompson in *Hesperia*, 1939, p. 309.

Athenian Daidalos.[1] He was apparently active as a celator and wood-carver in Athens between 620 and 610 B.C., left home to marry a Cretan girl who bore him two famous sons, Dipoinos and Skyllis, celators working in ivory and ebony, around 550 B.C., and employing a staff of masons. This pair must have taken on numerous apprentices from various states, for the list of their pupils includes Endoios of Athens who worked in ivory, Klearchos of Rhegium, bronze; Tektaios and Angelion of Sicyon, bronze gilt; and four natives of Sparta named Hegylos, Theokles, Medon and Dorykleidas, all celators working in gold and ivory. Most members of this company flourished about 525 B.C. and were credited with marble statues as well. They doubtless designed them, and directed their production at the hands of their staffs of stonemasons.

In similar fashion the succession of men who devised the admirable marble memorials for Athenian nobles in the sixth century B.C.[2] were painters or celators who brought to their designs all the delicate feeling of great and practised artists (Plates 45, 46).

Any attempt to pick out the works made by the members of these different guilds of celators is perhaps an exercise in futile ingenuity. These masters and their pupils were mobile. A State, a sanctuary, or a family, having decided on a monument of bronze, first bought the metal and chose the site; then gave the contract to a popular celator, whose staff of workmen travelling with him could build a foundry or workshop of sun-dried brick or timber anywhere, and pull it down when the work was finished.[3] The existence of four "styles" of work may be admitted: Ionian, Peloponnesian, Attic, West Greek; plump, spare, firm, and springy: but even these four styles are not always sharply distinct the one from the other.

We pass in brief review some few works made by celators in the seventh and sixth centuries B.C.; not the big things which called for help from workmen, but the finer things in gold, silver, bronze, sard, agate and jasper—the individual works of masters.

[1] Not to be confused with a mythical artificer for the legendary Minos.
[2] See Gisela M. A. Richter, *Archaic Attic Gravestones*.
[3] When Pheidias worked at Olympia, he too had a special workshop built.

Coinage, invented in the seventh century for commercial convenience, was not at first the concern of fine artists. Yet, before the century was out some fine dies began to be made, like that with the head of a roaring lion for an Ionian city (Plate 19a), and the Corinthian die of about 625 B.C. with a handsome Pegasus (Plate 19b). Gold work of Ionian style is represented by one of many ornamental plaques from Cameiros (Plate 20a), Corinthian work by a magnificent bowl of solid gold (Plate 20b), dedicated at Olympia by the family of Cypselos, Despot of Corinth from 657 to 625 B.C. Artists frequently turned out elegant heads of griffins in bronze (Plate 21a) to serve as the handles of cauldrons which were dedicated in many sanctuaries of Greece,[1] especially at Delphi among other splendid treasures. Sometimes miniature cauldrons in gold may have been offered, as there are golden griffin-heads (Plate 21b) that seem to be tiny models of the larger ones.

The love of heraldic animals for ornament lasted far into the sixth century, to the middle of which belong certain miniature gold plaques from Ionia (Plate 22). An early silver coin of Acanthus in Macedon shows a splendid lioness on a bull (Plate 19c). Thasos, also in the north, was one of the first states in the world to put human-like figures upon its coins which show a muscular kneeling satyr carrying a neat, complacent nymph (Plate 19d). This is the work of an Ionian engraver and it may fittingly be compared with two samples of Ionian celature of remarkably high merit.

First, an engraved scarab of sard made about 550 B.C.; a giant Sphinx magnificently muscular is seated on the head and rump of a bull which struggles to rise (Plate 23a). This was probably made in Chios, or for a Chian. In the neighbouring island of Samos there lived at this very date the famous celator, Theodoros, son of Telekles (see p. 37 above), who made a gold ring set with an engraved stone for Polycrates, despot of Samos; a ring concerning which Herodotus, in the forty-first chapter of his third book, has a romantic tale to tell. This sphinx-engraved sard is good enough to have been made by the Samian Theodoros. Second, a family likeness appears in another piece, an Ionian panel

[1] There is a direct reference to such treasures in lines 178 and following of the Homeric *Hymn to Hermes*, as Jacqueline Chittenden has pointed out to me.

in very high relief and of silver with additions of electrum. Two plump but tough amazons are riding upon splendid horses and a third amazon, fallen but not badly hurt, appears below (Plate 23b). The whole fragment is of high quality.

Now turn from the eastern Greek works of corporations like those said to have been founded by Melas or Telekles and contemplate some of the work made by celators of Peloponnesian stock. Spartan Laconian natives like Hegylos, and other pupils of the Dipoinos-Skyllis Guild, applying the art of celature to bronze figurines, produced compact, firm, wiry little masterpieces.

There is a mischievous Hermes from Arcadia made about 560 B.C. (Plate 25), wings on hat and on top-boots, carrying a scraggy ram. There is a bony horseman on a strong horse; reins and helmet-crest were once added, probably in silver (Plate 26a). The man looks a Lacedaemonian, the horse finds its best likeness on a Laconian vase-painting by the Rider painter (Plate 26b) of the same date—about 540 B.C. This bronze was found at Grumentum some eighty miles only away from Tarentum, the greatest of all the Spartan colonies. Contrast an attractive bronze made about 530 B.C. (Plate 27), of one of the young girls of Sparta about whom Plutarch wrote in the fourteenth and following chapters of his *Life of Lycurgus*, and who indulged in outdoor sports naked like the boys. Many such figures in bronze were made in Sparta at this time like the slender athletic girl (Plate 28) with long plaits falling over her breasts, who might be a daughter of the bony horseman of Grumentum (Plate 26a).

But of all Spartan bronzes the best is later still and seems to belong to the early years of the fifth century (Plate 29). You see a hard-bitten Spartan soldier, helmeted, his long curls hanging over his shoulders; he is wrapped from neck to ankles in a cloak, the folds of which gave the artist evident delight. You seem to feel the hard, even, metal cuirass underneath the woollen wrap. Here is more than the absolute fineness of poetic form and structure which we have learned to find in Greek celature. There is an inner emotion; there is a sense of drama and a fate that impends. We think we see Leonidas, silent in the Pass the night before Thermopylae, and if the man who made this little figure did not intend us to have this thought, his work is still so good that we

are very moved by it. The whole thing has the poetic quality of some fine epigram:

> "Tell them in Lacedaemon, passer-by,
> That here obedient to their laws we lie——"

Measure the Greek verse with the ear, the little figure with the eye; in the verse and in the figure there is that exceeding fineness which comes of concentrating on a few purified emotions.

FORMAL ART IN ATTICA

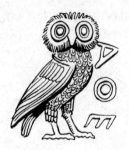

O N the surface it is evident that more is known about the history of sixth-century Athens than of any other city at that time. Ancient historians, Herodotus, Thucydides, Aristotle and others have had so much to tell. Yet each of these brilliant writers had, consciously or unconsciously, a cause to plead, a case to make out, for some great political figure of the past. The political hero might be Solon or Peisistratus, Cleisthenes or Themistocles, and those who held a high opinion of the constitution or institutions ascribed to their particular hero tended unwittingly to give the impression that Athens was internationally and economically insignificant until the great man—whoever he was—came along and took over power. In fact, we can be led to believe that Athens was a backward, feudal, nobles-plus-peasants kind of State until Solon, or Peisistratus, or Cleisthenes came forward to rule, after which splendid deliverance Athens burst into glory as the great instructress of all Hellas.

A careful study of Athenian art will prove that this was not the case. Indeed, it will prove the surprising fact that Athens was energetic, prosperous and enterprising long before the reforms of Solon in 594 B.C.

Our seeming wide knowledge of Athens during the hundred and fifty years before the Persian Wars can make interpretation

over-confident. On the whole, scholars have studied the material evidence along parallel lines which follow the vertical flow of history, and have concentrated, each scholar on his own favourite class of works of art.[1] Yet, if we require a general survey of art, we do better to study it in vertical cross-sections and to discover what in any given decade the mass of Athenian artists were about.[2] The emphasis will prove to be on painting, not because the art of celature in Attica lagged behind that of any other state, but because so great and so pleasing a quantity of painting on pottery survives that it becomes the measure of the other arts. This painting is to be considered as painting on the surface of what happens to be a pot—not, as in earlier and later times, the mere decoration of a pot with paintings. The same artists made panel pictures as well as vase-paintings. But the opportunities for painting the former were rare, whereas vases were in constant demand and served as the commonest base for the exercise of the painter's art.

The Greeks had no paper: papyrus was expensive, reserved for documents and unsuitable for drawing. Wax tablets had no permanence. In fact, the surface of the vase was the drawing-paper of the artist and it was in search of this that draughtsmen wandered from pottery to pottery in the exercise of their art. This is a fact to be borne in mind when appraising Greek ceramics, for there are always two different kinds to be considered: the case of the man who is decorating a pot, like the geometric or oriental-ising vase-painter, and the case of the man who is making a picture—either formal or representative—on what happens to be a pot.

It is significant that from 650 B.C. onwards Athenian potters had already established a big export trade and were sending their products overseas to Aegina, Italy and the East. Some of the painting on these vases, known as proto-attic vases, was exciting and powerful. On one such a pot of about 630 B.C. is a scene of Herakles slaying a centaur (Plate 30a) whose soul flits away in the

[1] Furtwängler, Hartwig, Beazley most of all, and many others have studied vase-painting ; Gisela Richter, Payne and Young, Attic sculpture ; myself, the coins.

[2] As I have endeavoured to do in a paper in the *Numismatic Chronicle*, 1946, pp. 97 ff.

guise of a target-headed bird, while a tiny stork stoops unconcerned between the monster's hind legs. This is a kind of early *surréalisme*, for it is dream stuff, and very good. It may serve to show how remarkable was the quality of Athenian art nearly forty years before Solon reorganised the State.

That which follows is a short account of what was going on, roughly, down the decades, in the artistic life of Athens for one hundred and fifty years. It is a description of the work of painters—all the best of whom gradually concentrated in Athens —of celators in electrum and bronze, and of celators turned to stone-work in low relief, as well as of sculptors.

Never before or since has so much excellence appeared in so small a state within so brief a time, for between 630 and 480 B.C. in one small city men produced the most intense artistic activity in the history of the world.[1]

From about 615 B.C. sculpture began to occupy numerous craftsmen in Athens, since some master, who must have been close to the Athenian Daidalos,[2] began to make the first mainland statues of young athletes (Plates 31–33). Originating in Attica, these celebrated figures continued to be carved until about 590 B.C. and presently the type became popular elsewhere (Plate 24). In Attica itself there was, of course, a close relationship between the work of such marble carvers and the smaller, more delicate work of metal casters and chasers, a good example of which is a firmly-made youth in bronze of about 600 B.C. (Plate 34). The best painter known in the decade before 600 is named the Nessos painter, after his masterpiece (Plate 30b), a powerful, well-patterned composition in which a tidy hero steps on to the back of an unkempt centaur.

Painting and sculpture continued to flourish all through the years which followed. Somewhere about 575 B.C. there was made one of the most attractive of all figures, the man with a new-born calf which has settled down comfortably on his shoulders (Plate 35). The two are bound together in composition by the calf's tail which falls along the man's left arm; and the little creature's head is tilted slightly, engagingly, towards the man's.

[1] See the article cited in the preceding footnote.
[2] See p. 38 above.

"The warmth and intensity of the man's expression make a vivid contrast with the passivity of the calf."[1]

The year 566 B.C. was one of the most important in the whole history of Athens. Peisistratus, in effective, though not yet in titular control of the State, established the greater Panathenaic Festival, a quadrennial event which did as much for the arts as for athletics. Under his influence too there arose the beginnings of careful scholarship, for the Homeric poems were moulded into the final and perfect form in which they have survived, while the birth of the drama was likewise on the way. At this point we are facing the dawn of all that is most elegant, most daring and most sensitive in the history of civilised man. Peisistratus may have marked the year 566 by the issue of a new kind of coinage for the Athenians with the head of Athena on the one side and an owl, the State's new coat-of-arms, upon the other (Plate 36a); and a few dies were made by competent engravers able to create designs of great strength.

Meanwhile the art of painting continued in the hands of many brilliant men. Pictures by two of them must serve. Several vases made and signed by a potter, Ergotimos, were painted and signed by his colleague Kleitias between 560 and 550 B.C. Of these the greatest is the celebrated "François vase", the main scene on which shows guests arriving for the marriage of the hero, Peleus, to the nymph, Thetis (Plate 37). Off on the right she was glimpsed through a half-open door, her white arm holding out a bridal veil. Before the house stands the bearded groom waving to his approaching guests. Beneath his right hand there runs downward the painter's signature. The guests from right to left are Iris and the centaur Chiron, Hestia and two friends, Dionysos with a present of vintage wine on his shoulder, the three Horai, two Muses, and Zeus himself driving a fine chariot with Hera beside him. After him there come the rest of the Olympians, a splendid procession.

Exekias was the other brilliant painter, working between 550 and 530 B.C. One of his pictures (Plate 38a) shows a scene of Athenian family life, the figures being given names of people in heroic legend because that was the fashion of the day. Kastor is

[1] H. Payne and G. M. Young, *Archaic Marble Sculpture from the Acropolis*, p. 2 f.

going off to ride on his horse Kyllaros, a fine thoroughbred drawn by a man who loved horses; the father, Tyndareos, pats the horse's nose; the mother, Leda, holds out a flower for Kastor; Polydeukes has just returned and pats the family dog, while a boy brings along what his master wants after his ride, a seat with clean clothing atop of it, and oil in a little flask to anoint with after the bath. The charm of these figures is best paralleled by the *kouroi* and *korai* of the sixth century; observe Leda and then look at a contemporary marble girl in Athens (Plates 43, 44). The same charm is in both.[1]

Another example of Exekias' work is in marked contrast. Sadness instead of bright contentment—Ajax, broken by dishonour, fixes his sword in the ground, preparing to throw himself upon it, his face furrowed with grief (Plate 38b). Emotion is betrayed here for the first time in painting, and through the unfamiliar convention of black-figure painting sympathy appears.

The work of such painters as these was very close to the work of contemporary engravers, and if less of Athenian celature has survived than of the finest Athenian painting, this is because thin metal is so much more perishable than baked and glazed clay. One lovely, though fragmentary, plaque from the Acropolis is very close in style to the work of the great Exekias and made about 550 B.C. A winged goddess, Nike or Dawn, faces in a chariot, the four horses placed in agreeable symmetry (Plate 36b). The material seems to be gold with a considerable admixture of bronze and it has rightly been called "one of the finest reliefs produced at any period".[2]

It is now that one comes to the contemplation of three works of art in marble which betray a sensibility so fine and are of a quality so great that they can scarcely be measured by ordinary standards. Since their makers are anonymous we must give them names, calling the first the "Rampin Master" after one of his two works[3]; the second, I think, the "Sphinx Master" from the smiling creature which tops his glorious monument.

The first master's earlier statue, now generally known as the

[1] Seltman, *Attic Vase Painting*, p. 28.

[2] Winifred Lamb, *Greek and Roman Bronzes*, p. 120.

[3] After the head, once in the collection of Monsieur Rampin, and now in the Louvre, belonging to his earlier statue.

Rampin Horseman (Plates 39, 40, 41), has a fine simplicity of body which serves to emphasise the rich and complicated decoration in hair and beard. He is not upright and frontal like most youths of the time, but his head has a turn away from the axis on which the statue is composed, and a tilt and a forward inclination which enhance its charm. The figure was made just before 550 B.C. Ten or twelve years later the Rampin Master made an even more lovely figure in marble—the "Peplos Kore" of the Acropolis [1]—a smiling girl wearing a classic peplos over a linen chiton (Plates 43, 44). Remains of colour add to our delight in this taut figure, of which it has been said that "in all Greek sculpture there is no figure more intensely and nervously alive. The sculptor was, indeed, one of the great masters of his time . . . with a dexterity which would seem miraculous in any artist but a Greek".[2]

The surviving monument by the "Sphinx Master" is about contemporary with the "Peplos Kore". On top of this gravestone is poised a springy sphinx who gazes into the distance; but below on the shaft in contrast is an idiom half-way between sculpture and painting, for it is in fairly low relief (Plates 45, 46). A broken inscription on the base is there to tantalise scholars and critics. It is tempting to accept a restoration of this, due to several people, and to read "To dear Megakles his father set me up as a monument when he died; with him lies buried dear Gorgo who died also".[3] Anyway, on the shaft we see them, brother and sister; Megakles as a young athlete, naked, trim of hair, holding a flower, a small perfume-vase slung from his left wrist; and in front of him little Gorgo in a peplos with a cloak over it, and a flower in her left hand. The delicacy of this relief is akin to the finest celature that ever the Greeks produced.

There is a very peculiar quality about the marbles made in Attica between 615 and 480 B.C., a quality which seems to separate them not only from all later sculpture, but also from most sixth-century sculpture made elsewhere. It is a quality that can best be described as ivory-like.

[1] Often referred to by her number as "679".
[2] H. Payne in Payne and Young, *op. cit.*, p. 19.
[3] G. M. A. Richter, *Archaic Attic Gravestones*, p. 72 f.

It was the great discovery of some seventh-century worker—Daidalos, or another—that you could treat marble as you could treat ivory. You could stain it like ivory, though you had to fix your stain by waxing, and you could paint it as you could paint ivory. Moreover, just as you added ornaments and accoutrements in gold to your ivory figures, so you could and did apply the same adjuncts in gilded bronze to your bigger marble figures. This is why, when we survey Attic sixth-century sculpture, either in the round, or in relief, or a thing like the horse (Plate 42) resembling some great chess-board knight, we suddenly perceive the existence of a strong kinship with ivory. For these Athenians, trained in an art of subtle, fine precision, were able to do in marble on the grand scale—sometimes on the giant scale—what celators had already done for centuries with ivory and in miniature (Plates 5–9, 14). And this is also why, when we survey Attic sixth-century sculpture, we may feel ourselves in contact with an art more truly poetic than any ancient art in the centuries to come.

The inconceivable was, of course, that ever a celator could work in ivory on the giant scale. Yet in the next century the inconceivable came to pass; the impossible took place under the magical fingers of the most celebrated of all celators—Pheidias. That, and nothing else, was really his title *in the ancient world* to undying fame.

About 530 B.C. an important change occurred in the art of painting on vases; someone invented red-figure—some pupil of the great Exekias working for a potter named Andokides introduced it. Now the flesh of females on the older black-figure vases had generally been white, and the Andokides painter produced a vase with female figures only on both sides, naked girls bathing, and Amazons with a white horse (Plate 47). This vase, or such another, gave the idea of reserving the red ground of a vase so that figures should appear light against a dark ground. A famous successor of the last painter was Epiktetos I, at work from about 525 to 500 B.C., who was author of many fine designs, like the tondo with a bearded, cloaked and booted reveller stooping to lift a large cup of wine; on the near side of him is a boy playing the double flute, a flute-case slung from his left shoulder (Plate 48a). For sheer compositional value this cannot be bettered.

For much of the reign of Peisistratus in Athens the artistic quality of the State's coinage had been poor, perhaps because the finest artists were so busy on countless other jobs that none could be spared for die-sinking. But under Hippias, who succeeded in 527 B.C., some experts at engraving were set to make dies, and the results were truly admirable. One large die, perhaps of 524 B.C., carries a head of Athena (Plate 49a) which is like the work of a follower of Exekias; a second (Plate 49b) recalls the Athenas drawn by the Andokides painter and could have been carved in 524 or 520 B.C. A third die and its companion owl-die, could have been made in 512 or 508 B.C. (Plate 49c), and is more reminiscent of typical works of sculpture of this period, like certain of the Korai. The style of these had by now undergone a change, for the women of Athens were wearing the very elaborate Ionic chiton with its mass of little folds (Plate 50) instead of the older, simpler, Doric dress.

A similar Ionic garment distinguishes a wonderful piece of celature of this date, a thin sheet of bronze made in the very same manner as were remotely early examples of art produced in Greek lands (Plate 2a, b, c), by being hammered over a matrix of bronze or stone. The man who made this excellent thing (Plate 48b) was a man whose ideas were close to those of a certain Athenian painter named Oltos, who was working between 525 and 510 B.C. The rather close relations which existed during the last quarter of this century between celators and painters appear in another work, a remarkable sard scarab (Plate 51a) of about 510 B.C., engraved with a kneeling figure of Herakles. Not only his face but his attitude and the spacing and modelling of his muscles put him into close association with the work of a famous painter named Euthymides, whose figure of Peirithous on the left of the painting (Plate 51b) is remarkably like that of Herakles on the scarab. The painting, which is also of about 510 B.C., shows on the right Theseus carrying off the not unwilling nymph Koroné whom Helen seems to wish to rescue. In this Athenian art of drawing and painting on vases one master after another learned fine anatomical drawing as well as skill at depicting the human form with the utmost economy of line. The poet Simonides, author of famous epigrams, lived for long in Athens

where he saw and handled work such as this. He was moved to what seems like the first piece of art-criticism in history, and wrote:

"Painting is silent poetry; poetry, speaking painting."

There were certain painters who began to work about 500 B.C., carried on until 480, lived through all the wild months of the Persian invasion, saw their city annihilated, their fleet victorious, and the final flight of the Asiatics from Greece. These same men lived to see Athens rise once more from its ruins and to pass on the torch of Attic art to their successors. So many of this group of painters were so good that a selection is not easy to make. However, most critics would approve the choice of two in particular. The first has been dubbed the "Berlin painter" after the home of his best surviving amphora; the other painted for a potter named Brygos, and so has been labelled the "Brygos painter". About 550 B.C. the black-figure artist Exekias had begun to paint; a pupil of his had been the Andokides painter, about 530 B.C., who had taught Euthymides about 510 some of this art, and Euthymides himself will have counted the Berlin painter among his pupils. Observe the picture upon one side of the great Berlin vase (Plate 52a). Hermes is there as the guest of the Seilens; in front of the god, who has emptied goblet and jug, stands a Seilen holding a lyre. The doe tripping between them is fascinated by the glittering cup and caduceus. This amazing vase was painted in the first decade of the fifth century; but where can you find a finer composition? As for the delicate outlines, muscles, inner markings, fine hands and forearms, the three-quarter foot of the Seilen, one might study them with unflagging pleasure and be ever more impressed that so much could be achieved with such economy of line.[1]

The Brygos painter worked mainly upon drinking cups, and had a marked fondness for Seilens, whom he represented with blasphemous audacity in one painting (Plate 52b) meditating an attack upon the Queen of Heaven. Hermes, who should intervene with the impartiality of a Herald, seems to make a gesture of encouragement; and it is well for Hera that Herakles now lives

[1] Seltman, *Attic Vase Painting*, p. 50.

among the immortal gods, for that man of action, clad in Thracian pyjamas and lion-skin, is about to deal with this fantastic assault upon divinity.[1] In the picture Hera herself wears a head-band from which rise four upright olive-leaves, a style which she has borrowed directly from Athena, who first appears with this ornamentation on coins of Athens minted between 490 and 480 B.C. Here, as often, a detail in the style of engraver and of painter establishes contemporary dating of their work. One of these coins (Plate 53b), struck perhaps in 486 B.C., is a splendid large silver piece of ten drachmas such as Athenian citizens were receiving from their Treasury at this time. The dies for both sides are fine examples of bold, deep engraving.

For the first twenty years of the fifth century plenty of ivory-like works in marble were still being made in Athens, and frequently dedicated upon the Acropolis. One of about 500 B.C. is the fine Chess-board Horse (Plate 42) ; another, surely made in 480 B.C., is the sulky, sleepy, sensual, high-breasted girl (Plate 53a), whom a certain Euthydikos dedicated to Athena a few weeks or months before the crash came.

What may have been the population of a State which was enabled for so long to indulge in so remarkable an artistic activity? Conjecture is not easy but we may gain some help from the latest estimates concerning the population of Attica more than half a century later. According to the most recent estimates,[2] the population about 431 B.C. was made up as follows: the citizens, 172,000 (including women and children); resident aliens, 28,500; slaves, 115,000. But the authorities are in agreement that during the sixth century and down to the time of the Persian wars, the number of citizens was less, the number of aliens and slaves "certainly much less" than it was in the mid-fifth century.

Now, if the total population of Attica about 431 B.C. was about 315,500 we may venture to guess that in the sixth century it can hardly have surpassed 200,000. That is to say, the total population of Attica then may have been the same as the population of Plymouth now. One would surely regard it as a matter for some

[1] Seltman, *op. cit.*, p. 59.
[2] A. W. Gomme, *Population of Athens in the Fifth and Fourth Centuries B.C.*, Oxford, 1933: George Thomson, *Aeschylus and Athens*, London, 1941, p. 347 *f.*

astonishment if in a period of one hundred and fifty years any one city, say, of the size of Plymouth or of Lille, were to produce so world-famed and glittering a galaxy of artistic talent in poetry, drama, engraving, sculpture and painting. We shall not be accused of exaggeration if we apply to Attica the word "magnificent".

The Persians hankered not only after conquest but also after culture. Into their net they had already swept the artists and craftsmen of all Ionia, the Islands and Eretria; and hundreds of such Greek artists were being employed on the great reliefs and friezes of royal Persian palaces and other monumental structures.[1] If, in 490 B.C., the Persians had won at Marathon they might have deprived the art-enchanted people of Athens of all their artists, carrying them off to work with other Greeks on the carving of stuffy, swaddled orientals instead of naked, healthy athletes.

In the event when the Persians came again ten years later their thoughts were only on vengeance and destruction. The damage they wrought was such that when the Athenians returned victorious and began to rebuild in 478 B.C. they could only shove their ancestors' battered sculptures underground for the modern world to find again in the nineteenth century. These glorious finds have taught us that the fifth-century art of Athens was no inexplicable miracle, but something founded in a long tradition. We now know that because one generation after another had, for more than two centuries, been devoted to fine art, literature, the humanities and bold experiment, the people of Athens were able to create that which still stands upon their Acropolis.

[1] This has been conclusively shown by Miss G. M. A. Richter, *Greeks in Persia*, in *Amer. Journal Arch.*, 1946, pp. 16 ff.

DRAMATIC ART

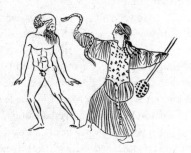

O UT of stress and fear came dramatic exaltation. Total destruction had been the fate of temples, houses and monuments in Athens, though Salamis, Aegina and the Fleet had been each one a refuge for her people. Returning victorious their first preoccupation must be with rebuilding city, townships, villages and farms. There was little thought in these first years of reconstruction for art, although vase-painters were perhaps the first to take up paint-pot and brush and to satisfy their need to make pictures in the busy new potters' factories. One phase of art seems, however, to have been too fine and fragile to survive the war, for you do not meet again in Athens the kind of carving in marble which makes you think of ivory.

Meanwhile in other Greek states the work of brilliant celators suffered no more than a brief interruption from the great war. Little has been said of the western Greeks of Italy and Sicily. They too had their troubles from Carthaginian attacks, but in lesser degree; and the Greeks of Sicily were by now producing works of engraving which might have aroused reasonable envy among other men of those days. It will be recalled that one of the pupils of the celebrated celators Dipoinos and Skyllis, who were sons of Daidalos, was a certain Klearchos of Rhegium of sixth-

century date,[1] and that Athenian potters had established, very early in the sixth century B.C., a most important trade with the Greeks of Italy and Sicily, all of which proved stimulating to art in the West, especially since a number of artists migrated there from Attica and Corinth.

By about 480 B.C. some brilliant engravers were at work in Sicily, like the man who cut dies for Syracusan silver coins, the types of which commemorated the victory of King Gelon and the Syracusans at Himera over the Carthaginians (Plate 55a). Ten years later another artist—the greatest of all die-engravers in history, who is known as the Aetna Master [2]—made dies for a coin at the behest of Hieron I, King of Syracuse and Aetna, for the latter city (Plate 55b), with a mighty head of a bald Seilen and on the reverse Zeus nobly enthroned. It was the same engraver who in 461 B.C. made dies for the nearby city of Naxos (Plate 55c). On the obverse is a head of the Wine-God with his delectable, dangerous smile; on the reverse a squatting Seilen with wine-cup, the most excellent composition and finest design ever made for a coin. There are two other works which are to be related to this masterpiece; one an engraved stone, a black jasper signed by Anakles of about 460 B.C., with a Seilen resting on a wine-skin (Plate 56b), a brother to the tough fellow of Naxos. The other is a bronze statuette found on Mount Aetna, of an athlete whose right hand once held a bowl from which he poured libation to a god (Plate 56a). His whole bodily structure resembles that of the Sicilian Seilens.[3]

A picture of Greek art after the defeat of Persia would be incomplete if only Western art were shown; accordingly, two examples of animal sculpture by highly-skilled celators may help to balance the impression. It was perhaps a Peloponnesian who made a horse in bronze (Plate 57) which, yoked with three others to a chariot, once stood in some sanctuary as record of a victory in the games. Equally attractive and more exciting is a splendid winged goat of silver and electrum (Plate 58), one of a pair of handles of a huge silver vase. The Seilen's head beneath the

[1] See p. 38 above.
[2] Seltman, *Greek Coins*, p. 132 f.
[3] Some have associated this figure with the name of the sculptor Pythagoras of Rhegium, pupil of Klearchos of Rhegium; but that is a guess.

goat's hind hooves is like a hall-mark to prove its Greekness, and this elegant masterpiece of celature is now recognised as the work of a Greek artist of high standing carried off to the East to work for Persian masters. This too may be dated close to 470 B.C.

There was one man who somehow seems to express the heroic, superhuman art which prevailed for a little while after the Persian wars: the poet Aeschylus. The great Athenian was so complete a part of the life and adventure of the times. Born at Eleusis, second city of Attica, in 525 B.C., he could remember the reign of Hippias and the birth of the democracy under Cleisthenes. He was writing plays before the great invasion began; he fought in the ranks at Marathon and as a seaman at Salamis. After this he wrote the oldest surviving historical play, *The Persians*, and from among many great plays left behind, one of the greatest dramas of all time—*The Oresteia*. He was at home in Sicily as well as in Athens. As a benefactor of mankind he had something of the nature of his own *Prometheus*. It has been remarked that Simonides gave the first piece of art-criticism when he said, "Painting is silent poetry; poetry, speaking painting". Aeschylus gave the second, according to a story told by Theophrastus and recorded by Porphyry in his book *On Abstinence*, for he is said to have compared new statues with old ones. The old, though simple in workmanship, he regarded as superhuman; and though he marvelled at the new statues for their elaborate workmanship, yet he considered that they had about them less of the superhuman. Such a statement is likely to have been made towards the end of his life—he died in 456 B.C.—when he already saw many of the softer, prose-like works of modelling set up in Greece.

The seeds of sculptural Dramatic Art had already been sown in the preceding century when the Greeks began to apply sculptural decoration to temples. A consideration of this particular art has been purposely withheld until this point. It is difficult to appraise the merit of architectural sculpture apart from the building to which that sculpture belongs. This might be claimed as a good reason for omitting it altogether from any survey of Greek art which is not intended to include the vast subject of architecture. But if it were omitted one would both be deprived of certain

interesting comparisons with other branches of art, and be denied the inclusion of the work of a man whom I hold to be one of the two greatest sculptors of all. So a short summary of that which led up to his work is desirable.

The sculpture on the earliest stone temple to carry such ornament, a building of about 600 B.C. in Corcyra, consists of frightening things, a Gorgon and giant leopards; and it has been held that they were put there to keep off evil spirits. Whether or no this be true, the Greeks very soon forgot about warding off bogies and turned to the telling of stories in stone or marble. Doric temples tended to carry sculpture in their gable-ends and on ornamental panels, Ionic temples to wear a long continuous frieze in relief. All these were convenient for representing varied schemes like the exploits of a hero or warriors, the battles of gods and giants, or Greeks and Amazons. Yet with certain notable exceptions, the men who made decorations of this kind were generally not men of as distinguished a calibre as the artists who produced smaller and more individual works. They were indeed sometimes men whom it would be fairer to call skilled masons than brilliant sculptors. A history of Greek sculpture would have much to tell about their work, but in a survey of Greek art as a whole one may not linger over it save to mention certain brilliant productions.

One such was built at Delphi for the people of Siphnos about 530 B.C. This was no temple, but a so-called "Treasury" like some huge marble casket meant to hold valuables; it was therefore particularly suitable that it should carry as ornament a running frieze of sculptured scenes like the band carved round a box of ivory.

Before the other exceptional sculptures on buildings are mentioned it will be necessary to consider another phenomenon of Greek art—the creation of large statues in bronze.

Among the makers of statues there are two different kinds: sculptors and modellers. Michelangelo stressed the difference in the words, "I mean by sculpture that which is done by taking off: that which is done by putting on is similar to painting".[1]

The sculptor begins with a block of material before him; he conceives the finished statue within the block; and, while his

[1] *Cf.* A. J. B. Wace, *An Approach to Greek Sculpture*, 1935, pp. 12 *ff.*

chisel cuts away what is superfluous to his organic conception, his creative instinct works from within outwards. His technique is best suited to poetic art.

The modeller begins with a lump of clay at his side; he perceives and constructs his subject as he goes along; and, while his fingers add and mould, his constructive instinct describes his subject from without. His technique is best suited to prose art.

Thus the sculptor is at heart a poet though he may choose, like the sculptor of an Egyptian portrait-head, to employ prose form. The modeller is at heart a prosaist though he may, like the modeller of some Greek terracotta statuette, force his model into poetic form under the influence of major poetic works of art.

Where in this scheme of things are we to class Greek bronzes? A bronze figure is a cast and therefore bears a kind of second-hand relationship to the artist's original work, though it does acquire the artist's creative or constructive intent if he himself works over the bronze which has been cast from his work.[1] But, how did he make that original work—did he carve it or model it? On the answer to that question may depend the explanation of its poetic or prose character. An examination of small early bronzes[2] made in Greek lands will help to supply an answer.

In Minoan times bronze figurines, like the bull and toreador (Plate 10b), have all the air of casts from clay models. A clay figurine would first be baked to harden it, next encased in wet clay moulds which would be sun-dried, taken from the model and baked in their turn. A bronze cast from these has all the semblance of a clay figure changed into another material. But turn to bronzes of the Greek geometric age and other methods appear, for most of such bronzes look simply and delightfully wooden. Bulls or horses mounted on elaborate openwork stands could never have been made from models of clay (Plate 12a, b). The very stands are typical of the wood-carver's craft, and we cannot doubt that in this case carved wood models were encased in wet clay moulds, which, after being sun-dried, would

[1] As certain famous ancient sculptors are alleged to have done. Wace *op. cit.*, p. 8.

[2] For example, in the plates of *Greek and Roman Bronzes* by Winifred Lamb.

be taken from the wooden figures and fired so that bronze might be cast into them.

From about 800 B.C. for more than three centuries the Greeks generally made their small bronzes from carved wooden models, a conclusion that seems obvious, not only from the appearance of the figurines themselves (Plates 16a, b, 25, 26a, 27–29, 34), but also from certain details, such as the occurrence of thin sharp ridges, like the helmet-crest of the Spartan soldier (Plate 29), or the borders of garments on various charming statuettes of girls made between 480 and 460 B.C. (Plate 63a, b); all of them the work of skilled celators.

Somewhere about the middle of the sixth century artists began to make large hollow-cast bronze statues, which were likewise made from great wooden figures as recent research has proved. A statue like the Delphic charioteer (Plates 61, 62) was not made from a figure of modelled clay, but from a finely sculptured statue of wood. This wooden statue was taken to pieces at the waist, neck and elbows, and each member was first cast separately in bronze, then fitted into place by the founders, and finally chased all over, probably under the eye of the artist himself. It is dated to 476 B.C.

It is well known that European sculptors like Peter Vischer of Nuremberg and his sons, working round about A.D. 1500, produced their admirable bronzes from carved wooden originals that still survive; but that the Greeks did this has only recently been realised, and it is a fact which must modify our whole conception of Greek art. The man who began with a block of wood from which his knife and chisel cut away what was superfluous was thinking from within outwards and employing a technique suited to formal or poetic art. His finished bronze made from this wood-carving had also normally a truly formal character, hence the impressively poetic effect of a masterpiece like the Delphic Charioteer.

The name of the artist who produced this masterpiece is unknown; the date of its creation an approximation. But it is recorded that only one year before that date an important work of art in bronze was set up in Athens. The story that attaches to it is as follows. Nearly forty years previously Hipparchus,

brother of Hippias, had been assassinated by a couple of aristocrats who had a personal grievance against him. After Hippias had been expelled and democracy established this pair, named Harmodios and Aristogeiton, were—quite wrongly, of course—canonised by the Athenians as "Liberators" and a bronze statue group of them, made by an Athenian named Antenor, was set up. When the Persians sacked Athens they carried Antenor's group off as a trophy. Within two years of the Persians' flight from Greece the Athenians had ordered a new bronze group, which was set up in 477 B.C., and the commission was given to a firm consisting of two Athenian celator-bronze-workers named Kritios and Nesiotes. The group has vanished. All that survives is a copy, not in bronze, but in marble ; and a marble copy of a bronze has the same degree of cheapness which a lustre-ware milk-pot possesses in relation to a pure silver Georgian cream-jug. It is both rash and ungenerous to use these rather cloddy marbles—made to the order of Hadrian about A.D. 130—as evidence for the work of two people who in their own day were surely great artist-producers.

There is, however, a contemporary work of art which may throw light upon these men and their establishment. Athenian potters and vase-painters did on occasion produce vases which by their subjects made allusion to and paid compliments to other members of the same profession,[1] and since potters and smiths, like painters and celators, were men of kindred callings, it is not surprising to find more than one vase-painter depicting scenes of the kind of work which was going on, as it were, across the street. Now the Brygos painter—he who painted the Invasion of Olympus (Plate 52b), already discussed—had a colleague who, for lack of his real name, is called the Foundry painter, and this man painted on the outside of a cup two remarkable scenes of the activities in a bronze statue-maker's establishment. The persons present are two workmen, who occur twice, a bellows boy, the two owners and a visitor, an athletic youth who has looked in and, to amuse himself, has picked up a hammer. He is centrally placed and is the only one named, for the inscription reads "Diogenes is a fine lad. Oh yes!" (Plate 54b). For the rest, a

[1] See especially J. D. Beazley, *Potter and Painter in Athens*, 1946.

capped workman squatting on a low stool pokes the furnace, behind which a boy works the bellows. On the wall are a pair of horns serving as a rack from which are slung two hollow moulds for the faces of bronze statues, and a series of intaglio matrices such as celators use. To the right of the picture another workman in a loin-cloth is fastening together the various parts of a new-made bronze statue that rests on a bed of clay. Nakedness is correct for young Diogenes, the free-born; but well-conducted servants should wear something, and if the work is too hot for clothing at least the worker must wear a hat. That is the convention.

And now look at the other side of the cup (Plate 54a). The men are at it again, the same two, "Cap" and "Loin-cloth", finishing off a great bronze statue of a hero, double-life-size. This figure, which still stands beneath a scaffolding, is receiving its final work-over under the watchful eyes of, and with personal directions from the two elegant owners. Why not call them Kritios and Nesiotes? The vase could have been painted precisely at the time when the Athenian State honoured them with the commission to make the statue group of its national heroes, and at the time there cannot have been many other firms like theirs in Athens.

The other method employed in ancient as well as modern times for making figures of hollow-cast bronze is known as the *cire perdue* method. A statue is first moulded in clay, and covered in a thick coating of wax on which all delicate details—as it were the epidermis of the statue—are modelled by the artist. Once the wax has hardened the whole is packed in moulds of clay and the combined mass placed in a furnace which melts the wax out leaving a space, between outer clay mould and inner clay core, into which molten bronze can be poured. Great heat is requisite so that all the wax may be sweated out. This method was known to the Egyptians from whom the Greeks learnt it; but neither of these peoples was able to produce large figures by this method— at most a life-size head, or a half-life-size statue like the Apollo of Piombino in the Louvre (Plates 59, 60a).

After a bronze figure had been cast by the *cire perdue* technique it was tooled all over to produce the necessary finish. But since the artist began with a mass of clay which he constructed into a figure, moulding it from without, he was employing a technique

best suited to representative or prose art. His finished bronze made from a clay and wax model had also normally a truly modelled effect.

From all this it is apparent that Greek bronzes, both small and large, are some of them to be classed as works of sculpture, some as works of modelling. The latest of the large *sculptural* bronzes that survive are the Delphic Charioteer and the nearly contemporary Chatsworth head of Apollo (Plate 60b). The earliest of the hollow *modelled* bronze figures seems to be the Apollo Piombino (Plate 59), made about 490 B.C., who now appears as a forerunner of Greek descriptive art. His successor is the bronze boy (Plate 67) of about 440 B.C. known as the "Idolino".

By the beginning of the fifth century there were sculptors of statues in marble, sculptors of statues in bronze-from-wood, and modellers of statues in bronze-from-clay. These artists—more especially those of the two first groups—were bound to influence one another, and one of the most obvious cases of such influence is to be seen in the sculptures from the gables of the Temple of Aphaia in Aegina, one of the exceptional cases of sculpture on a building referred to above.[1] Though these figures, which were made about 490 B.C., are of marble they have the appearance of bronze statues with their tight hard surfaces and sharp contours. It is possible that little models were made by celators both to guide the masons who carved them, and to suggest the composition of groups and poses of figures. Since contemporary small solid-cast bronzes were usually made from wood models it is very likely that the models, or "paradigms" as the Greeks called them, for the Aeginetan figures were also of wood.[2]

A good example of the mutual exchange of stylistic influences between stone-carvers and wood-carvers is to be found many centuries later in English monumental sculpture; for, while stone tomb effigies are the rule in our cathedrals and churches, there are also many admirable effigies of wood.[3] The oldest surviving,

[1] See p. 55 f above.
[2] Unfortunately these figures from Aegina are so grievously over-restored that we must refrain from illustrating them.
[3] A. C. Fryer, "Wooden Monumental Effigies in England and Wales", *Archaeologia*, lxi, 19, pp. 487 ff., also issued as a separate publication with many illustrations. Ninety-three are still extant and authentic records of twenty-two

made about 1280, is that of Robert, Duke of Normandy, in Gloucester, the most recent that of Sir John Oglander who died in 1655 at Brading in the Isle of Wight. Their perishable nature has made them rarer than the more durable stone effigies which they must have once outnumbered. But the wood-carver's craft and style have left their mark upon the monuments of stone in England [1] just as in ancient Greece.

Since we now know that the Greeks used wooden models, it seems possible to trace the influence of the wood-sculptor's art not only in the gable-groups from Aegina, but also in that finest of all ancient monuments—the sculpture of the Temple of Zeus at Olympia (Plates 64–66).

It is the work of a single master who made first the east metopes, or panels, then the east gable, next the west metopes, last the west gable-group: for this the internal evidence is conclusive. The twelve labours of Herakles are the theme of the panels; in the east gable was a scene of preparation for a chariot-race, Zeus in the centre; in the west gable, centaurs trying to break up a wedding-party, and tamed by Apollo. He worked at these for some fifteen years, completing them between about 460 and 455 B.C.[2] His helpers were probably a few masons who may have roughed out blocks for him; but, since the whole bears the marks of his in-dividuality and of his growth, he must have designed all and finished all himself. Relief sculpture like that of the metopes may be regarded as the result of surface drawings by the master carved into the block. With the gable-groups it would be other-wise and some kind of model must first have been prepared.[3] Observe how the mighty central groups form each a solid kernel which supports the whole composition reaching out to the wings so that the whole thing is interlocked—animals and monsters, boys and women, children and greybeards, heroes and gods, rest and wild turmoil. The Olympia Master, like Aeschylus, saw a

more that have been destroyed. Hundreds more have perished unrecorded. In addition to wood and stone there are a number of bronze effigies.

[1] Compare for example the robes of the Rector of Clifford, c. 1280 (wood), Fryer, loc. cit., p. 10, with the robes of the fourteenth-century alabaster Virgin in Nottingham Museum, O. E. Saunders, A History of English Art in the Middle Ages, 1932, fig. 73.

[2] E. Buschor and R. Hamann, die Skulpturen des Zeustempels zu Olympia, 1924, pp. 13 ff. [3] Wace, op. cit., p. 36.

humanity transfigured by its destiny; he pierced beyond this heroic world to more awful shapes; like Aeschylus, he was a seer and a poet who thought not in abstractions but in vivid images. He created a world of his own around the three divine beings: Herakles, Zeus and Apollo. Like Aeschylus, he composed his trilogy with elements now graceful, now terrifying, now starkly supernatural. There is nothing haphazard, but deep thought and elaborate metrical design.

The material in which the master made his trial pieces was probably wood, rather than clay or stone, for there is much about the finished sculptures that suggests the wood-carver's art, not only in the splendid formality of draperies but in heads and bodies as well. It is this that makes us aware of a certain kinship between the bronze-from-wood figure of the Delphic Charioteer (Plate 62) and the marble-after-wood Kladeos (Plate 64a) with his formal bodily planes. It is this that makes the heavy robes of the women (Plates 64b, 65) look like the boles of pine and olive growing in the Olympian Altis.

Those who know it well return again and again to contemplate the great symphony of the west gable. Swinburne called the *Oresteia* of Aeschylus "on the whole the greatest spiritual work of man"; and when F. L. Lucas described this gable as "perhaps the noblest sculpture that I know",[1] he was moved in the same way. Only a mature, clear-minded man in whom all spiritual reserves had been crystallised could have produced sculptures so sanely balanced and so clear, but with a deft touch of the symbolic; for into the turmoil of twisted limbs there gleams the eternal sanity of the god and his two champions. Yet neither the Attic Theseus nor the Thessalian Peirithous at the god's sides are the heroes of the fight. Only the invisible Apollo.

Thus Aeschylus saw the god rebuking the Furies:

> "Out of my shrine I charge you. Hence! begone!
> Avoid this holy ground. Go instantly!
>
>
>
> Oh loathsome, heaven-detested creatures,
> Bonds may be loosened. There are many means
> To free the captive".[2]

[1] "The Criticism of Poetry", *Proc. Brit. Acad.* xix, p. 12.
[2] Translation J. T. Sheppard. Aeschylus *Eumenides*, 178/9, 644/6.

This Apollo (Plate 66) trails an idle bow, for he fights with weapons of the spirit against the centaurs. Yet their very animal ferocity is transfigured into a kind of symbolic grandeur. A Prospero might call them each

> " as disproportionate in his manners
> As in his shape ".

And yet each monster has his stunted soul; like Caliban crying:

> " You taught me language; and my profit on't
> Is, I know how to curse. The red plague rid you
> For learning me your language!"

There can be sympathy for these centaurs as there can be sorrow for the ancient goddesses of Earth that plagued Orestes.

But in the centre stands Apollo, one arm stretched out above the tumult, the embodiment of the Greek faith, beyond all others sane.

CHAPTER VI

DESCRIPTIVE ART IN GREECE

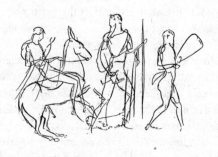

THUCYDIDES was perhaps sixteen when Aeschylus died.
If so, at the age of fourteen he may have witnessed the first per-
formance of the *Oresteia* in Athens. Aeschylus was in the sixties
when the temple of Zeus at Olympia was completed; Thucydides
may have been nearing forty when the Athenians finished the
Parthenon in 432 B.C. The greatest dramatic poet and the
greatest historian may have met; but save that they were both
Athenians and both soldiers they had nothing in common.

Aeschylus created a world that was entirely his own: Thucydides
showed men as they were and left his readers to judge. The same
difference lies between the sculptures of Olympia and of the
Parthenon, for it is the difference between great poetry and great
prose.

Descriptive realism was essential to Thucydides, who had little
reverence for previous writers and whose narrative has the
solidity and verisimilitude of evidence in which every word is
weighed. He wrote as a contemporary, but with his mind on
posterity, telling that his work "is composed as a possession for
ever rather than as a prize composition to be heard for the
moment". Compare this proud claim with the words which
Plutarch in his life of Pericles used of the Parthenon and the
Propylaea :—

"They were created in a short time for all time. Each in its fineness was even then and at once age-old; but in the freshness of its vigour it is, even to the present day, recent and newly wrought."

There were prose-writers before Thucydides, just as there were descriptive artists before the Master of the Parthenon. In literature the Ionians, Heraclitus and Hecataeus, of whom only fragments survive, preceded Herodotus, the lively humorous teller of stories woven into a fine historical whole. In art there were the makers of the partly realistic Apollo of Piombino (Plate 59), and of the Florentine and Beneventum bronze boys (Plates 67, 69a) made about 440 B.C. But most of the sculpture that might have supplied the real parallel to Herodotean prose has perished just because it was of bronze which was melted in post-classical times. The fact, however, remains that prose literature and art-prose began to appear among the Greeks at about the same time, and that before the fifth century was out each had produced its masterpiece; the history of Thucydides, and the sculptures of the Parthenon.

What cause or causes led to the adoption of descriptive realism in art to the near exclusion of poetic formalism? It is of no use to talk of development or growth, for the Parthenon no more grew out of Olympia than the history of Thucydides out of the dramas of Aeschylus. Rather, it seems that the fifth-century Greeks, having experimented in realistic art, began to find it more to their taste than formal art because they acquired a liking for verisimilitude. To this liking two factors perhaps contributed.

In the first place, after the Persian wars the production of athlete-statues of men and boys in bronze seems to have become very common, and these, as the employment of the *cire perdue* method increased, were the product of the modeller's art which tends to realism more naturally than true sculpture or carving. Moreover, a bronze statue in its original unpatinated state had very much the colour of a thoroughly sun-bronzed body, and so the colour helped the lifelike effect which the bronze-from-clay statue possessed. Thus the admiration bestowed on the living athlete might be expanded to embrace a lifelike image of him.

In the second place, some of the spirit of the older Mediterranean

race, which the incoming Greek northerners had subjugated but not exterminated, was apparently beginning to have its influence. The predominant Greek stock was and long remained Indo-European—even Northern—for as late as the first century of our era Antonius Polemo [1] wrote:

"Where the Hellenic and Ionic race has been preserved in its purity its representatives are naturally big men, broad, upright, compact, white of skin, blond . . . with yellowish hair, soft and nicely curly; the forehead square, the lips thin, the nose straight, the eyes liquid with much light in them."

Yet the pre-Hellenic element was not negligible among sections of the population, especially in the depressed classes, and the growth of democratic institutions in many states gave these people a voice. Their ideas, their tastes began to be of account, and it was natural to the realistic Mediterranean man, to prefer verisimilitude to poetic formalism in art. It is instructive to compare early Mediterranean works by Minoan celators of the sixteenth century B.C. with Greek figures. Youthful statuettes, like the ivory boy (Plate 9), are less different in conception and in realism from the "Idolino" of about 440 B.C. (Plate 67) than is the "Idolino" from the Rampin rider (Plates 39–41), who was made only about a century earlier.

The Parthenon sculptures were on account of their absolute restraint the most perfect art-prose work of the Greeks. The narrative frieze which tells the story of the Panathenaic procession of Athenian citizens is quite obviously prose-like in character. Even at its east end the company of gods, supposed to be invisible to the worshippers, are ideal, but possible, and therefore realistic, Attic aristocrats and their wives. If the Lapith and Centaur metopes are the least satisfactory parts of the Parthenon's decorative scheme, this is just because it was difficult to be realistic with Centaurs, though the Lapith men are good representative athletes. As for the gable figures of the Parthenon, they have only to be compared with figures from the Olympia gables and the two different forms become instantly apparent. Contrast the reclining Kladeos with the reposing "Theseus" (Plates 64a, 69b), the standing Hippodameia with the moving "Iris", the crouching

[1] Quoted by Adamantius, *Physiognomica B*, 32.

Lapith-women with the seated "Fates". Contrast stylised garments, heavy like grained olive-wood, with moulded draperies, clinging and transparent, and you are aware of two totally different modes of expression. The very technique proclaims that a different material was employed for their model by the designers; for the Master of Olympia seems to have carved his "paradigms" in wood, the designer of the Parthenon gables to have modelled them in clay. Of this there seems little doubt.[1] The exquisite draperies of the figures are reproductions in marble of clay-modelled originals. The designer desired realism and achieved it.

The theme of the gable-groups is also something very different from that of the Olympia sculptures with their great trilogy exalting Herakles, Zeus and Apollo. There is nothing awful or mysterious, no embodiment of the essential Greek spirit of sanity; but rather, old tales about the gods of Athens used because they serve as symbols that readily assume a rationalist meaning. At the east end Athena new-sprung from the brain of Zeus, because the average Athenian knew himself to be a citizen of the most enlightened of all cities. At the west end the contest of Athena and Poseidon for the land of Athens; the gods performing their magic for the favour of mortals. If the rationalist Pericles and his friend Anaxagoras were shown the first design for this they may have smiled lightly though conceding that it would flatter the people. In truth the glorification of Athena was only the glorification of Athens, and every Athenian knew it. Thus the gables may be said to have their counterpart in the famous funeral speech put in his second book by Thucydides into the mouth of Pericles with its praise of the greatness of his city and her resources.

It is certain that a large number of masons were employed to make the sculptural decorations of the Parthenon and that their organisation and team-work were of outstanding excellence. But who was the designer, whose the constructive brain that planned the great narrative in marble? Who may have made the original models for the pediments?

We do not know.

Essay after essay, book on book, has been produced on the assumption that it was Pheidias, but there is not a word in any

[1] Wace, *op. cit.*, pp. 37 *ff.*

ancient author or inscription to justify this supposition. Pheidias has had a strange fascination since mediaeval times, nor has the modern world yet rid itself of the attraction of his magical name despite the fact that not an original, not the fragment of an original, from his hand survives. Thucydides had no reason to mention his name. Centuries after Thucydides came a variety of references to his work, the most circumstantial being found in Pausanias and Plutarch. But even Plutarch only reports that Pheidias was "general manager and general overseer, under Pericles, although the several works had great architects and artists besides"; and later on, that "Pheidias the modeller was contractor for the statue"—meaning the gold and ivory Athena inside the temple. Pliny designates him as a master of celature, which he certainly was.[1] Manager, overseer, contractor, celator are the terms employed; not sculptor or designer. This manager may have selected themes and subjects before giving some anonymous sculptor the job of designing the figure decoration. But who that designer was we do not know.

Pheidias, the magical celator, was, of course, the maker of the celebrated gold and ivory Athena Parthenos that stood in the Parthenon. There are literary descriptions of this lost statue which inspire us with the belief that the great image was truly fine in the Greek sense. There are also, unfortunately, copies of Roman date which can only mislead. When he made the Athena Parthenos in Athens, and later the seated Zeus at Olympia, both of gold and ivory and on the giant scale, he was fulfilling the highest ambition of Greek art which had begun, more than a thousand years before, to make works of ivory and gold.

The Parthenon, the Propylaea and the other buildings which stand upon the Athenian Acropolis are all perfection. Only a people devoted to art through centuries as the Athenians were

[1] Pliny, *Nat. Hist.*, 34, 54. On the toreutic art which closely concerned him, see Gisela M. A. Richter, *Amer. Journ. Archaeol.*, 45, 1941, pp. 377 *ff*. She notes that it was an art practised, like painting, by the free-born and not by slaves. If Pheidias used the sculptor's mallet he certainly "lost face". Aristotle (*Nic. Ethics*, 1141a) links his name with stone-work, but this is no proof that he did more than design what his workmen executed in stone. B. Schweitzer, *der bild. Künstler, etc.* (Heidelberg 1925), goes too far in "debunking" the sculptor's status. He observes (p. 55) that architects and painters were men of good standing; but he quite forgets celators who were of the highest standing of all.

could have created such things. These buildings were the work not of a monarch, not of a cultured aristocracy, but of a whole people. If the sculpture of this epoch has not quite so exalted a quality as have the carvings by the Master of Olympia it is not to be forgotten that the Parthenon itself is the finest architectural masterpiece of mankind. And if Olympic art be more exalted the Parthenon sculptures have splendour and fineness. So little of the representational art that preceded them survives that they themselves seem Zeus-sprung, like Athena. They have verisimilitude without imitativeness; naturalism without illusion, feeling without sentimentality; in them the ideal is realised rather than the real idealised.[1]

Representational art-prose of such supreme quality was not to be seen again in the world before the days of Michelangelo.

Painting and drawing during the fifth century followed the tendencies of literature and sculpture. In poetic art the thing created is itself the exciting thing; in prose art the composition is exciting because of the subject matter. Pictures continued to be drawn and painted on Attic pottery, and the poetic manner of the Berlin painter (Plate 52a) was carried on by artists like the Brygos painter (Plate 52b), who worked between 500 and 470 B.C. and handed on the art to younger men. The work of three such may serve to tell in outline the story of drawing and painting upon vases in Athens. Two, whose work was so close the one to the other that some have regarded them as one, were the Pistoxenos and Penthesileia painters flourishing between 478 and 460 B.C. To the former is assigned a striking picture of Herakles as a boy followed by his nurse, an old wrinkled woman (Plate 70a); to the latter a charming white clay bobbin with Nike offering an ornamental fillet to a boy athlete (Plate 70b). Simple, narrative, prose-like art is best exemplified in the drawing of a man named the Achilles painter, who worked mainly between 450 and 430 B.C. and was, therefore, exactly contemporary with the people who carved the sculpture of the Parthenon. He excelled at sensitive pictures of the daily life of women (Plate 70c).

[1] The realised ideal corresponds in a sense to Aristotle's "probable impossibility", which in art he says (Poetics, 1461b), is to be preferred to an "improbable possibility"; the last is something like an idealised reality.

After 430 B.C. there is a falling off in Athens of work by men of the highest skill, and this is no matter for surprise. Plague wrought havoc in the city at the beginning of the war which broke out in 431, and, as the campaigns dragged wearily on, the Athenians inevitably knew less and less of those moods of contentment and vigour requisite for the making of great art.

The stream of Greek creative art flowed on, but elsewhere than in Athens.

Written accounts indicate Argos as a great centre dominated by the personality of Polykleitos, like Pheidias a famed celator, and like Pheidias the maker of a giant statue of ivory and gold. This was a Hera for the chief temple of the Argive State. Polykleitos himself, as head of a big staff, directed the making of many statues of youthful athletes in bronze. The Florence bronze boy (Plate 67) may be an original from his workshop, the sensitive head (Plate 69a) from Beneventum—another original of this time—is surely close to Polykleitos, and so is a statuette in bronze of a plump but very youthful naked girl in a bathing cap (Plate 68) found in Macedon, which had some relations with Argos because its kings were of Argive descent.

As for celature in its purity, the enquiring critic who seeks in three regions of the Greek fifth-century world will reap a great reward. The regions are Chios, Peloponnese and Sicily.

Long ago, about 630 B.C., a flourishing guild of celators had been established by a certain Melas [1] in Chios, and from that time on the Chians proved their devotion to the arts. A genius arose among them who has left about twelve surviving examples of his work done between 450 and 430 B.C. as engraver of precious stones, a number of which he signed in full: "Dexamenos the Chian made it". His favourite materials were chalcedony, yellow jasper, and rock crystal, and most of the stones on which he worked were scaraboid in shape. Their distribution is a token of his wide popularity in the Greek world, for it seems that at least three were found in Attica, three at Kertch in the Crimea, and one each in Messenia and Macedonian Chalcidice.[2] Herons (Plates 71a, b), flying or standing, were among the subjects he favoured,

[1] See p. 37 above.
[2] See J. D. Beazley, *The Lewes House Collection*, p. 48 f.

and his portrait of a bearded man (Plate 71c) is an evident master-piece. In the illustrations all these engraved gems are shown three times the diameter of the original and have therefore nine times its area, in spite of which they have fineness and delicacy. Seen in the original their microscopic daintiness seems almost magical.

The kind of celature produced in Peloponnese can be studied in both gems and coins. Among the former is a sard engraved toward the end of the fifth century, but cut thin and re-set by some Greek three or four centuries later again. Engraved on this is the head and upper half of a young boy's body and a branch of laurel, all within a cable border (Plate 71d). Its affinity with the Argive bronze (Plate 69a) shows this as close to the Polykleitan school. Another head of startling delicacy is found on a coin of the small city of Troizen in Argolis, a head, engraved about 460 B.C. (Plate 71e), of Athena as a young girl. Two others of very great merit come from the other side of Peloponnese, from the land of the people of Elis who controlled the great sanctuary at Olympia. Such coins as these could not escape some influence from the work of the Master of Olympia himself, and a likeness exists between the dainty running Nike (Plate 72a) and some of the Lapith girls carved on the temple (Plate 64b). The other Olympian coin is twenty years later and will have been minted precisely in 420 B.C. It displays the head of a frowning eagle, and upon a leaf of white poplar below the bird's beak is the signature of the artist "DA . . ." (Plate 71f). Only a celator held in the highest repute would have been allowed to set even so abbreviated a signature upon coinage closely associated with the holy Festival of Zeus.

Greek Sicily in the fifth century before our era can display for us an artistic history which comes near to being as remarkable as that of Athens in the sixth century. Exciting as are the marbles of the Parthenon and certain sensitive tombstones of Attic work, it is not among such things that the finest art of the fifth century is to be sought. The most admired artists among the Greeks themselves were not the masons, nor even the modellers, casters and finishers of fine bronzes—but the celators. Their actual signatures survive with some frequency, though they have no

correspondence with the literary tradition. A list of celators said to have been famed in the ancient world can be compiled from the pages of Pliny and Athenaeus and will contain, besides the great names of Pheidias and Polykleitos, the mention of other artists of renown and special experts at silver-work like Mys, Mentor and Kimon. The last may or may not be the same person as the great Syracusan engraver whose actual work survives to please the eye. In any case it is he and his contemporaries, rather than the shadowy names listed by subsequent cataloguers, who must matter to us. One may still experience a catch of the breath at the first glimpse of a work by the Chian Dexamenos, the nameless Peloponnesian engravers, and the dexterous, inspired men who worked in Sicily, Euthymos, Phrygillos, Euainetos, Herakleidas and Kimon.

There was a great tradition, evidence of which has already been presented in the dies made by the maker of the Syracusan Victory coins of 497 B.C. (Plate 55a) and the Aetna Master (Plates 55b, c). An attractive die with the head of Artemis Arethusa made about 450 B.C. (Plate 72b) makes a transition from those earlier dies to the subtle work of Euthymos, Phrygillos and Euainetos (Plates 72c, d, e). Herakleidas made and signed a die (Plate 72f) for the people of Catana with an impressive head of Apollo. These are only a few works selected from a rich repertory.

It has been shown beyond all doubt that cups and bowls and other fine works of silver were made by the same people who made such dies as these.[1] They were often citizens of distinction, and at least one, Prokles, was for a while head of his State.[2]

Silver-ware of the fifth century before our era is of exceptional rarity, for the circumstances under which it would have been buried are only of two or three kinds. The Greeks themselves did not generally bury very valuable articles of gold and silver with their dead, but rather, fine painted pottery along with certain metal objects of lesser value. On the other hand, barbarian chieftains living on the fringe of the Hellenic world and much influenced by Greek taste habitually acquired the work of Greek artists of the first class, and these men, for whom elaborate and

[1] G. M. A. Richter, *Amer. Journ. Arch.*, 1941, pp. 363 ff.
[2] See Seltman, *Class. Rev.*, 1946, p. 118.

costly funerals and tombs were prepared, often had some of their favourite possessions buried with them. So it comes about that some examples of magnificent Greek celature have been found in the tombs of Thracian princes in Macedonia and Bulgaria, and of Scythian chieftains in South Russia.[1]

A second reason for the burial of silver-plate would be the danger of threatened invasion, and in such a case the owner might take the best of his treasures out into the open country and hide them underground, near some farm which he owned. If death or some other disaster prevented the owner from unburying his possessions, the Treasure Trove [2] may be discovered in modern times. There is a magnificent silver drinking-horn which probably was buried in such circumstances (Plates 73a, b) and which was found near Tarentum, the greatest Greek city of Southern Italy. It was made about 420 B.C. and is in the form of the sensitive and exquisitely modelled head of a young doe. There are remains of gilding on the upper edge of the cup and inside the animal's ears. Black niello enamel is inlaid round the nostrils, and the eyes were once inset, probably with onyx. On the upper part of this drinking-cup there appear figures in relief. Here, in what is certainly the finest surviving Greek silver vessel of the second half of the fifth century, there is precisely the same kind of technical accomplishment as appeared in celature of a thousand years before (Plates 1d, 3, 4).

The third circumstance which may have led to the burial of hidden treasure was the piratical raid, but since piracy was exceedingly rare in the Mediterranean as long as any Greek State possessed a powerful fleet, we are not likely to discover pirates' hoards in this period.[3]

The quality of some celature in Sicily has a character of its own, but a good deal of the celature produced among the Greeks of Southern Italy appears to show a marked Athenian influence

[1] E. H. Minns, Scythians and Greeks, 1913: B. D. Filow, die Grabhügel-nekropole von Duvanlij, 1934.

[2] Such an explanation has been given for the burial of the famous Mildenhall Treasure of the late fourth century A.D., now in the British Museum. (See p. 119 below.)

[3] The famous Treasure of Traprain, found not far from Edinburgh, was a pirate's hoard of the fourth century of our era.

and might almost be called Athenian Colonial art. Such an influence is evident in the silver drinking-horn (Plate 73) mentioned above, the very scene on which is an episode in Attic legend, and it is also clear in a brilliant contemporary work, a pair of dies for a silver coin minted at the small Greek city of Terina, but engraved by one of the most brilliant die-sinkers of the time (Plate 74a).

The subject on both sides is Nike, or Victory, who was patron goddess of the city. Her head surrounded by a wreath is on the obverse; the goddess herself on the reverse, seated upon an overturned amphora, holding in one hand a delicate caduceus with which she is gently teasing a little bird perched on the fingers of her other hand. One of these fine dies carries the initial of the engraver, the letter *phi*, a man who made coin dies for a number of Greek cities in Southern Italy and who probably gave his services to Syracuse as well.

In this survey we may seem to leave the last decade of the fifth century B.C. in a mood of confidence. This is because celature is here the theme of our study and it is of the nature of celature to maintain a steady level of excellence.[1] Other arts change from better to worse, or from worse to better, but celators seem always to have retained a higher degree of sensitivity than other artists because of the very delicacy of their art.

[1] It was the same in France from the Middle Ages through the Renaissance to the end of the *Ancien Régime*. Gold and silver smiths were held deservedly in high regard. King René of Anjou himself worked, with Clement Pic of Vezelay, at celature about 1445. On the subject generally see Jean Babelon, *L'Orfèvrerie Française*, 1946.

RHETORICAL ART IN GREECE

DURING the early fourth century before our era two fresh literary forms came into existence—the philosophic dialogue and rhetoric. Histories too were produced, but Thucydides could have no peer. Of the new forms the philosophic writings were honest *in intention* since they sought the truth for its own sake; rhetoric, on the other hand, was dishonest *in method* because it tried to influence opinion, to play upon the emotions, and to pervert the truth if a palpable advantage might thereby be gained.

Fourth-century art, except for celature, appears to have followed the lead of the less reputable literary form, and simple naturalism gives place to illusionism. The philosophy of Plato, which was completely hostile to the sophistry of the rhetoricians, became aware of this perversion and consequently adopted a firm resistance to art.

The characteristic purity of Parthenonic art with its fine restrained realism made an impression which endured for several decades. Even the sculptors who made the frieze of the temple of Apollo at Bassae in Arcadia felt something of this influence, and, though that frieze is both vigorous and vulgar, it has a certain frank honesty. Greek relief on the whole remained during the fourth century superior to substantive sculpture because it was apparently the product of direct carving, but contemporary statues from about 430 B.C. onwards appear to have been produced

by pointing off from clay or clay and wax models, and, being the result of modelling, are not strictly to be classed as true sculpture. They were all representational and they tended towards the illusionistic; and illusionism bears the same relation to representation as rhetoric to historical prose.

One Greek at least in a later age was aware of a certain resemblance between art and oratory, for Dionysius of Halicarnassus compared the rhetoric of Lysias with the art of Polykleitos and Pheidias; that of Isocrates with the art of Calamis and Callimachus. As nothing from the hands of these celators survives, there is no means of checking the value of his criticism, but the aesthetic implication and the method are of interest.

During the fifth century the Argive Polykleitos—famed as a celator and bronze worker—wrote on something akin to an aesthetic problem, if it is true that he produced a pamphlet on the proportions of a statue; but, like his recorded statues, his book has not survived. The next authority to be considered is Socrates, whose remarks are mild but not serious. A philosophic interest in art started with Plato, but his speculation drew him towards a marked hostility to fine art.

The recorded opinions of Socrates and the views of Plato show their attitude towards art as one rather like amused toleration, or open enmity; neither of them betrays any inclination towards aesthetic perception. This has been an obvious source of perplexity to more than one scholar, and an attempt to defend Plato has been made on the plea that Plato meant two different things by the word "mimesis" and its cognates,[1] that he recognised a good and a bad "imitation", as he possibly did. It cannot, however, be denied that Socrates and Plato showed some vagueness in confusing art and morality, nor had they come to perceive the practical independence of aesthetics from ethics. Plato himself was no mean poet before he abandoned poetry for dialogue, and in the latter he showed himself a born dramatist. He was drawn to the world of his childhood which he used as the time-setting for his dialogues because he disapproved so strongly of his own day. He hated sophistics and the rhetoric of the sophists whom he made the butts of Socratic wit. He attacked the arts with the

[1] J. Tate, *Classical Quarterly*, 1928, pp. 16 *ff*.; 1932, pp. 161 *ff*.

fury of a great artist [1] because they too appeared to him as illusions, and the fault lay with his own contemporaries, with modellers and painters who supplied him with a second-rate aesthetic stimulus.

There are many passages [2] which proclaim Plato's censure on art, but it suffices to recall the principal accusation brought by philosophy against art, an accusation of fraudulent imitation. The indictment rings out most clearly in the tenth book of the *Republic* (603a, b):

> "Painting, and in short all imitation, is concerned with works far removed from truth, and converses with that part of us which is far from wisdom to no healthy and genuine purpose. Thus imitation being base in itself, and joining with that which is base, generates base things."

Plato saw clearly enough that the ultimate aim of accurate imitation was not a statement of truth, but a triumph of deception. Contemporaries taught him this, Parrhasios and Zeuxis among them. The tale of their unseemly competition is familiar: Zeuxis painted grapes which the birds came to peck; but the other painted a curtain which appeared to hide a picture beneath and thus deceived his brother artist. Accordingly Parrhasios, the cleverer trickster, gained the prize. The story is both amusing and *bien trouvé*, for it does represent the spirit and intention of fourth-century art. All original pictures are lost to us, but the vases tell us something at least about contemporary painting as a whole, and these fourth-century vases have been stigmatised by Beazley as generally "insipid, vulgar, vacuous", and "mannered". With statuary it was not far otherwise. The Greek artist modelling in clay had in the fifth century abandoned the poetically lively for the prosaically lifelike; by the fourth century he was so charmed with the results of his own skill and sleight of hand in making the semblance of a man that he passed from representation to imitative illusion, from prose to rhetoric. After Thucydides, Demosthenes; after the Master of the Parthenon, Praxiteles.

[1] See P. Schuhl, *Platon et l'art de son Temps*, 1933, p. 22 f. Gorgias the sophist perhaps invented an aesthetic of illusionism, *ibid.*, p. 35. Late sources declare that Plato himself studied painting. See *ibid.*, Appendix VI.

[2] Collected by R. G. Steven, *Classical Quarterly*, 1933, pp. 149 ff. And see especially, P. Schuhl, *op. cit.* and B. Schweitzer, *Der bildende Künstler, etc.* (Heidelberg, 1925), pp. 73 ff.

The orator had no scruple in the use of delusion when the means appeared to him to be justified by the end; the artist enjoyed himself in the exercise of illusion and his public was satisfied with the result. So he consecrated himself to the game of make-believe, lost sight of any clear purpose, and played with his toys. In fact, he became a virtuoso and nothing more.

Scopas the Parian and Praxiteles the Athenian were younger contemporaries of Plato and the most celebrated sculptural virtuosi of their generation. Our direct knowledge of the work of Scopas is slight: there are bits of the Mausoleum which Beazley calls "a wild enormity of ancient magnanimity", there are copies, and there are fragmentary School-pieces from Tegea. But when they are set beside ancient accounts of his work it is clear enough that his main powers lay in his virtuosity.

An artist as popular and active as Scopas almost certainly modelled his originals in clay and wax and the marble figures would be pointed off by assistants, and by this method duplicates could be and were produced. The only clear facts about this artist are his activity and his popularity; yet in both he appears to have been eclipsed by Praxiteles.

The works of Praxiteles were produced both in bronze and in marble. His originals would therefore have been modelled, and the convincing suggestion has been made that "if he, like Rodin, planned to have the models of his bronzes also worked in marble he would have realised at once that some form of support was inevitable". Accordingly, "in composing his statues he deliberately made the support an essential part of the design so that the figure could be executed either in bronze or in marble without any great alteration".[1] Something akin to mass-production prevailed in his studios if we are to believe the ancient accounts of the many figures turned out in duplicate and in larger multiples. Athens and later Rome both had his groups of Demeter, Persephone and Iacchus. Megara and Mantinea had his Leto, Apollo and Artemis, Megara and afterwards Rome his Tyche, Megara again and Athens the Satyr by him, Thespiae and Delphi a Phryne; while in addition to the celebrated Aphrodites of Cnidus and of Cos, at least three others existed, not to mention four

[1] A. J. B. Wace, *An Approach to Greek Sculpture*, p. 46 f.

statues of Eros recorded in Thespiae, Messana, Parium, and some fourth city.

Any list of his works sounds impressive, but only one piece is still extant. Of all the artists before the Hellenistic age celebrated in ancient authors there are only two, Paionios and Praxiteles, whose actual contemporary work both survives and can be certainly identified. A fair impression of Praxiteles and his work can be formed because the faithfulness of the numerous surviving copies of his statues can be checked by the Hermes, which is apparently an original, carved in his studio after a cast of a clay model (Plates 75, 76). The older fashion of lavishing on Praxiteles as high a measure of praise as the Romans bestowed upon him has given place in recent years to a reactionary disparagement which may lead critics to extremes. We do not take seriously the critic who accuses Praxiteles and his fellows of aiming at mere sex-appeal, of making "objects of substitute-gratification", of which the sole characteristic is "caressibility".[1] Freudian ideas do not always fit the ancient world, and, in a civilisation in which the genuine article was obtainable at a much lower figure than the supposed gratification-substitute, there could be no call for the latter. King Nicomedes of Bithynia offered to pay the whole national debt of the bankrupt Cnidian State as the price of the Praxitelean Aphrodite because he was in his way an art collector —not a man with a Pygmalion complex.

Another critic, indulging a lively and cynical wit, has written of the "carnal corruption of Praxiteles".[2] Perhaps this phrase is a little too severe because it seems to imply a kind of moral censure on art, and is in effect the very blunder which Plato made in opposing art on moral grounds. The sensuality in the work of Praxiteles is in itself no aesthetic fault; but if it was his intention to deceive, to imitate accurately, to duplicate Phryne in waxed and tinted marble, that would have been both aesthetically and intellectually dishonest. "Compare the Hermes (of Praxiteles)," writes a third critic, "with a fifth-century original; the fifth-century flesh seems made of some neutral substance, the flesh of the Hermes of muscles and fat; it has not only the surface bloom

[1] R. H. Wilenski, *The Meaning of Modern Sculpture*, p. 46.
[2] A. W. Lawrence, *Classical Sculpture*, p. 256.

and sheen of life, but the warm lifted swell of a living organism."[1]
This would be prose art transformed to vivid rhetoric, implying
that the statue was made to create an illusion of reality. The hair
roughly cut with a drill might look like real hair, the rich folds
of the cloak imitating linen should set off the naked body of a
youth who looks into the distance dreamily—even vaguely—and
vagueness is the own child of rhetoric.

But was the statue when first completed entirely designed for
illusion? There is more for us to learn about this important
figure which presents so startling a change from the works in
marble made by Greeks in the two preceding centuries. The
adverse opinions of modern critics appear to agree with the
thoughts which Plato might have had about such a work of art.
Nevertheless, there is much to be said in this statue's favour; for,
if we cannot find it in our minds to rate it highly from an aesthetic
and philosophical angle of approach, we can find it in our hearts
to appreciate it as a moving religious idea. More perhaps than
any statue in the whole of Western art—pagan and christian—
this Hermes is the "immortal personification of human kindness".

To perceive this fully one may bear in mind that this figure,
unlike most of the marbles of Praxiteles, originally stood in the
open air, its back to a wall, and on an older pedestal than the one
discovered with it. Thinking of it thus you should endeavour
with some fine photographs of the figure before you (Plates 75,
76) to reconstruct its colouring.

Envisage the whole of the god's skin, not painted, but *stained*—
even as ivory can be stained—a rather deep sun-burnt red, almost
the colour of a pale Victoria plum; then think of the whole as wax-
impregnated so that it acquires the surface sheen of living skin.[2]
The baby Dionysos held by the god would not be tinted at all,
only waxed; so the child was pale ivory-white. All this had been
done by the sculptor's competent staff of workmen; but now
along came Praxiteles' favourite painter, Nikias, to apply colour,
maquillage and gold. Nikias with fine enamel painted the eyes of
the god and the baby-god. Eyelashes and eyebrows appeared in
black, a touch of black in the nostrils, scarlet for the lips of both of

[1] Beazley in *C.A.H.*, vi, p. 536.
[2] See p. 34 above.

them, brown for the god's nipples and pubic hair, and heavy brown paint all over the tree-trunk on which he rests his left arm. Next, the drapery—you would expect saffron yellow for the robe, which is slipping from the child, and for the great mass of raiment on the tree-trunk a bold bright blue. Finally came hair and sandals which were both treated in a similar fashion. Paint was applied—a bright strong terracotta red which, while still wet, was heavily dusted with powdered gold.

Now think that you see such a statue, over life-size, thus coloured standing out of doors in the hot brilliant sunlight of Greece. The sun upon the bright golden sandals seems almost to cut the god off from weighing upon his pedestal; the sunlight striking the intricacies of his red and gold hair gives a thousand reflections and the startling illusion of a flickering halo. Here was illusion indeed, but not a deceptive trick to make you think a living young Greek stood upon a pedestal; rather the illusion—if you believe in Hermes—that here stands the living god, young, immortal and infinitely kind.[1]

It is aesthetically inadequate for any artist to do no better than to imitate nature, and when you look upon this statue, all white and glossy as it now is, you may be right to think it is doubtful taste to imitate a human form so deceptively. Praxiteles may have made other figures, especially of Aphrodite and Eros, which one might have censured. But imagine Hermes with all that colour and gold and you may concede that it is good—to represent a god.

Some of Praxiteles' contemporaries, and some of his imitators, practised illusionism because their public desired it and admired it. For this we need not blame them if we bear in mind that it was a question of preference and of taste. They only erred if and when they pretended that such art was better, because more deceptive, than other art-forms. Such was the liking for illusionism that the art-connoisseur, who now began to appear in the ancient world, preferred the art of Praxiteles to that of any other, and when Romans developed a taste for Greek art they frequently tended to follow the same trend. That is why so many originals from his

[1] I am indebted for much of the above interpretation to Jacqueline Chittenden with whom I have many times discussed the religious aspect of the statue.

studio found their way as loot to Rome; that is why his works were so extensively copied. Moreover, his was in most cases, though not always, an indoor art in contrast to the outdoor art that had gone before. His statues were not intended to be provocative of desire, but only to excite the admiration of the spectator for the artist's powers of illusion; and the normal beholder who gazed on the world-famed Cnidian Aphrodite in ancient days would be less filled with the desire to become a second Anchises than thrilled at finding himself playing the second Paris.

Into an artistic *milieu* dominated by the ideas and styles of Zeuxis, Parrhasios, Scopas, and Praxiteles, there came the searching brilliance of Plato's enquiries. He rejected imitation and illusion in art as immoral, and if he was mistaken in his reason for it, he was right in his rejection. If it is to be rejected then it must be because, like rhetoric and journalism, it is unaesthetic and therefore deadening to the taste; because it is a poorer form of representation than honest prose.

Aeschylus never had to face this problem. The early statues that he is said to have called superhuman were in the nature of poetry; the figures he criticised as having less of the superhuman were at least simple prose.

Plato's hatred of illusionism made him the enemy of all art until as an old man, after a visit to Egypt, he wrote the *Laws*. Then a sudden and astonishing change leads him to the praise of art; but only of Egyptian art, because in that country

"it was and still is," he says, "forbidden to painters and all other producers of designs to introduce any innovation or invention, whether in such productions or in any other branch of the arts, over and above the traditional forms. And if you look there you will find that the things depicted or carved there ten thousand years ago are no whit finer or poorer than the productions of today, but wrought with the same art."[1]

It is as though formal art suddenly discovered to him in his old age its essential, poetical, metrical quality.

More that is of value for the aesthetic study of Greek art is to be

[1] *Laws*, ii, 656 d. etc. On this passage see P. Schuhl, *Platon et l'art de son Temps*, p. 20. In the *Philebus*, 51 b, c. Plato expresses enthusiasm for pure form and colour and geometric patterns. He was himself at least a poetic artist.

derived from some of the chance fragmentary remarks of early writers, from a comparison of the trend of art with the trend of literature, and even from Plato's hostility than from the *farrago* of extracts which the elder Pliny concocted for the information of statue-collectors among the dilettanti of Imperial Rome.

The popularity of this and kindred writings, the zeal for "labelling", for attaching once-celebrated names of sculptors to ancient statues—and to copies of ancient statues—have placed the study of Greek marble sculpture under a severe handicap. The study of ancient coins or vases has all the advantage because the student gleans his knowledge from the actual objects themselves uncontaminated by preconceived notions derived from ancient "authorities" like Pliny, who has been described as "an ignorant and uncritical compiler from sources of undeterminable value".

If examples of painting in the fourth century had survived we should probably find that its tendencies too followed those of rhetorical literature and that, like the reputed work of Zeuxis and Parrhasios already mentioned, illusionism was the chief aim. With celature this was not the case, as far as our information goes, though for all we know some perverse "artist" might have tried his hand at making grapes of yellow amber or carving a life-size toad from pudding-stone. If he ever did, such "stunts" have not survived.

Coins may once again serve to introduce the celators' art at this time, beginning with a Syracusan piece which links on to the work of the engravers whose dies have already been mentioned. Kimon was one of the latest of that group of celebrated men whose signatures appeared on Sicilian coins, and his work seems to be partly before, partly after the year 400 B.C. On a silver ten-drachma coin he set the head of the city goddess Artemis Arethusa (Plate 74b), which looks like the portrait of a sophisticated daughter of some Syracusan aristocrat. Compare this with the Demareteion piece of 497 B.C. (Plate 55a) and you will be made aware of a profound change, for Demarete's coin is a piece of poetry in silver; Kimon's girl is in the manner of brilliant prose.

There were other Greek die-engravers who learnt from the example set them by the famous Syracusans and who, during the fourth century, produced some work of very high quality. Such

is the head of Artemis upon a coin of the Achaeans in Peloponnese (Plate 74c) made about 366 B.C., and such is the facing head of the nymph Larissa on a drachma (Plate 74d) minted about 380 B.C. in the chief city of Thessaly. The little masterpieces produced by Greek celators were not only coin-dies and gems but also jewellery made for personal wear. The production of this, which had always been of so high a standard, remained splendid throughout the fourth century, for the artist still combined an almost in-credible minuteness of work with a design so admirable that it will always allow of enlargement to two or three times its actual size. Typical examples are a pair of golden earrings with gay glass beads strung on each ring below an exquisite head of a dolphin who holds a golden pebble in his mouth (Plate 79a). These are of about 350 B.C.; and perhaps of like date is the large gold bracelet ending in the heads of two snakes which have inset garnets for eyes and hold uncut emeralds in their jaws (Plate 79b). One of the loveliest works in gold is a boy Eros from Athens made shortly before the end of the fourth century (Plate 79c). His left hand rests on a pillar and in his right he holds an apple or quince, his tall wings are still slightly stylised like a lingering breath of the poetry in archaic art. The tiny figure is carved out of solid gold and delicately tooled.

The comparatively large number of jewels and ornaments of this period are evidence of the prosperity of Greece, of the skill of the celators, and of the good taste of their patrons. Observation shows that in Greece between the sixth and fourth centuries B.C. the sources of art-patronage appear to have varied. In the sixth century artists were commissioned to make works for temples, sanctuaries, autocrats and men like the sport-loving aristocracy, and only rarely for the pleasure of women: in the fifth century for sanctuaries, lovers of the Games, the governments of States, Graeco-barbarian chieftains, and—rather more often than form-erly—for the womenfolk, who were given many painted vases, fine mirrors and jewels. Turn now to the fourth century and it may almost seem as though works of art made to flatter women, to please them and be used by them, had a greater vogue than any others. Praxiteles himself was, to say the least, very much in-fluenced by the tastes and ideas of his mistress, Phryne, with whom

he had the most happy relationship. In sculpture, as in painting, feminine figures, nymphs, victories, and the boy Eros, son of Aphrodite, appear to predominate.

One source of this markedly feminine influence on art was undoubtedly Corinth, which during the fourth century obtained on account of its prosperity a wide cultural influence in Greece; and, since Corinth was a state in which *demi-mondaines* were well thought of, there was a special call to cater for their needs. Among the many metal products of the age none was more pleasing than certain mirrors on the cases of which drawings of exquisite quality were engraved. On one mirror-cover (Plate 77), made very early in the fourth century B.C., is the picture of a plump girl wearing a beret like a bathing-cap, shoes and a robe which has slipped down below her waist. She is seated on a bench upon which couches a chimpanzee-like Pan—no insult to the god for the Greeks loved apes and monkeys; under the bench is a goose; on it, behind the girl, a little love-god offering advice on the game which is being played; it is the game of "five stones". This is from Corinth, and so is the next (Plate 78), which is engraved with a fine drawing of Aphrodite and her son. She is naked but for a pair of slippers, and seems to lean lightly upon a rock while, with her left hand, she supports the young Eros who is learning the use of bow and arrow.

Recent research has revealed, as one has already seen, the remarkable extent to which colour was employed in the decoration of Greek marble sculpture. It is very probable that a great deal of colour was likewise used to enhance such pictures as these upon bronze mirror-covers, and the colour was in all likelihood some solid paint of an enamel-like quality. If this was the case the effect would be similar to the work of a modern Jugoslav artist, Milivoj Uzelac, who has revived the technique of engraving a figure with deep firm lines and then illuminating it with paint (see Supplementary Plate I). The metal he uses is aluminium, not bronze; but his work may help an understanding of the appearance which these Greek bronzes may originally have presented. It is likely that art such as this, combining fine bronze, skilled engraving and subtle colour, was responsible for the fame in the ancient world of Corinthian bronze work.

BIOGRAPHY AND PORTRAITURE

THERE was one sculptor who endeared himself to posterity as much as did the Athenian Praxiteles. This was Lysippus of Sicyon, whose *atelier* appears to have produced statuary in the mass and on a scale surpassing all predecessors. The statement that he made no less than one thousand five hundred statues is, of course, one of the wilder flights of Pliny's statistical fancy. But until one clearly identifiable piece of this lost legion is discovered we cannot express any opinion upon the aesthetic merits of the work of Lysippus. It has been shown [1] that a large number of late copies of the lost originals—mainly copies several times removed—survive. Yet these can only tell something of the technique and mannerisms of the unknown copyists, and can afford a rough idea, but no more, of the attitudes in which the originals stood, besides confirming up to a point the ancient reports of Lysippus' versatility. Of his own style, of his characteristic mannerisms, of his powers as a modeller we know, it must be emphasised, nothing.

Let us imagine what might be a parallel case. Michelangelo was at work on the ceiling of the Sistine Chapel between 1508 and 1512. In 1540, that is, twenty-four years before the great Florentine's death, a certain Giorgio of Mantua had prepared and published a number of engravings of the Prophets and Sibyls.

[1] F. P. Johnson, *Lysippos*, 1927.

These contemporary copies are strong. They render something of the sculptural character of the master's frescoes; but they are inaccurate and rather bad. About two hundred and fifty years later, one, Tomaso Piroli, made other engravings of the same figures; and it is instructive to compare them both with the Mantuan's plates and with photographs of Michelangelo's original frescoes (see Supplementary Plate II). Piroli's work is more accurate than the engravings of 1540 and yet it is a travesty, for it has all the mannerisms of the eighteenth century; in addition, it is commonplace. Now if the Sistine Chapel had been destroyed by fire and no prints of either the Mantuan or Pirolian engravings had survived, but if we had some poor French woodcuts after the Mantuan and some third-rate English engravings after Piroli, how much should we really know of the incomparable grandeur of the originals? We should know that Michelangelo painted certain figures, in certain attitudes, holding certain attributes. We should be in possession of these historical facts and remain in ignorance of the aesthetic merit of the master's works. That is how we stand to Lysippus.

There is one case in which an original sculpture in the round and a later copy of it both survive. The original is the bust in Athens of a young man known as the "Eubuleus", not certainly attributable to any known artist, but having much of that illusionist delicacy which Praxiteles had made fashionable. The copy is in the Capitoline Museum in Rome and is a startling travesty.[1] The original's style could not have been imagined from this hard dead piece of work; and most copies need have no greater merit than this.

One original fourth-century statue has frequently been associated with the name of Lysippus—the marble athlete, Agias, at Delphi (Plate 80). But to many there will seem no valid reason for calling him the author of an unlabelled statue.[2] The arguments for and against a Lysippean origin have befogged what are, after all, the main questions. Is the Agias a good statue? And, if it is, does it matter in the least who was the maker?

[1] A. W. Lawrence, *Classical Sculpture*, Plate 100.
[2] For a full account see Johnson, *op. cit.*, Ch. VI, and for a list of thirty-two authorities marshalled in opposite camps see *ibid.*, p. 124 *f.*

The Agias, as honest prose art, stands for history, and the whole group of which he formed part was set up with an historical narrative intent. But he stands at the same time for a special type of history—biography—for the Agias differs from both the Parthenonic "Theseus" and the Praxitelean Hermes in one striking characteristic. Theirs are both ideal types though realistically presented; his is an Individuality described—in fact, a portrait. Prose art has achieved biography. Life-size portraiture in our meaning of the word was non-existent,[1] not only in the archaic period, but in the whole of the fifth century. Now the real Agias was great-grandfather of the dedicator of the monument; therefore the statue is not an actual likeness; but it is cast in a biographical mould; it is a piece of imaginary character-drawing. Literature provides the parallel again, for it was the fourth century that saw the birth of biography when Xenophon wrote lives of Cyrus and of Agesilaus. In writing of the former he was drawing upon the imagination and describing a character of the past; the latter, however, was Xenophon's contemporary, and his biographical panegyric must have been written between 360 and 354 B.C.

About the time when the Agias was set up, Alexander succeeded to the throne of Macedon. The son of Philip, who dwarfed all the Greek worthies of the past, changed the whole character of history, and while he lived, history was the biography of Alexander. With him true portraiture of the living man came into common use among the Greeks. Some Hellenistic writer known to Pliny declared that "Alexander decreed that none but Apelles might paint his portrait, none but Pyrgoteles engrave it (on gems), and none but Lysippus cast his statue in bronze", and Horace had already dignified the tale in verse.

The story is silly, like much of Hellenistic biography, and deserves no credence. But it does illustrate the point that a real interest in portraiture began with Alexander, just as real personal biography started with the histories of the great Macedonian written by Ptolemy Soter and Aristobulus, and other literary evidence exists for the interest in portraiture at about this time, notably in the *Characters* of Theophrastus which were published in

[1] There was, however, miniature portraiture on coins and gems.

319 B.C., for in these satires it is said to be a habit of the Flatterer, when he is paying a visit, to pass remarks upon the speaking likeness of the portrait of his host.

Among the surviving Greek portraits there are examples of outstanding quality, and it may safely be said that there are few finer portraits in the world than the Euthydemus of Bactria in Rome (Plate·82a), the bronze Demetrius I of Syria, likewise in Rome (Plate 81), and the Copenhagen Pompey (Plate 82b). These, like all Greek portraits, have a touch of the ideal on account of their biographical quality, for the biographer cannot but make something of a hero of his subject. In this lies their contrast to the almost exaggerated realism of Roman Republican portraiture, for the Romans employed masons to make them portraits from a peculiar and pietistic motive. Greek portraiture arose out of the world's admiration for famous men; Roman portraiture out of a funeral custom, the intention of which was to preserve the memory of the newly-deceased. The Greek portrait expresses not so much the man and his character as the man's experience and achievement. It is a prose biography rather than an obituary notice like the Roman. This is said without any slur being implied on the competent journalistic eulogium: for it is in this last that you catch the momentary and characteristic impression of a man, while the biographer's picture is the outcome of thought and reflection on his life. Roman portraits of the Augustan age were less successful because the artists then tried to compromise between the two forms, to combine character impression with broad biographical effects, and the result was often weak, sometimes flabby. With the Flavian emperors and Trajan the competent obituary type of portrait returned and something more consistent was the result. In each reign the form of art favoured by the Court was the form which became popular among the subjects of the Roman Empire.

By the end of the fourth century B.C. most of the forms of fine art had been discovered by the Greeks: poetic or formal art had come first; then types of prose art, representational, illusionistic; and last, true portraiture; the Greeks had carved, modelled and cast, had engraved, drawn and painted. It remained for a philosopher to take stock and write a treatise on art. This

happened, for before the end of the century the foundations of aesthetics were laid by Aristotle.

The *Poetics* of Aristotle [1] deals with literary art, and the fine arts are only introduced here and there in order that parallels may be drawn. That Aristotle drew these at all is a matter of sufficient significance, especially as he lived in an age when no formal art was being produced in Greece. He laid the foundations of aesthetics but he constructed nothing definite upon them, for most of the aesthetic problems which have since been raised never occurred to him. Yet "precise" answers to almost all such questions have been extracted from his writings by the unwise zeal of his admirers.[2] Devoted as he was to classification and analysis, he brought an analytic brain to the subject and concerned himself with the representative, constructive, descriptive side to the exclusion of the formal, creative, organic side of art which he failed to recognise. "Aristotle's psychology does not admit of such a faculty as a creative imagination, which not merely reproduces objects passively perceived, but fuses together the things of thought and sense, and forms a new world of its own." [3] He would in fact have approved of the primitive cave-man's bison, and failed to perceive the significant form in the work of his own geometric ancestors. He opens the *Poetics* with the statement that all arts are modes of imitation, wherein he shows what seems to us a singular lack of understanding of the true nature of poetry. It is possible that the fine arts of his day were responsible for his adoption of this view and that they caused him to transfer the theory of imitation to other arts. If he thought about archaic art he probably found it slightly ludicrous, as Plato did in the days before he discovered Egyptian formal art, for he had declared that "were Daidalos to be reborn and make statues such as those by which he had won his fame, he would be laughed to scorn". Aristotle would surely have concurred, for he lived in an art-world bounded by the Parthenonic style, bronze athlete-statues,

[1] The outstanding edition with translation and commentary is S. H. Butcher's *Aristotle's Theory of Poetry and Fine Art*, ed. 3, 1902, from which much that follows is derived. The best linguistic commentary is that of I. Bywater, 1909.

[2] Butcher, *ibid.*, p. 113 *f.*

[3] Butcher, *ibid.*, p. 126.

the soft dreamy compositions of Praxiteles, and the realistic portraiture of his own day. It was representative or illusionistic, in short, imitative. Therefore he could not envisage an art like the archaic which deliberately departed from nature, and we feel he was mistaken in implying of the poet that "in fashioning his material he may transcend nature, but he may not contradict her",[1] for more recent philosophic thought would say that the poet is at liberty not only to contradict but to defy nature; that poetic art is necessarily unnatural art.

Despite these shortcomings there is much in the *Poetics* of value and of great significance. Aristotle stressed the opposition between poet and historian which, as we have seen, was reflected in the fine art of the fifth century; his conception of fine art was entirely detached from any "theory of the beautiful"—a separation which was characteristic of all ancient aesthetic criticism down to a late period [2]; he was likewise the first who attempted to separate the theory of aesthetics from that of morals, maintaining consistently that the end of poetry is a refined pleasure.[3] His distastes were healthy, as when he showed disapproval of the sophistry, sentimentality and false rhetoric that occur in the Euripidean dramas. In portraiture, the most characteristic art of his own age, he expected the likeness to be something *finer* than the subject represented,[4] and this it would naturally be in a biographical type of portrait-making which treats its subject as a hero. If the principles he laid down forbade the use of pure symbolism they likewise forbade pure realism: "that is, the literal and prosaic imitation which reaches perfection in a jugglery of the senses by which the copy is mistaken for the original".[5]

Yet there is one saying of Aristotle's that has won currency above the rest:

"Art imitates nature" is the apophthegm that has done more harm to the theory of fine art than any other, for it has too frequently been made to mean "art *must* imitate nature". It wrought with all the force of Aristotle's authority upon the

[1] As Butcher, *Aristotle's Theory of Poetry and Fine Art,* ed. 3, p. 134, interprets.
[2] *Ibid.*, p. 161. [3] *Ibid.*, p. 238.
[4] *Poetics*, 1454b, 9. [5] Butcher, *ibid.*, p. 390.

Italian renaissance and even on a preceding age, for the greatest of Italian poets voiced the saying:

"If thou note well thy Physics,"[1] wrote Dante in the *Inferno*, "thou wilt find, not many pages from the first, that art as far as it can follows nature, as the scholar does his master".[2]

With such authority behind him who shall blame Leonardo for the saying that "the most praiseworthy painting is that which has the most conformity to the thing represented"?

There was another view: and it was held by Greeks of an earlier age, by Scythians, Celts and Saxons, Slavs and Byzantines, even as it is held by critics and artists of our own day.

[1] Aristotle, *Phys.* ii, 2.
[2] *Inferno* xi, 100 f. Carlyle's translation.

PANTECHNICON

FROM the Homeric age down to the time of Alexander the Greek imagination as expressed through literature and art tended to be under the control of reason and to be limited, save in rhetoric, by a sense of measure and a faculty of self-restraint. We are aware of a reserve of power and of a deliberate *sophrosyné*, the Greek term for moderation. The poet, historian, philosopher, celator, sculptor, draughtsman, each of them could do more if he chose, but he does not wish to confuse himself or us. Except for the orator and the illusionist, the Greek artist is bent on perceiving as truly as he may, and on expressing what he perceives, whether it be poetic or like prose in form. After Alexander there came an absolute change. The scope of literature and art became as wide as the geographical horizon. But where it gained in breadth and diversity it lost in power as well as in absolute fineness.

Alexandria, planned by its founder in 331, took five years to build, for its mint first began to issue tetradrachms in 326 B.C.[1] The last tetradrachms of the city were issued under Diocletian as late as A.D. 300. These six centuries and more of continuous Greek coinage in the city that inaugurated the Hellenistic age are symbolical of the duration and unity of Hellenistic civilisation. The ways and manners of the pedants who dined and talked with

[1] Charles Seltman, *Greek Coins*, 1933, p. 212.

Athenaeus in the third century of our era had a kind of formal continuity with those of the learned circle that associated with Alexandrian librarians like Callimachus and Apollonius Rhodius in the early third century B.C.

The whole Hellenistic civilisation was uniform in its very diversities, and its art can be treated as a single though complicated cultural episode. The ages which preceded it had each been distinguished by a particular literary and corresponding artistic form. There had been the epic, then varying types of poetry, then the drama followed by history, oratory and the philosophic dialogue, and finally biography. There had been geometric art, then archaic formalism, next the dramatic formalism of Olympia followed by fine representationalism, illusionism, and lastly portraiture. The literature of the Hellenistic age, like our own, provided all these things together, and added in with them other subjects—mainly scientific, like geography, biology and mathematics, including mechanics and astronomy. The art of the Hellenistic age likewise provided all the different forms together and added some fresh forms—such as landscape painting and anatomical sculpture.

In the bulk, therefore, Hellenistic literature and art did again what had already been done before. In this sense they might be called archaistic. But "archaistic" is, like "beautiful", one of those much misused, ill-defined, and inappropriate words. It usually carries a deprecating air, as who shall say, "he archaises because he is too feeble to originate"; or, "this is archaistic, therefore second-hand, therefore second-rate"; which is a poor sort of syllogism. Moreover, when we say "archaise" what exactly do we mean? "Archaise"—in relation to what? There is the narrower use meaning "imitate what is archaic", and the wider use, "imitate what is older (but not necessarily of the archaic age)". The latter is, of course, the more logical sense, for it is equally true to say that Eric Gill archaised in adopting some of the mannerisms of Saxon art, and that Wren archaised in using the general style of St. Peter's in the Vatican when he planned St. Paul's in London. In view of their uncertain meanings it is probably wiser to prefer paraphrases to the words "archaise" and "archaistic", and to say that Hellenistic literature and art

generally did again what had once been done. It was no fault to re-use old forms if they were used well; but they rarely were.

The great mass of Greek Hellenistic literature was in prose form, and so was the mass of Hellenistic sculpture.

Much of the literary prose which has disappeared was, as the fragments show, definitely second-rate and lacking in any attention to style. In historical writings truth was usually "sacrificed for dramatic effect or facts were perverted to point a moral".[1] In the kingdom of Pergamum and the Seleucid province of Asia Minor there arose writers practising what was called the "Asianic" style, which was either affected and pretentious or else bombastic and flamboyant. Only at Rhodes it seems that traditions of Attic sobriety survived. Yet one writer had none of these faults, the Peloponnesian Polybius of Megalopolis, who was born about 198 and died in 120 B.C. Inspired by admiration for the achievements of the Romans he became the intellectual successor of Thucydides in his approach to history, sharing with the great Athenian an unflagging zeal for truth.

All the characteristics of Hellenistic prose crop up in the representational sculpture of the age. There are figures which betray a lack of proper attention to style while they aim at illusionism, others which repeat stock formulae without intelligence. Worst is a group in Athens of about 100 B.C.—Pan, Eros and Aphrodite[2] —a phenomenal piece of styleless vulgarity dedicated in Delos by some newly rich merchant of Syria, though made by a Greek.

The "Asianic" style in literature was, as we saw, either affected and pretentious or else bombastic and flamboyant, and these same faults appear most readily in monuments of "Asianic" origin. Affectation and eccentricities mar the substantive statues of the second Pergamene School, and there is pretentiousness in the most famous of all Hellenistic marbles, the Aphrodite of Melos, an "Asianic" work made in the mid-second century B.C. by a certain (Age)sandros, son of Menides of Antioch on the Meander. This Aphrodite is really an older type modified competently and yet somewhat self-consciously to suit the style of the day. Bombastic work also flourished in Asia Minor and its greatest *tour-de-*

[1] E. A. Barber in *C.A.H.* vii., p. 255.
[2] A. W. Lawrence, *Later Greek Sculpture*, Plate 63.

force was achieved in the gigantic frieze of the Pergamene Altar, which later seemed to the author of *Revelation* [1] to be Satan's own seat. It is an empty triumph of virtuosity for all its brilliance of composition and technique, but at least its flamboyance is without vulgarity—a remarkable achievement.

The most unbridled of all ancient sculptures is the group that seems to achieve an unfortunate combination of all the faults noted in Hellenistic literary prose. Lack of stylistic sense, truth sacrificed to dramatic effect, pretentiousness, flamboyance—you may see them all at once in the world-famous Laocoon (Plate 83). Three Rhodians made it about 25 B.C., a clever piece of technique actually composed of six different blocks of marble; but cleverness is no compensation for the outrageous lack of taste that is betrayed. It owes its fame to the elder Pliny's enthusiasm:

> "The Laocoon, placed in the house of the emperor Titus, should be rated above all works of art, whether in painting or in sculpture. The brilliant Rhodian artists, Agesander, Polydorus, and Athenodorus, collaborated in an agreed design, carving out of one block of stone the man and his children and the intricate coils of the snakes."

Here for once Pliny is not quoting from another source; he knew the statue well himself. It is interesting to learn his own attitude towards a work of art. Rediscovered near the baths of Titus in the year 1506 it began to exercise a deplorable influence on European art, though there were two painters who had the courage to mock it—Titian and the Cretan, Domenikos Theotokopoulos, known as El Greco, whose canvas (see Supplementary Plate III) is not only a magnificent picture but also a subtle jibe at the Rhodian brothers' production. In this, as in many other examples of Hellenistic representational art, the sheer technical competence of the sculpture is never in question; but the conception, the design, the affectation, these are what often disturb and sometimes repel.

The Rhodian brothers who made the Laocoon belonged to an age when the greatness of the Rhodian school had faded. But there is one work which proves that island school to have been capable of true fineness in art. At Rhodes, as we have already

[1] *Revelation*, ii, 13.

seen, the traditions of Attic sobriety appear to have survived in literature; in art it was the same. It was probably after gaining naval victories in 191 and 190 B.C. that the Rhodians commissioned Pythocritus son of Timocharis[1] to make them the great marble Nike on a prow for dedication in Samothrace (Plate 84). There are some works of art in the Louvre as good as this; but there is scarcely anything better; and it is of the Hellenistic age. In this monument the poetic and the prose form are skilfully combined; not, however, in a spirit of compromise as in Egyptian art or in some Greek works of the early fifth century, but in a kind of Shakespearian fashion. First we are aware of the great rectangular base on which is balanced the thrusting prow, a geometric solid that has come alive and become an elaborate poetic form. On this a twisted spiral of drapery and wings; Nike, a goddess, feminine, mainly human in form. This is descriptive, representational; and yet there is a perfectly smooth dramatic shift from one form to the other, like one of Shakespeare's transitions from verse to prose. In the whole range of Hellenistic art Pythocritus alone dares comparison with the Parthenon master and Michelangelo.

Polybius, the Peloponnesian, became the intellectual successor of Thucydides. By analogy we should look among the Greeks of his day for some artist sufficiently interested in the Parthenonic style to attempt its revival. Chance produced the man in Peloponnese itself, in the neighbour-city of Megalopolis, Messene. There Damophon flourished between 200 and 150 B.C., and the original cult-statues with two others that he designed for a temple at Arcadian Lycosura have been found. These figures are deeply influenced by Parthenonic art, as is evident despite the fact that the marble was carved by inefficient masons. Damophon made the clay models; his stone-cutters were inferior workmen. As an artist he is of a far lower rank than his contemporary, Polybius; but it is interesting to observe the almost simultaneous revival of the methods of Thucydides and the Parthenon master in second-century Greece.

Art after Alexander was not always representational or

[1] See H. Thiersch, "die Nike von Samothrake", *Nachrichten der Gesellschaft der Wissenschaften zu Göttingen*, 1931.

illusionistic, though such may have been the most popular forms, with illusionism as the more admired. After all, there was Aristotle who had said that art imitated nature. Herodas, who wrote between 280 and 260 B.C., described in his fourth Mime, or playlet, the visit of two women to the temple of Asklepios in Cos, and made one of them admire a sculptured boy with the words, "Why, one would say that the sculpture would talk", and imagined her exclaiming before a painting by Apelles: "Look, this naked boy will bleed if I scratch him!" Yet some seventy miles away from Cos, in the Graeco-Carian city of Tralles, art of a definitely formal and poetic type was being produced even as Herodas lived and wrote.

Herodas himself was one of those who showed originality in the use of metrical form in literature after poetry had lost its brilliance for the better part of a century. The new poetry was no longer of the kind performed on public occasions and enjoyed by crowds, but something made for a limited and exclusive society of cultured amateurs, and the poets, as later in Rome, reached their public through the booksellers. Callimachus, Apollonius Rhodius and Theocritus are the great names now.

As far as form was concerned, Latin literature was, like Roman art, an unbroken continuation of the Greek, with the added stimulus and guidance of Roman patronage. If we treat, as we may, the Hellenistic and Hellenistic-Roman ages as a single cultural unit, we find three periods that were especially prolific in fine poetry: the golden age of Alexandrian poetry between 290 and 240 B.C.; the golden age of Latin poetry in the last half-century B.C.; and the Latin silver age which began under Claudius and Nero in the middle of the first century of our era.

In each of these periods when literary poetic form was flourishing there was a corresponding outcrop of poetic formalism in art. It was never a strong growth because its appeal was limited to the same type of cultured society which relished poetry. The bulk of monumental art was still popular art, and imitation was in general demand. But in a few the taste for poetry may be said to have taken the form of a taste for formal art.

To the Alexandrian poetic age belong certain monuments from Carian Tralles, notably a most elegant formal Caryatid in

Constantinople (Plate 85). To class such a statue as something "retrograde" is to misunderstand it and to assume the fatal hypothesis that representational Greek and Hellenistic art was some sort of an advance on a supposedly childish archaic art, instead of another and different artistic form. The Tralles Caryatid is a fine statue; and, if it is inferior to a sixth-century Attic *Kore*, the same must be said of Theocritus' poem for Hieron II of Syracuse when that is compared with Pindar's first Pythian Ode for Hieron I. In both cases old forms have been re-used, not perfectly, but well. Another statue of the early third century from Tralles presents a cloaked boy boxer (Plate 86); the simple stark folds of the cloak recall the art of the Olympia master, the composition and the plain stele on which the boy leans give the work a markedly poetic character, but the head is prosaic in form.

The Latin golden age, the age of Virgil and Horace, has left a much larger output of formal sculpture, but this is partly due to chance. There are well-known pieces in Naples: a bronze youthful Apollo (Plate 87a), and the bronze girls from Herculaneum, as well as the little striding Artemis from Pompeii. The Metropolitan Museum in New York has a charming formal girl's head of this period (Plate 87b). The Capitoline *Spinario*, pulling a thorn from his foot, is of mixed form—formal head, realistic body. The last is perhaps a product of the school of Pasiteles whose followers, Stephanus and Menelaus, contemporaries of Virgil, have left signed statues of poetic, but inferior poetic form. These Graeco-Roman artists, who were equally facile in prose mood, grew into the Augustan School. Pasiteles himself was a voluminous writer on art as well as a practising celator and director of an establishment employing many masons. It is recorded of him that he said: "Modelling is the mother of celature and of tooling statues". From this it would appear that he thought an artist should first model in clay that work which he later meant to engrave. In this he was advocating a change of technique; for early celators began by engraving and chasing metal dies or reliefs, from which they could, if need be, make clay casts or impressions when they wished to duplicate their finished productions.[1]

[1] See Dorothy Thompson, *Hesperia*, 1939, pp. 285 ff.

In the silver age of Latin, formal works found favour once again. The reliefs on a triangular candelabrum base in Rome are of this type. There is an admirable head of a Sphinx in Copenhagen and a curly griffin in the Chicago Art Institute. But the best of all surviving poetic works of the Claudian period is in the British Museum: the small bronze statuette of *Kore* type with diamond-inlaid eyes (Plate 89), resembling the figures of "Hope" on Claudian coins.

All these formal statues and reliefs are usually classed as archaistic; but the name is to be avoided unless we are prepared to apply it equally to Theocritus, Virgil and Lucan for recasting methods and metres that an earlier age had once employed. There is no evidence that the Greeks and Romans ever applied the term "archaistic" to the arts, nor that they thought of this formal type of art as in any sense retrograde. The word *archaismos* was employed by literary critics to denote such linguistic forms as had become obsolete and were being used by pedants out of pure affectation. Formal art had run on continuously down to the time of its use by Alcamenes towards the end of the fifth century. The available evidence indicates a lessening of its employment during the fourth century and its revival at the beginning of the third. But in Athens there were certain arts carrying on the formalistic tradition right through the fourth century; Panathenaic painted amphorae, and coin-dies. If these are taken into account it actually never lapsed.

Though Hellenistic art was mainly concerned with remodelling ideas and forms of the past, it had innovations to show which ran parallel to some of its new literary forms. The most apparent of these were anatomical sculpture and landscape painting.

The work of two artists will serve to illustrate the kind of statues that appear to have been flayed so that every muscle and its function startles the eye. Agasias of Ephesus made about 100 B.C. a naked fighter in this fashion. An equally sensational anatomist was Apollonius, son of Nestor of Athens, working at about the same period, who made the marble Torso Belvedere in the Vatican and the bronze boxer of the Museo Nazionale in Rome (Plate 88) with his battered bestial face and blood-soaked beard.

The diversity of sculptors and the frequency of their signatures

in the centuries after Alexander is not to be taken as a token of their rise in public esteem. In the old days a great artist won his fame as a celator and only on rare occasions signed his name. But now the sculptor seemed to clamour for recognition by the prominent placing of his name upon his work. Socially the mason had never had the position which a celator or painter might enjoy, and by the later Hellenistic age the marble sculptor's calling was much misprized. Lucian, a Hellenistic Greek born in Syria about A.D. 125, has left an autobiographical account of certain events in his youth. After he had left school his father, having but slender means and unable to educate him as a scholar, apprenticed him to his brother-in-law, the boy's maternal uncle, "an excellent workman in stone and supposed to be one of the best statuaries". There followed a dream in which there appeared to him two women:

"One of them seemed to be a working woman, masculine looking, with untidy hair, horny hands, and dress kilted up; she was all powdered with lime, like my uncle when he was chipping marble. The other had a beautiful face, a comely figure and neat attire. At last they invited me to decide which of them I would live with; the rough manly one made her speech first.

'Dear youth, I am Statuary—the art which you yesterday began to learn, and which has a natural and family claim upon you. Your grandfather and both your uncles practised it, and it brought them credit. If you will turn a deaf ear to this person's foolish cajolery, and come and live with me, I promise you wholesome food and good strong muscles; you shall never fear envy, never leave your country and your people to go wandering abroad . . .'

This and more said Statuary, stumbling along in strange jargon, stringing her arguments together in a very earnest manner. When she stopped the other's turn came.

'And I, child, am Culture, no stranger to you even now, though you have yet to make my closer acquaintance. The advantages that the profession of a sculptor will bring with it you have just been told; they amount to no more than being a worker with your hands, your whole prospects in life limited to that; you will be obscure, poorly and illiberally paid, mean-spirited, of no account outside your doors; your influence will never help a friend, silence an enemy, nor impress your

countrymen; you will be just a worker, one of the masses cowering before the distinguished, truckling to the eloquent, living the life of the hare, a prey to your betters. . . . Whatever your real qualities you will always rank as a common craftsman who makes his living with his hands.

Be governed by me, on the other hand, and your first reward shall be a view of the many wondrous deeds and doings of the men of old: you shall hear their words and know them all, what manner of men they were; and your soul, which is your very self, I will adorn with many fair adornments, with self-mastery and justice and reverence and mildness, with consideration and understanding and fortitude, with love of what is fine and yearning for what is great. . . . Dame Statuary here had the breeding of Socrates himself; but no sooner could he discern the better part, than he deserted her and enlisted with me; since when his name is on every tongue.'

I waited not for her to bring her words to an end, but rose up and spoke my mind; I turned from that clumsy mechanic woman and went rejoicing to lady Culture." [1]

There is, however, no reason to suppose that the calling of a celator who worked in gold, silver, ivory and precious stones suffered from any loss of regard. The immense wealth of gold and silver which appears to have been released to the ancient world at large after Alexander's conquest of the East helped to increase the number of gold and silversmiths in an opulent age. As a result a fair amount of celature of a quality less fine than formerly began to appear because many more people could possess silver drinking-cups and jewellery of gold. Nevertheless, some very fine silver-work was made, by artists of sensibility, like a pair of dishes from Taranto (Plates 90a, b), their centres in high relief, each with the heads and shoulders of a pair of lovers. But the finest of the celators seem to have turned their attention to a new technique, or rather to a technique that had already existed in a small way and which they now developed on a grand scale— the technique of cameo-cutting. [2]

For the great celators who set out to carve sardonyx, agate, amethyst and other precious materials there must have been something, part scientific experiment, part romantic adventure,

[1] H. W. and F. G. Fowler, *Works of Lucian Translated*, 1905, vol. i, pp. 3 ff.
[2] See A. Ippel, *Guss und Treibarbeit in Silber*, *Winckelmannsprogramm*, No. 97; especially p. 41.

in their undertaking. To cut successfully a layered cameo was to fight a duel with a precious but almost intractable substance and to win the contest. The city in which this relatively new art attained an almost perfect mastery was Alexandria in Egypt, founded by Alexander himself in 331 B.C., and ruled and glorified by Ptolemy I, son of Lagos, a kinsman of the royal Macedonian House, who became first Governor, and presently King, and Pharaoh, after Alexander's death in 323 B.C. It will have been after that date, but before 309 B.C., that the most impressive sardonyx of all was cut, the Imperial Cameo of Vienna (Plate 91). This great stone of nine coloured layers, every one of which is put to use to help out the design, bears a head of the divine Alexander himself in a helmet ornamented on bowl, cheek and neck-pieces with the serpent, thunderbolt and head of Zeus Ammon, all symbols of the god reputed to have been his father. Beside him appears the profile of a young queen, her royal crown almost hidden by a stitched veil of oriental style. This cannot be Alexander's mother as some have thought, but must portray his queen, Roxané, an Iranian princess and mother of the infant son whose guardian Ptolemy claimed to be. The stone would seem to have been cut to honour the parentage of this boy, Alexander IV, who was murdered, together with his mother Roxané, in 309 B.C. After that date the queen would not have been depicted.

From this time on for several centuries the most competent celators turned their attention more and more to the making of cameos, large and small, and at the same time devoted themselves to the cutting of fine intaglios. As examples of the smaller kind there are a facing Medusa in onyx (Plate 92a) of early Hellenistic style, and a nicolo (Plate 92b) with a portrait of King Mithridates VI of Pontus who reigned between 120 and 63 B.C. This remarkable man was himself a great lover of fine gems, and his collection, presented to the Roman people by Pompey, launched among rich Romans of good taste a fashion for collecting these things that surpassed all former efforts. Julius Caesar himself proved to be one of the greatest of collectors, for the historian Suetonius records the fact that he paid high prices for gems that were the work of the famous Greek engravers of other days, and Caesar gave a

collection of ring gems to the temple of Venus Genetrix, his supposed ancestress. Another such collection was given by Marcellus, nephew of Augustus, to a temple of Apollo in Rome.

But the greatest patron of contemporary engraving and cutting of precious stones was Augustus himself. His "Court Celator" was the celebrated Greek Dioskourides, maker of the emperor's own personal seals and many other intaglios and cameos besides. His works generally bore his signature as on a celebrated amethyst (Plate 92c) with the head of Demosthenes which illustrates his great skill at producing facing heads. One reason why so many of his gems survive will be the fact that his work, admired for centuries after his death, was never buried but kept in imperial and ecclesiastical Treasure Rooms through the dark ages of Europe's history. Dioskourides had followers in his art like his son Hyllos, and many imitators who were witnesses to his fame. In all the long line of men of genius devoted to the art of celature there are two names, among those whose actual creations still survive to our day, which overtop the rest: Dioskourides and Benvenuto Cellini. Yet this is but a statement of their fame and does not alter the fact that many of us may hold a preference for the work of other artists like Dexamenos and the great die-engravers of fifth-century Sicily. There were also in the Hellenistic age certain sculptors, mainly in Alexandria, who began to work in extremely hard stones, basalt and later porphyry, using tools and a technique like those of cameo-cutters. Their work was large-scale celature rather than sculpture-from-modelling of the predominant kind.

In the Roman Empire the great and the wealthy showed their preference for the work of celators either in precious stones, gold, silver or delicately cast and chased bronze. The older and the solid bourgeoisie had also a certain taste for painting; but the vulgar, the newly rich, the prosperous Latin business man, the provincial proud of his new-won Roman citizenship—all these loved more than anything else a good marble statue.

Much fine drawing and painting must have been produced during the third and subsequent centuries but little trace of it survives. The fresco-painters and panel-painters are names and little more. Late adaptations—mainly Pompeian house-decorator

work—of their paintings sometimes hint at their powers of composition, but leave us guessing about aesthetic values. In one case we are tantalised by a hint of what has been lost. Philoxenus of Eretria late in the fourth century B.C. painted a great battle picture (Plate 93), Alexander's attack on the bodyguard of Darius in the battle of Issus, and some wealthy Hellenistic Pompeian citizen had it copied in mosaic for his floor. Think of Titian's entombment lost; but the mere record of its composition not lost. Suppose its subject preserved on a frayed and tattered piece of *Gobelins*. It would be interesting; it would certainly be a travesty. Since there is grandeur left in this broken Pompeian mosaic, what may not the original have been? Even in the copy there is something descriptive of the relentless will of Alexander, of the panic terror of Orientals before the terrible strength of the North.

Great as was the output of original or quasi-original work in the Hellenistic-Roman period, it was almost as nothing compared with the production of copies of statuary. To walk through the classical sculpture galleries of Rome—Vatican, Capitoline, Conservatori, Lateran, Terme; then through those of Naples and Florence; next to visit Paris and wander in the Louvi : to have dropped in on Brussels, Cassel, Dresden, Munich—su ₁ tour would leave one overwhelmed by the agalmatomania, the "craze for statues", that obsessed the corporations and well-to-do citizens of the Roman Empire. The fashion, not only for gems but also for statue-collecting, was begun by Hellenistic princes. The Attalids of Pergamum collected antiques, including early pieces; their neighbour of Bithynia, King Nicomedes, did likewise and tried in vain to add the Cnidian Aphrodite to his treasures; the more powerful Ptolemies and Seleucids doubtless gave the lead both in patronising living artists and in collecting old masters. But where these princes were, or claimed to be connoisseurs, the Romans, with some exceptions, were simply amassers. Greek art was and long remained the fashion; to become a person of account you must have statuary in your home. And so constant and great a demand must have been met by some organised system of supply.

Your Roman in search of statuary for house or garden or villa must first have sought advice from friends, and consultations would call for reference to the text-books; Pasiteles, Varro and

the Elder Pliny, any of these would serve as a collector's *vade mecum*. Then would come a visit to the middleman, some knight or freed-man who was broker for the supply of "works of art" and had his agents in Rome, Naples, Athens, Pergamum, Ephesus, Alexandria and elsewhere. From the multiplicity of surviving copies one can reconstruct in imagination this broker's catalogue, which might well start with the Latin words *signa Veneris*, or "statues of Venus", for if he was a practical man he would list the most popular commodities first.

He could do you a Venus by Praxiteles, Scopas, Lysippus or Doedalsas. Yes, Parian, Pentelic, Pergamene, Carrara or Luna; but if you took his advice he would recommend Parian for a Venus—a little dearer, but worth it. Or an Apollo? A nice line in Calamis, Pheidias, Praxiteles or Scopas? If you asked him an Apollo would go well as pendant to a Venus. You wanted to give a statue to the local gymnasium? Now, why not an athlete? There were nice Polyclituses—a Diadumenus or a Doryphorus; a Myron Discobolus looked well against a wall; of course there was that Lysippus Apoxyomenus figure—difficult and a little costly. He himself found that the Diadumenus line went better than anything. Amazons, Gauls, Cupids, Dianas, Satyrs, Mercuries, Minervas, would you like any of these? *All* after the great masters, of course. "You choose your subject, artist, and marble, give us a little time and we guarantee satisfaction." Another customer arrives whose purse is shorter; he cannot afford whole statues. Well then, a nice bust? Let him name his favourite poet or philosopher and the bust can be his to add distinction to his residence.

I make no apology for the last paragraph, for commonplace though it sounds, it represents the kind of thing that must frequently have occurred in a civilisation where the "newly-rich" were constantly rising to the social surface. Such men, utterly ignorant in matters of art, and demanding only that the piece of marble carved for them should be nice marble, could be supplied with the most inferior work, and were. A Lucullus or Caesar, if he wanted a statue, would have insisted on quality and a measure of accuracy; Tiberius or Nero were privileged to sequestrate original masterpieces; but the ordinary customer was happy to

acquire the copy of a copy based on some worn plaster-cast once taken from a remote original.

Such are the things that have been recovered in their hundreds from the ruins of the Graeco-Roman world. Such are the things that have been doctored and patched by past generations of Italian repairers before plaster-casts of them have been made to serve as examples of the Antique in Schools of Art. Yet art-masters are not alone to blame, for in the whole sphere of classical studies nothing has been more grossly over-valued than these accumulations of carved marbles. Lessing, Winckelmann, Michaelis and many others have done a grave disservice by mis-directed enthusiasms and whole art histories of the ancient world have been built on sand, or rather—if such a concept be possible—on an imitation of sand. Fortunately for our day the last half-century of excavation in the Near East has found the bed-rock of original Greek art, and we can build our art-histories with greater confidence.

Meanwhile what of the copies, now that they are known for what they are? If they are almost valueless for the study of art, they have their importance for the historian who is interested in social and economic aspects of the Roman Empire, and for the Latinist who may welcome a material commentary on certain books of Pliny.

Statue collecting was the fashion in his day for all who could afford it; art connoisseurship was for the few, a polite pose adopted by the cultured society man. We have learnt the Elder Pliny's considered opinion as an educated man-of-the-world about the Laocoon, and beside it we may set the dilettantism of his nephew, the younger Pliny. He writes at about the end of the first century of our era to his friend, Annius Severus:

"From an estate, which has fortunately come my way, I have just bought a Corinthian bronze statuette, small, but pleasing and finely executed, as far as I can judge, though perhaps I have but little taste in this as in other matters. Still, I do feel that I can understand this statuette. It's a naked figure, of course, and neither conceals its blemishes (if any) nor hides its merits. The subject is a standing figure of an old man. Bones, muscles, sinews, veins and wrinkles are just those of a living man; his hairs are few and vanishing, his forehead wide, face screwed up,

neck thin, arms drooping, chest flat, stomach hollow. The back view has the same effect as the front. Patina and colour alike prove it to be a genuine antique. In fine, it has the quality to hold the attention of artists and to delight even Philistines, and this induced me, a mere beginner, to buy it."

The younger Pliny's taste can only be described as "precious", and his bronze must have been a very ordinary little *objet d'art*.

The great Pantechnicon rolled on, capacious for every banality and every talent: Pliny's little old *arterio-sclerote* and the lovely little London diamond-eyed *Kore*; the sleek Apollo Belvedere and the tough Demetrius of Syria; the unworthy Medicean Venus and the elegant Tralles Caryatid; Satan's seat in Pergamum and the triumphant prow on Samothrace.

The catholicity of Hellenistic taste was like that of our own day when you may find two neighbours, the one delighting in Sir Lawrence Alma Tadema, the other in Pablo Picasso. The difference probably lies in this; that whereas our modern neighbours will inveigh against the alleged depravity of one another's tastes, the Greek and Roman collectors would have shown cultured modesty and friendly toleration.

MUSEUM

IT is probably better to possess inferior statues and pictures than to possess none at all, for out of a society containing many misguided collectors there will arise a few with taste and intelligence, and in a civilised polity something in the nature of a Museum will come into existence. Once you have anything like a museum then you have at least the rudiments of scientific method applied to the contemplation of fine art, for when the curator takes over, the dilettante departs.

Now, scientific method is by no means necessary as an aid to the contemplation of art, which can obviously be appreciated by itself for itself regardless of time or place. But classification is an aid to the cultivation of taste. An unbiassed museum mind can disentangle muddles, and it helps indirectly by isolating antiquarianism to promote freshness and originality in art. While some will say illogically, "This is of the Past, the Past was great, therefore this is great, let us imitate it", there are always others who will say, "This was of the Past and of antiquarian interest, but we are of the present, let us do something different".

When the Emperor Hadrian built his huge villa at Tibur he was founding something very like one of the first museums. His biographers write with emphasis on his passionate Hellenism, on his expert knowledge of painting and on his own practice of the

fine arts.[1] Of the various emperors who took a definite interest in the artistic activities of their times one might be tempted to say that Augustus was an art patron, Nero an unstable genius, the Flavians trustees, and Hadrian a scholarly curator. If Hadrian's successor, Antoninus, lacked the enthusiasm, he at least possessed the *pietas* and the sense of responsibility required both to conserve and to augment the collections of his predecessor at Tibur.

Hadrian, who in his exalted position might have accumulated originals without incurring the reproach of vandalism, contented himself with the acquisition of copies. Lists,[2] incomplete though they are, of these copies are truly impressive, beginning with a large collection of Egyptian works and an Asiatic idol, ranging through versions and adaptations of Greek sixth- and fifth-century types to Hellenistic subjects, and closing with the original works of contemporaries, the most important being the representations of the emperor's favourite, Antinous. There were copies of the works of celebrated artists like Kritios and Nesiotes, the Master of Olympia, Myron, the Master of the Parthenon, Praxiteles, Scopas, Lysippus, Epigonus of Pergamum and his school, and Stephanus. There were busts of poets, orators, philosophers and statesmen.

All this was Greek, not Roman; for indeed there was no truly Roman art. It is worth recalling and stressing the apt remark that "what we are accustomed to term 'Roman' art is not the art of the Roman people or of the Roman race, or 'Greek art under the Romans'; it is Greek art in the Imperial phase".[3] It is unsound to seek to link up this Graeco-Roman Imperial art with semi-barbarous Italic and strange Etruscan origins.

In passing, it may be noted that sixth-century Etruscans had adopted an earlier east-Greek poetic art-form without clear under-standing, and had done to it something that can best be described in modern jazz terminology—they "hotted it up". Compare any nearly contemporary Greek and Etruscan works presenting

[1] J. M. C. Toynbee, *The Hadrianic School*, 1934, p. xxiii.
[2] P. Gusman, *La Villa Impériale de Tibur*, 1904; H. Winnefeld, *Die Villa des Hadrian bei Tivoli, Jahrbuch*, Ergänzungsheft, iii, 1895. A proper catalogue of Hadrian's Museum at Tibur has yet to be made.
[3] J. M. C. Toynbee, *op. cit.*, p. xiii. The whole of Miss Toynbee's argumen and her refutation of Wickhoff and his followers seems incontrovertible.

kindred themes or subjects and the powerful vulgarisation of the latter is evident. It would be easy to multiply instances. As for realistic Etruscan sculpture of the second century B.C., this was nothing but a degraded imitation of Greek Hellenistic work.

But we may return to Hadrianic art and the outstanding creation of his time; a form derived from athletic prototypes of long ago and yet conceived with such newness and unity that it comes through almost like a fresh creation—Antinous (Plate 94). "The picture of Antinous is no mere presentation of the Emperor's Bithynian favourite in the flesh, but rather of the new god Antinous. Greek classical tradition summons up all its force once more in order to give form to a divine Ideal. There is more here than the fortuitous coincidence of an Imperial command, a clever artist and the abject flattery of subjects. Stirred with genuine devotion, the Greeks sought and found a worthy expression of their gratitude when they created, as solace for a ruler bereaved by a mysterious death, the Being of the divine Antinous for their own age and for all time."[1] Even more skilful than the statue made by a skilled and efficient mason is a small ivory-like relief in marble of Antinous made and signed by Antonianos of Aphrodisias (Plate 95), a brilliant Greek celator who also signed a delicate intaglio with the same youth's head (Plate 96a) and made dies for bronze medallic coins struck in Peloponnese in honour of the dead Antinous.[2]

With a look at the Naples Antinous (Plate 94) we may speak farewell to the last of the fine Hellenic naked athlete types in marble, even to the last good Greek ideal god-type glorified by its very humanity. There was to be poetry still in Greek art; the formal splendour of pomp and circumstance was to be for long a theme; and celature of elegance and fineness was to delight cultivated citizens of the empire. But the shamefaced Oriental, disrespectful of human bodies, made his influence ever more felt in the world; and you may almost see vines and leaves and draperies creeping furtively up figures carved in marble, bent on concealing evidence of their sex. So depraved a custom could only demean still further the craft of carving in marble.

[1] G. Rodenwaldt in *C.A.H.*, xi, p. 791.
[2] See Charles Seltman in *Hesperia*, 1948.

A phase of extreme vulgarisation in marble sculpture did, however, precede the phase of concealment, and it occurred under the first oriental dynasty that assumed the imperial purple. Up to the year 193, all the rulers of the Roman Empire had been westerners. The patricians of the Julio-Claudian line had been followed by men of Italian, Spanish or Gallic descent, all imbued with the European tradition. But when the government of the civilised world passed into the hands of an African from the region of Carthage whose wife was a clever Syrian devoted to the cult of an eastern Baal, then it was that inevitable changes began to occur. Septimius Severus was an African, a brilliant soldier and a relentless power-politician. In the words of Gibbon, "he promised only to betray, he flattered only to ruin; and however he might occasionally bind himself by oaths and treaties, his conscience, obsequious to his interest, always released him from the inconvenient obligation". His wife, Julia Domna, was a woman who combined beauty, a brilliant mind and the gift of government with boundless ambition. It was her influence which kept the Severan dynasty in being and her Salon which guided the thought and taste of the age. But she was no westerner at heart, like Cleopatra or Livia.

The elder offspring of this union between Africa and Syria was Caracalla, a rascally megalomaniac who presumed to proclaim himself the reincarnation of Achilles and Alexander the Great. It was this brutal creature who, as Emperor, proved to be patron of the final episode of marbled vulgarity in Rome by decorating his celebrated Public Baths with statuary and letting them serve as yet another museum for the Roman people.

Were a critic asked to select the three nastiest "works of art" from the ancient world, he could hardly go wrong in naming the Farnese Bull, Herakles and Flora, all made to grace Caracalla's Baths, which, as an architectural masterpiece, were, of course, quite admirable. Two young men tying a helpless woman to a mad bull is not an attractive subject save to some jaded habitué of the amphitheatre. But the complaint against it is one, not of bad subject, but of rotten art. The other two are a marble giant and giantess. The former, a Herakles ten feet high, presents the vast frame of a naked man draped in great gobbets of bulging muscles.

Half-unconsciously perhaps the sculptor, named Glykon of Athens, made a cynical caricature both of the over-developed athlete and of the over-realistic statue. A like stricture may be passed on the other figure, a great wench—Flora, Hora or Hebe—like a vast plump village girl vainly attempting a minuet. Each of this dreadful pair is a *magnificatio ad absurdum*.

Taste and refinement still existed in the civilised world, but it turned away from such stuff as this, for it was still in the hands of the elegant celators. It is possible to date with accuracy some of the finest works of celature made under the Severan dynasty. Caracalla was succeeded, after a brief interlude, by a degenerate young cousin, alleged by some to be Caracalla's natural son, named Varius Avitius, who was high priest of that same Syrian Baal whom Julia Domna honoured. This pampered and painted boy of fourteen took the name of his god Elagabalus, and became Emperor in A.D. 218. In the following year he married a young Roman girl, Julia Cornelia Paula, descendant of an ancient patrician house. After a few months the degenerate Syrian youth tired of her and divorced her in order to marry a Vestal Virgin. But coins with the portrait of Julia Paula were struck, and from these it is possible to identify the girl on a sardonyx cameo of exceptional fineness, once among the Marlborough gems, as a portrait of the young empress (Plate 96b). It is obvious that this could only have been made in A.D. 219.

Everything in which Elagabalus was concerned was repellent. "The incongruity of a circumcised Augustus, who abstained from the flesh of swine to perform with a ritual purity the obscenities of a Syrian cult, and who paraded in public tricked out in the effeminate finery prescribed by its ceremonial, offended a public opinion which was not exacting in morals but expected a traditional decorum in its rulers." [1] The corrupter of the dignity and religion of Rome met a well-deserved end in A.D. 220 and was succeeded by his first cousin, Gessius Bassianus Alexianus, who took the name of Severus Alexander. This excellent young man was able to adapt himself to European ways and thought and consequently enjoyed a reign, comparatively long for those days, of fifteen years. He displayed a tolerance that may have

[1] S. N. Miller in *C.A.H.*, xii, p. 55.

surprised some at least of his christian subjects by giving to their Founder a friendly welcome when he caused a statue of Christ to be placed with other figures worthy of reverence in the imperial house-chapel in Rome.[1]

Caracalla had started a new cult of Alexander and revived the whole Alexander legend; his young cousin, Alexianus, took it up with enthusiasm at a time when the world was seeking avidly for any ideal to sustain faith in the destiny of mankind. Some fifty or sixty years earlier Arrian, using older sources, had written his popular history of Alexander the Great, which must have served many as a kind of gospel of the Macedonian hero who was once again dominating men's imaginations.[2] Great Games were held at frequent intervals in memory of Alexander the Macedonian, Founder, and in honour of Severus Alexander, Ruler of the Civilised World. In, or just before, A.D. 230 some of the most accomplished celators made as prizes for these Games certain large medallions of solid gold which were discovered at Tarsus. The larger pieces (Plates 97a, b, 98a) are inscribed in Greek on their reverses and bear portrait heads of Philip of Macedon and his son Alexander. The lesser coin, still large, has the bust of the Emperor Severus Alexander and a Latin legend, including a date which corresponds to A.D. 230 (Plate 96c). The centre of a silver dish found in Egypt is Alexandrian work of exactly the same period (Plate 98b). It might have come out of the same brilliant *atelier* as the golden medals. All this is work as superb as anything that could have been made in the days of Augustus or the first Ptolemies.

Painting in this same age was also able to display its excellence especially in the making of miniatures upon glass set against a gold-leaf background. A certain Greek named Bounneris signed one of these (Plate 102a) with portraits of a mother and two children, and another similar work, unsigned (Plate 102b), shows an agreeable male likeness. This is a fine aristocratic art which was to give rise later to the art of illumination on vellum; and it is an art contemporary with the philosopher Plotinus, a man more sensitive to fine art than ever Plato or Aristotle had been.

[1] *C.A.H.*, xii, p. 68.
[2] See A. D. Nock in *C.A.H.*, xii, p. 416.

Meanwhile, what of sculpture? The third century of our era was a time when men no longer believed in the gods and when athletes were all professionals. The market-places and hippodromes of great cities and the sanctuaries surrounding famous shrines were, each one of them, by now like a great outdoor museum crowded, even cluttered, with statuary of various epochs of the past. Had there been a desire to add to all these it would have been hard to find the room. But there was no longer any desire. The masons now found employment on a new kind of work that rose into great favour—the funeral sarcophagus.

Of all the uses to which carved marble may be put the most dangerous to good taste is funerary commemoration, for it may be claimed that marble tomb monuments have rarely been successful as works of art. Certain quite early Spartan slabs of about 600 B.C. are more interesting than attractive. The Athenians all through the sixth century had produced the finest gravestones ever made (Plates 45, 46), and in the fifth turned out a number in true good taste. But by the fourth century they too were making heavy over-loaded monuments which can even now by their very sentimentality embarrass the beholder. The monuments of the Roman Republic and the earlier empire do not really please either. Indeed, stone masons soon learnt to run stock lines which would appeal to the immediate sentiment of the bereaved. Much has been written in praise of the many marble sarcophagi carved in high relief and produced in many parts of the ancient world in the second and third centuries of our era, but it is exceedingly doubtful whether these should ever be classed with serious works of art. Certainly no Greek or Roman of taste would thus have classed them. They were the kind of stuff that Lucian would have been trained to make had he in his dream [1] chosen the humble and despised calling in which "Dame Sculpture" had tried to enrol him.

However, there were some sculptors who worked not in stone but in bronze, which brought them close to the work of the celator. Scarcely anything of theirs has survived, but that which has is truly impressive.

Two bronze works representing great imperial personages serve

[1] See p. 102 f. above.

to show a powerful change that now took place in art. One, the red paint still on his lips, is a head of Claudius II, victor over the Goths (Plates 99, 100), who wore the purple between A.D. 268 and 270; the other, a whole figure gigantic in size of the Emperor Valentinian I (Plate 101), who reigned a century later from 364 to 375. The former head was not made in the lifetime of Claudius, but soon after A.D. 310 when Constantine the Great decided to trace his descent from the family of that heroic man. Here is a startling change in feeling, away from the kind of portraiture that had been turned out for centuries. Look once again at the gentle, ideal Antinous (Plate 94) of Hadrian's reign, and then at these stark, powerful heads of emperors. It is another art-form, totally different. Antinous is described in a eulogy of smooth and polished prose. The god-like emperor is rhythmically hammered out, chiselled and tooled in poetic, even in epic form. Art no longer claims or desires to imitate nature, but has risen above nature to independent creation. And art is in this following precepts and theories propounded in the Enneads of Plotinus, who, of all ancient philosophers, was most given to understand fine art. This is not merely an attempt to portray a tough soldier who has risen to high rank in the school of war; it is a creation in bronze of the awesome idea of the world-ruler, vicegerent on earth of Sol or Jupiter, which Claudius II seemed; or Vicar of the Almighty, to which office Valentinian as successor to Constantine might lay claim.

The unknown makers of these splendid bronzes were of the same tradition as many celators who made dies for large medallions, which were so frequently struck in this period. Typical of this strong poetic art of die-sinking are medals of Diocletian (Plate 103a) made at the end of the third century, and of Constantine the Great (Plate 103b) struck in Constantinople between the years 324 and 337.

After the beginning of the third century it becomes possible to recognise three kinds of art in the ancient world, imperial, popular and aristocratic. An emphatic change in form took place in imperial art long before Constantine adopted christianity—a change, as just observed, to strong poetic form.

Popular art still clung to the now outworn prose formulae of

Hellenistic times which were used on things like the clumsy marble funeral chests. But with the adoption of christianity popular art was bound to experience a severe set-back, for it is evident that Constantine's new religion soon became the cause of great changes. Whatever the spiritual advantages of the new faith it was certainly a misfortune for the art of the people that some promoters of christianity should at that time in the fourth century of our era lay an overwhelming emphasis on qualities which to a Hellenic mind must have seemed not virtues but perversions. A wistful admiration for the life of contemplation and penance, fear of the world of men, preparation for the tedium of a very concrete heaven, a haunting preoccupation with sin, a crazy exaltation of virginity, human sacrifice—not the simple kind that ends quickly with the stroke of a knife, but sacrifice through years of starvation, filth and flies in the burning sand of deserts; when such things happen in the world, art must wilt. While, instead of incense and the fat of lambs, the odour of holy hermits of both sexes rose miasmically heavenwards, there was little to encourage regard for the fine arts of mankind. "The ascetic movement grew," writes Gilbert Murray, "to be measureless and insane. It seemed to be almost another form of lust, and to have the same affinities with cruelty." [1] There must be a pause till the hermits should discipline themselves, which in time they did. The church must now proceed to recover the spirit and purpose of her founders untarnished by complicated superstitions or ignoble cults.

All this, of course, had its effect on the people but not on rich and flourishing persons in the upper strata of society, who continued serenely to enjoy the fine things that Greek celators could make for their pleasure. The most attractive work seems to have been made by Greeks of Alexandria. Such is the ivory leaf of a diptych, now in London, made about A.D. 392 or 400 as a wedding gift for a girl of the Greek aristocratic family of the Symmachoi domiciled in Rome, people who still preferred the older faith. The carving (Plate 104) of a graceful girl, in a garb hardly altered since the days of Pericles, and dropping incense on an altar, is evidence that exquisite celature was still made.

[1] *Five Stages of Greek Religion*, p. 236.

Perhaps half a century earlier than this ivory, but made in Alexandria too, is one of the most astonishing examples of ancient art—or indeed of the art of any epoch—the great silver tray from the Treasure of Mildenhall in East Anglia, discovered in the winter of 1942–43 (Plates 105, 106). In the centre is a medallion with facing head of Okeanos, then a frieze of naked ocean nymphs, tritons and sea monsters; and, in the big outer zone, Dionysos, Pan and a rout of maenads and satyrs. There is no concealment here of the splendour of human bodies because this was made for a rich citizen of the empire living in Britain, a man with none of the scruples and unhealthy pruderies that were now common among less fortunate people.

The ancient Greek city of Byzantium was selected by Constantine to be the "New Rome" in A.D. 324. There can be little doubt that, just as fine artists flocked to Alexandria when that city was founded in 331 B.C. by Alexander, so skilled celators now made their way to Constantinople. One product of an engraver's work in this city has already appeared (Plate 103b)—a fine medallic coin. Another, which is from its type and character probably to be attributed to this city and to the age of the Constantinian Dynasty, is a Phalera, or circular ornament for some valued horse, perhaps a race-horse. It is partly amuletic because it is engraved on the flattened reverse of what was, almost three centuries before, a current bronze coin of the Emperor Nero. His head, worn though it is by circulation, has been left on the obverse because it seems that Nero was "good luck" in the races! However, it is the other side which attracts—a little masterpiece of damascene, or inlay work. Into the bronze disk of the old coin is inlaid a four-horse chariot (Plate 107a); the driver's head, palm-branch and wreath, and the chariot basket, as well as the reins of the horses are of gold, his garment and the wheels are silver; the black horses themselves in niello. Such work as this was being made about 1550 B.C. (Plate 1d) by Greeks of the Bronze Age, and it is only by chance that there remains so little between that epoch and the beginning of the Byzantine era of a very fine kind of celature, the art of which can never have been lost.

The depredations of barbarians from Alaric the Goth to Baldwin of Flanders have left little to survive of the finer arts practised

in Greek lands during eight centuries. One work in gold and one in ivory may afford a glimpse of the power and elegance of unknown artists. The gold masterpiece is a medal set in its own contemporary frame of solid gold wrought by a brilliant celator of Constantinople for Ravenna in A.D. 423. The medal portrays a remarkable person, the Empress Galla Placidia (Plate 107b). Captured at the age of eighteen by the conquering Goths, this princess, already famed for her looks, intelligence and exquisite manners, was married to the barbarian Gothic King Adolph, in whom she discovered not only a husband but a lover. In 418 he was assassinated at Barcelona and his widow, at first ill-used by the murderer, was rescued by a certain Constantius, a troublesome "climber", whom she reluctantly married. Widowed a second time, and now more happily, she joined the Court of her half-brother, the Emperor Honorius, and scandal fixed on these two rumours of an incestuous affection. However, by 423 she was effectively established as the ruler of the western half of the empire as empress-guardian of her infant son. That is why so splendid a medal was produced in honour of the famous Augusta, Galla Placidia.

It is not to be forgotten that at a time when in Western Europe elementary scholarship was of the greatest rarity, and illiteracy was normal alike for king and peasant, the people of the Byzantine Empire enjoyed, a great number of them, a high standard of education.[1] In Constantinople up to the twelfth century the Epics of Homer were still studied as keenly as Holy Writ, and for this reason Greek classical allusion, myth and history kept their place in the minds and in the art of the educated people, parallel with, but mainly apart from all that was concerned with christian liturgy and legend. It is generally agreed that certain remarkable ivory wedding caskets with scenes from ancient classical sources are as late, some of them, as the eleventh century of our era. The finest of them all, the famous Veroli Casket in London, was perhaps made about A.D. 850, or possibly a century later. It can provide a fitting end to the story of ancient Greek art. Upon it are shown, with all the antique skill of fine celature, Europa on the Zeus-bull, Iphigeneia child of Agamemnon, Helen and Paris,

[1] See Steven Runciman, *Byzantine Civilisation*, Ch. IX.

Bellerophon with Pegasus, Aphrodite and Ares, Dionysos, nymphs and centaurs (Plate 108a, b).

The same satisfying art of the carver in ivory which flourished in Crete around 1550 B.C. (Plates 5–9) was still being practised in Constantinople 2,400 years later.

When, under the guise of a "crusade", the richest city of the world and the last centre of Hellenism was sacked in the year 1204 by the live business men of Venice and the loutish chivalry of Western Europe, only very little was saved. A few carved precious stones and ivories might escape destruction, but all of gold and silver and bronze went into the melting-pots of the greedy victors. And if there were ancient statues of marble which had in the fourth or fifth centuries escaped the hammers of defiling monks, these were now destroyed by crusading pietists who might set against their too frequent breach of the Sixth, Seventh, Eighth and Tenth Commandments, their punctilious obedience to the Second.

To every Greek in those grim days it seemed the end. Yet it was only a pause in history, a sleep, a stupor, before a rebirth that was to come. Once before, ancient Greece, captive, could captivate her Roman conquerors. A second time, the spirit of Greece which is Humanism passed to Italy, to France, to England, and again some men and women began to find in the art and the letters of Greece that which can loosen bonds and lead men out to liberty and happiness.

BIBLIOGRAPHICAL NOTE

for readers in search of further information from books in English

CELATURE. A comprehensive book on celature as a whole has yet to be written. Important branches of the art can be studied in the following: the Introductions by F. H. Marshall to *Catalogue of Jewellery, Greek, Etruscan and Roman, in the British Museum*, 1911; and by H. B. Walters to *Catalogue of the Silver Plate, Greek, Etruscan and Roman, in the British Museum*, 1912, and *Catalogue of Engraved Gems and Cameos, Greek, Etruscan and Roman, in the British Museum*, 1926. Further, see Miss Gisela Richter's Introduction to *Greek, Etruscan and Roman Bronzes in the Metropolitan Museum of Art*, New York, 1925. See also Winifred Lamb, *Greek and Roman Bronzes* (Methuen), 1929 (o.p.).; Charles Seltman, *Greek Coins* (Methuen), 1933 (o.p.); J. H. Middleton, *The Engraved Gems of Classical Times* (Cambridge University Press), 1891 (o.p.); and G. F. Hill, *Select Greek Coins* (Vanoest, Brussels), 1927.

PAINTING. Any book or pamphlet written or sponsored by J. D. Beazley, especially *Attic Red-Figure Vase-Painters* (Oxford University Press), 1942. The most recent book on Attic red-figure painting is Gisela Richter's *Attic Red-Figured Vases* (Yale University Press), 1946.

SCULPTURE IN STONE AND MARBLE. For the sixth and early fifth centuries B.C. the following are uncontaminated by intrusive copies of statues: Bernard Ashmole, *Late Archaic and Early Classical Greek Sculpture in Sicily and South Italy* (*Proceedings Brit. Acad.*) 1934; H. Payne and G. M. Young, *Archaic Marble Sculptures from the Acropolis* (Cresset Press), no date; Gisela Richter, *Kouroi* (Harvard University Press), 1944; and for the Hellenistic age, A. W. Lawrence, *Later Greek Sculpture* (Jonathan Cape), 1927. Other books on Greek sculpture most unfortunately mix in later copies with the originals. For sculpture from temples, any of the books on Olympia, the Parthenon, etc., are deserving of study. An essay of value is the inaugural lecture of May 17th, 1935, by A. J. B. Wace, entitled *An Approach to Greek Sculpture*, Cambridge, 1935.

ABBREVIATIONS

A.G.	A. Furtwängler, *Antiken Gemmen*, 1900.
A.M.	*Athenische Mittheilungen*.
A.O.	R. M. Dawkins, *Artemis Orthia*, 1929.
A.P.	R. Delbrueck, *Antike Porträts*, 1912.
A.V.P.	Charles Seltman, *Attic Vase Painting*, 1933.
B.C.H.	*Bulletin de Correspondance Hellénique*.
B.M.C.	*British Museum Catalogue of Greek Coins*.
B.M. Eph.	D. G. Hogarth, *British Museum Excavations at Ephesus*, 1908.
B.M.J.	*British Museum Catalogue of Jewellery*.
B.S.A.	*Annual of the British School at Athens*.
C.A.H.	*Cambridge Ancient History*.
Delphes	P. de la Coste-Messelière, *Delphes*, 1943.

Dendra	A. W. Persson, *The Royal Tombs at Dendra* (Lund), 1931.
D.S.M.	H. Bulle, *Der Schöne Mensch*, 1912.
F.B.	E. Langlotz, *Fruehgriechische Bildhauerschulen*, 1927.
F.R.	A. Furtwängler and K. Reichhold, *Griechische Vasenmalerei* (Munich), 1904—(continued by F. Hauser and E. Buschor).
G.A.,C.C.	Jacqueline Chittenden and Charles Seltman, *Greek Art, A Commemorative Catalogue of an Exhibition at the Royal Academy*, 1947.
G.C.	Charles Seltman, *Greek Coins*, 1933.
G.R.B.	Winifred Lamb, *Greek and Roman Bronzes*, 1929.
J.H.S.	*Journal of Hellenic Studies.*
Myk.	G. Karo, *Schachtgräber von Mykenai* (Munich), 1930.
Ol. I	E. Buschor and R. Hamann, *Die Skulpturen des Zeustempels zu Olympia*, 1924.
Ol. II	G. Rodenwaldt and W. Hege, *Olympia* (London), 1936.
V. & A.I.	M. H. Longhurst, *Victoria and Albert Museum Catalogue of Carvings in Ivory*, 1927.
Z.	A. B. Cook, *Zeus*, 1914 *to* 1940.

DESCRIPTION OF ILLUSTRATIONS

Pl. 1 (a) Bronze double-axe 8 in. long. About 1550 B.C. From Mouri, near Mallia, Crete. A. B. Cook Collection. *Z.* iii, p. 1144, Fig. 894. (b) Gold ring, bezel intaglio. A king in battle with three foes. 1·4 in. long. About 1650 B.C. From Mycenae. In Athens. *Myk.* Pl. 24, 241. (c) Large dark agate, intaglio. Lion on bull. 1·7 in. across. From Dendra. In Athens. *Dendra*, Pl. XIX. (d) Part of dagger blade, bronze inlaid with gold and silver and gold alloy. Scale 1/1. About 1550 B.C. From Mycenae. In Athens. *Myk.* Pl. 93, 395.

Pl. 2 (a) Stone matrix, intaglio moulds. 8·8 in. long, 4 in. wide, 0·8 in. thick. About 1600 B.C. From Siteia, Crete. In Heraklion. *Ephemeris Archaiologike*, 1900, Pl. 3. (b, c) Gold ornaments embossed and chased, 2 in. high and 2 in. diameter. About 1550 B.C. Both from Mycenae. In Athens. *Myk.* Pl. 30, 75; Pl. 20, 38.

Pl. 3 Gold cup, embossed and chased. Width with handle 8·7 in. About 1500 B.C. *Dendra*, frontispiece.

Pl. 4 Silver cup with sheet-gold lining, embossed and chased. Width with handle 5·5 in. About 1500 B.C. *Dendra*, Pl. II, Pl. XVI.

Pls. 5, 6 Gold and ivory goddess. Height 6·3 in. About 1550 B.C. In Boston, Museum of Fine Arts.

Pls. 7, 8 Gold and ivory girl toreador. Height 7 in. About 1550 B.C. In Toronto, Royal Ontario Museum.

Pl. 9 Gold and ivory toreador. Height 5·2 in. About 1550 B.C. In Oxford, Ashmolean Museum.

Pl. 10 (a) Drawing of fragmentary fresco from the Palace at Knossos. About 1500 B.C. (b) Bronze. Toreador somersaulting over

bull. Height 4·6 in. About 1600 B.C. Collection of Captain Spencer-Churchill. *G.A.,C.C.,* Pl. 3.

Pl. 11 (a, b) Frescoes. About 1600 B.C. From Hagia Triada, southern Crete; in Heraklion; and from Phylakopi, Melos; in Athens. *Monumenti Antichi* XIII, 1903, Pl. VIII. *J.H.S.,* Suppl. IV, Pl. III.

Pl. 12 (a, b) Bronze. Horse and Bull. Heights 3·8 in. and 2·7 in. About 800 B.C. From Olympia. In Paris, Comte de Nanteuil Collection.

Pl. 13 (a, b) Ivory brooches with inlay of Baltic amber. 4·8 in. across and 2·5 in. high. About 820 B.C. From Sparta. After *A.O.,* Pl. 132, 4; Pl. 134, 1.

Pl. 14 Ivory girl. Height 6 in. About 820 B.C. From a tomb in Attica. In Athens. *A.M.,* LV, 1930, Pls. V, VI.

Pl. 15 Bronze sheet cut out and engraved with two hunters. Height 8 in. About 700 B.C. From Crete. In Paris. Photograph, Louvre.

Pl. 16 (a, b) Bronze. Youth. Height 7·8 in. About 650 B.C. From Delphi. In Delphi. *Delphes,* Fig. 10. (c) Ivory Eunuch priest wearing robe engraved with patterns common on Greek geometric pottery; round his neck a large rosary. Height 4·4 in. About 650 B.C. From Ephesus. In Constantinople. *B.M. Eph.,* Pls. XXI, XXIV.

Pl. 17 (a, b) Ivory girl priestess wearing a garment engraved with patterns common on Greek geometric pottery. Height 3·8 in. About 650 B.C. (c) Ivory sphinx with curled wings and feather-pattern on chest. Height 1·8 in. About 650 B.C. Both from Ephesus. In Constantinople. *B.M. Eph.,* Pls. XXI to XXIII.

Pl. 18 Part of battle-scene, restored, on a Corinthian jug (the Chigi vase). About 640 B.C. From Veii. In Rome. *Antike Denkmäler,* II, Pl. 44.

Pl. 19 (a) Stater of electrum. Head of a roaring lion. Scale 2/1 About 650 B.C. From an Ionian city. *B.M.C.,* Pl. II, 1. (b) Silver stater of Corinth. Pegasus, below letter Q. Scale 2/1. About 625 B.C. *G.C.,* Pl. II, 20. (c) Silver four-drachma coin of Acanthus in Macedon. Lioness on bull. Scale 2/1. About 540 B.C. *G.C.,* Pl. VII, 8. (d) Silver two-drachma piece of Thasos. Satyr carrying nymph. Scale 2/1. About 550 B.C. *G.C.,* Pl. VI, 15. All in the British Museum.

Pl. 20 (a) Ornamental gold plaques with winged Artemis facing, between panther cubs. Scale 1/1. About 625 B.C. From Cameiros in Rhodes. In London. *B.M.J.,* Pl. XI, 1128. (b) Large bowl of solid gold inscribed with dedication by the family of Cypselos, despot of Corinth from 657 to 625 B.C. Diameter 6·7 in. Weight about 30 oz. From Olympia. In Boston. Photograph, Boston Museum.

Pl. 21 (a) Bronze head of a griffin from the rim of a bronze cauldron. Height 5·9 in. About 600 B.C. From Greece. Humfry Payne Collection. *G.A.,C.C.*, Pl. 30, 124. (b) Golden griffin's head, perhaps from the rim of a miniature cauldron. Height 1 in. About 600 B.C. Eastern Greek. In London. *B.M.J.*, Pl. XIV, 1234.

Pl. 22 Miniature gold plaques from a necklace, with figures of harpies, griffins, cocks, sphinxes, stags and flowers. Ionian work. Scale 2/1. About 550 B.C. From Anatolia. Leigh Ashton Collection. *G.A.,C.C.*, Pl. 73, 277.

Pl. 23 (a) Translucent sard scarab engraved with a sphinx, head reverted, seated on the head and rump of a bull. Ionian work. Scale 5/2. About 550 B.C. Probably from Chios. Charles Seltman Collection (formerly Southesk). *A.G.*, Pl. VI, 29. (b) Panel in repoussé silver with electrum additions. Two Amazons on horseback, a third below. Height 8·4 in. About 550 B.C. Found near Perugia. In London. Photograph, British Museum.

Pl. 24 Marble. Youthful athlete. About life-size. About 565 B.C. From Tenea, near Corinth. In Munich. Photograph, Munich Museum.

Pl. 25 Bronze. Hermes wearing conical winged hat and large winged boots, carrying in his arm a scraggy ram. Height 4·7 in. About 560 B.C. From Andritsaena in Arcadia. In Athens. *B.C.H.*, 1903, Pl. VII.

Pl. 26 (a) Bronze. Horseman wearing engraved helmet of Corinthian type. The reins and crest were probably added in silver. Height 9·9 in. About 540 B.C. From Grumentum in Lucania. In London. Photograph, British Museum. (b) Tondo from the interior of a Laconian cup by the Rider painter. Horseman with a volute headdress. Nike flies to crown him, five birds present. About 540 B.C. In London. *B.S.A.*, 34, Pl. 45b.

Pl. 27 Bronze. Young girl holding flower. Height 6·8 in. About 530 B.C. From Sparta. Formerly in Trau Collection, Vienna. *F.B.*, Pl. 45.

Pl. 28. Bronze. Young girl serving as a mirror-support. She has long plaits of hair and stands upon a tortoise. The paws of cats rest on her shoulders. Height 6 in. About 530 B.C. From Sparta. In Berlin. Photographs by courtesy of E. A. Lane, Esq.

Pl. 29 Bronze. A Spartan soldier wrapped in a cloak, wearing Corinthian helmet with double crest. Height 4·3 in. About 490 B.C. From Sparta. Morgan Collection, Wadsworth Atheneum, Hartford, Connecticut. Photograph, Wadsworth Atheneum.

Pl. 30 (a) Restored drawing of part of a main frieze on a vase. Herakles, his chariot behind him, has given a death-blow to a

	centaur. The target-headed bird is perhaps the centaur's soul. Decoration is orientalising. About 630 B.C. From Attica. In New York. *A.V.P.*, Pl. III, 1. (b) Panel from vase by the Nessos painter. Herakles killing Nessos. About 610 B.C. From Attica. In Athens. *Antike Denkmäler*, Pl. 57.
Pls. 31, 32, 33	Marble. Youthful athlete by the Master of the "Sounion" group. About life-size. About 615 B.C. From Attica. In New York. Photographs, Metropolitan Museum.
Pl. 34	Bronze. Youthful athlete with right arm raised. Height 5·3 in. About 600 B.C. From Andros. Collection of Captain Spencer-Churchill. *G.A.,C.C.*, Pl. 31.
Pl. 35	Marble. Bearded man wearing a cloak and carrying a calf. Rather under life-size. About 575 B.C. From the Acropolis. In Athens.
Pl. 36	(a) Silver four-drachma coin of Athens. Head of Athena in crested helmet. Reverse, owl, a sprig of olive, and part of the city's name. Scale 2/1. About 566 B.C. In Brussels. *G.C.*, Pl. III, 16. (b) Plaque, apparently of gold heavily alloyed with bronze. Nike in four-horse chariot, facing. Height 2·7 in. About 550 B.C. From the Acropolis. In Athens. *G.R.B.*, Pl. 42b. Photograph by courtesy of Dr. Winifred Lamb.
Pl. 37	Part of scene on a mixing bowl (the François vase), painted by Kleitias. About 560 B.C. Attic work from Etruria. In Florence. *F.R.*, Pl. I.
Pl. 38	(a) Panel from vase by Exekias. Castor and family. About 540 B.C. Attic work. In the Vatican. *F.R.*, Pl. 132. (b) Panel on vase by Exekias. Ajax fixing sword in ground and preparing to throw himself upon it. About 540 B.C. From Attica. In Boulogne. J. D. Beazley, *Attic Black-Figure*, Pl. 7.
Pls. 39, 40, 41	Marble. Horseman by "Rampin Master". About life-size. Just before 550 B.C. From the Acropolis. The head in Paris, the rest in Athens. Photographs from a cast.
Pl. 42	Marble. Horse. About half life-size. About 520 B.C. From the Acropolis. In Athens. Photograph by courtesy of G. M. Young, Esq.
Pls. 43, 44	Marble. Girl by the "Rampin Master". About two-thirds life-size. About 540 B.C. From the Acropolis. In Athens. Photographs by courtesy of G. M. Young, Esq.
Pls. 45, 46	Marble. Funeral monument in memory of Megakles and Gorgo. Total height of monument nearly 14 ft. About 540 B.C. From Attica. In New York. Photographs, Metropolitan Museum.
Pl. 47	Panels from both sides of a vase by the Andokides painter. Bathing girls and Amazons. About 530 B.C. From Attica. In Paris. Photographs, Giraudon. *A.V.P.*, Pl. 9b.

Pl. 48 (a) Drawing on dinner-plate by Epiktetos. Two revellers. About 520 B.C. From Attica. In London. (b) Plaque of bronze. The goddess Athena. Height 14 in. About 510 B.C. From Athens. In Athens.

Pl. 49 (a, b, c) Silver four-drachma coins of Athens (compare Pl. 36a). Scale 2/1. About 524, 520, and 512 B.C. In London and New York. G.C., Pl. IV, 6, 7, and Pl. V, 11.

Pl. 50 Marble. Girl in Ionic chiton. About life-size. About 510 B.C. From the Acropolis. In Athens. Photograph by courtesy of G. M. Young, Esq.

Pl. 51 (a) Translucent sard scarab engraved with kneeling Herakles. Attic work. Scale 5/2. About 510 B.C. Charles Seltman Collection (formerly Southesk). A.G., Pl. XV, 26. (b) Panel from a vase by Euthymides. Rape of Korone. About 510 B.C. From Attica. In Munich. F.R., Pl. 33.

Pl. 52 (a) Figures on vase by the Berlin painter. Hermes and Seilenos. About 500–490 B.C. From Attica. In Berlin. J. D. Beazley, Der Berliner Maler, Pl. 3. (b) Scene on a cup by the Brygos painter. Seilenoi in Olympus. About 485 B.C. From Attica. In London. F.R., Pl. 47.

Pl. 53 (a) Marble girl dedicated by Euthydikos. About two-thirds life-size. About 480 B.C. From the Acropolis. In Athens. (b) Silver ten-drachma coin of Athens. Scale 2/1. About 486 B.C. In Berlin.

Pl. 54 (a, b) Scenes on a cup by the Foundry painter. Work on bronze statue-making. About 475 B.C. From Attica. In Berlin. F.R., Pl. 135.

Pl. 55 (a) Silver ten-drachma piece of Syracuse, victorious chariot. Reverse, head of goddess and dolphins. 479 B.C. (b) Silver four-drachma piece of Aetna, head of Seilenos. Reverse, Zeus seated. About 470 B.C. (c) Silver four-drachma piece of Naxos, head of Dionysos. Reverse, Seilenos seated. About 460 B.C. (a) and (c) in London; (b) in Brussels. G.C., Pl. 14, 9; Pl. 25, 7, 9. All scale 2/1.

Pl. 56 (a) Bronze. Youthful athlete pouring libation. Height 7·9 in. About 460 B.C. From Aderno. In Syracuse. F.B., Pl. 89. (b) Black jasper scaraboid seal-stone signed "Anakles," reclining Seilenos. Scale 4/1. About 460 B.C. In New York. Photograph, Metropolitan Museum.

Pl. 57 Bronze. Statuette of horse, one of four from a chariot. Height 16·5 in. About 470 B.C. In New York. Photograph, Metropolitan Museum.

Pl. 58 Silver and electrum handle of a vase in the shape of a winged goat. Height 10·8 in. About 470 B.C. Greek work. From Persia. In Paris. Photograph, Giraudon.

Pl. 59 Bronze. Statue of Apollo. About half lite-size. About 490 B.C. Found at Piombino, Italy. In Paris. Photograph, Giraudon.

Pl. 60	(a) Head of the Apollo, Plate 59. (b) Bronze. Head of Apollo from a cult statue. Height 12·7 in. About 470 B.C. Found at Tamassos in Cyprus. In the Collection of the Duke of Devonshire at Chatsworth. *G.A.,C.C.*, Pl. 64.
Pl. 61	Head of Charioteer, Plate 62.
Pl. 62	Bronze. Charioteer. Life-size. About 476 B.C. From Delphi. In Delphi. *Delphes*, Pl. 151.
Pl. 63	(a) Bronze. Young girl wearing peplos and serving as a mirror-support. Height about 6 in. About 460 B.C. From Attica. In Copenhagen. Photograph, National Museum, Copenhagen. (b) Bronze. Girl spinning. Height 8·5 in. About 450 B.C. In Berlin.
Pl. 64	(a) Marble. River-god Kladeos from the angle of the east pediment of the Temple of Zeus at Olympia. About 460–455 B.C. *Ol. I.*, Pl. 29. (b) Marble. Woman kneeling from the west pediment of the same temple. *Ol. I*, Pl. 43.
Pl. 65	Marble. Lapith bride assaulted by centaur, from the west pediment of the same temple. *Ol. I*, Pl. 53.
Pl. 66	Marble. Apollo from the centre of the west pediment of the same temple. *Ol. I*, Pl. 62.
Pl. 67	Bronze. Boy pouring libation. Almost life-size. About 440 B.C. From Pesaro (found A.D. 1530). In Florence.
Pl. 68	Bronze. Girl. Height about 12 in. About 420 B.C. From Macedonia. In Munich.
Pl. 69	(a) Bronze. Head of a youthful athlete. Life-size. About 420 B.C. From Beneventum. In Paris. Photograph, Giraudon. (b) Marble. "Theseus" or "Dionysos". Over life-size. From the eastern gable of the Parthenon. From the Acropolis. In the British Museum.
Pl. 70	(a) Scene from a cup, the boy Herakles and his nurse, Geropso. By the Pistoxenos painter. About 470 B.C. From Attica. In Schwerin. *A.V.P.*, Pl. 29b. (b) Scene on a bobbin by the Penthesileia painter. Nike and boy athlete. About 470 B.C. From Attica. In New York. (c) Scene on a white-ground vase drawn by the Achilles painter. About 440 B.C. From Attica. In Athens. J. D. Beazley, *Attic Red-figure Vase Painters*, p. 643, 136.
Pl. 71	(a) Chalcedony scaraboid seal-stone, signed "Dexamenos made it". Flying heron. Scale 3/1. From Crimea. In Leningrad. (b) Another, unsigned. Standing heron. Scale 3/1. From Chalcidice. Collection of Count Chandon de Briailles. (c) Mottled jasper scaraboid seal-stone. Signed as (a). Portrait head. Scale 3/1. From Attica. In Boston, Museum of Fine Arts. All about 440 B.C. (a) and (c) are turned to show direction of the actual gem. (d) Sard sliced from scaraboid and mounted in gold ring. Bust of boy. About 410 B.C. Scale 3/1. From Macedonia. Formerly

Sir Arthur Evans Collection. (e) Silver drachma of Troizen. Head of Athena. About 460 B.C. Scale 2/1. Charles Seltman Collection. *G.C.*, Pl. 16, 8. (f) Silver two-drachma coin of Olympia. Eagle's head and white poplar leaf. Signed DA. . . . About 420 B.C. Scale 2/1. In Berlin. *G.C.*, Pl. 64, 6.

Pl. 72 (a) Silver two-drachma coin of Olympia. Running Nike. About 450 B.C. *G.C.*, Pl. 15, 8. (b, c, d, e) Silver four-drachma coins of Syracuse, (b) unsigned, (c) by Euthymos, (d) by Phrygillos, (e) by Euainetos. (f) Silver four-drachma coin of Catana signed by Herakleidas. All between 450 and 410 B.C. Scale 2/1. (c, d) in Lockett Collection; others in British Museum. *G.C.*, Pl. 22, 8, 11, 12; Pl. 26, 3.

Pl. 73 (a, b) Silver drinking-horn shaped as the head of a doe, and with figures in relief. Gilt and enamelled. Length 10·6 in. About 420 B.C. Found near Taranto (S. Italy). In Trieste. *Revue Archéol.*, 39, 1901, Pls. 16–18.

Pl. 74 (a) Silver two-drachma piece of Terina. About 420 B.C. (b) Silver ten-drachma coin of Syracuse signed by Kimon. About 400 B.C. (c) Silver two-drachma piece of Achaia in Peloponnese. About 366 B.C. (d) Silver drachma of Larissa in Thessaly. About 390 B.C. Scale 2/1. All in the British Museum. *Cf. G.C.*, Pls. 21, 4; 24, 1; 35, 15; 34, 11.

Pls. 75, 76 Marble. Hermes with the child Dionysos, by Praxiteles. Over life-size. About 343 B.C. Found at Olympia. In Olympia. *Ol. II*, Pls. 85, 90.

Pl. 77 Bronze mirror cover. Engraved. Diameter 7·3 in. About 380 B.C. From Corinth. In London. Photograph, British Museum.

Pl. 78 Another, similar. About 350 B.C. From Corinth. In Paris. Photograph, Giraudon.

Pl. 79 Gold Jewellery. (a) Pair of dolphin-headed earrings. Scale 3/2. About 350 B.C. (b) Bracelet. The snakes' eyes of garnet, they have uncut emeralds between their jaws. Scale 1/1. About 350 B.C. In Athens. (c) Figure of Eros. Scale 3/2. About 320 B.C. From Athens. (a) and (c) in Davis Collection, London. *G.A.,C.C.*, Pls. 75, 74.

Pl. 80 Marble. Ideal portrait of Agias. Life-size. About 330 B.C. From Delphi. In Delphi. *Delphes*, Pl. 187.

Pl. 81 Bronze. Head of portrait statue of Demetrius I, King of Syria 162 to 150 B.C. Life-size. From Rome. In Terme Museum, Rome. *A.P.*, Pl. 30.

Pl. 82 (a) Marble. Portrait head of Euthydemus, King of Bactria about 200 B.C. Life-size. From Ionia. In Museo Torlonia, Rome. *A.P.*, Pl. 29. (b) Marble. Portrait head by a Greek sculptor of Pompey the Great. About 50 B.C. Life-size. From Rome. In Copenhagen. *A.P.*, Pl. 32.

Pl. 83	Marble group. Laocoon and his sons, by Agesander, Polydorus and Athenodorus of Rhodes. About 25 B.C. Life-size. From Rome. In the Vatican.
Pl. 84	Marble. Nike on the prow of a warship, by Pythocritus of Rhodes. About 190 B.C. Gigantic. From Samothrace. In Paris. Photograph, Giraudon.
Pl. 85	Marble girl caryatid. About 270 B.C. Over life-size. From Tralles. In Constantinople. M. Schede, *Gr. u. röm. Skulpt. zu Konstantinopel*, Pl. 28.
Pl. 86	Marble. Boy in cloak. About 270 B.C. Life-size. From Tralles. In Constantinople. M. Schede, *op. cit.*, Pl. 15.
Pl. 87	(a) Bronze. Head of statue of Apollo. About 25 B.C. Three-quarter life-size. From Pompeii. In Naples. (b) Marble. Head of a goddess or girl. Life-size. About 25 B.C. In New York. Photograph, Metropolitan Museum.
Pl. 88	Bronze. Head of the statue of a boxer by Apollonius, son of Nestor of Athens. About 100 B.C. Life-size. In Terme Museum, Rome.
Pl. 89	Bronze. Statuette, a girl. The pupils of the eyes are diamonds. About A.D. 50. Height 6 in. In London. Photograph, British Museum.
Pl. 90	(a, b) Two silver dishes, each with a pair of lovers. About 250 B.C. Diameter, each 6·8 in. From Taranto. In Taranto. P. Wuilleumier, *Tarente*, Pl. 21.
Pl. 91	Sardonyx cameo of nine layers, Alexander the Great and Roxane. About 315 B.C. Height 4·5 in. Alexandrian work. In Vienna. *A.G.*, Pl. 53, 1.
Pl. 92	(a) Onyx cameo, Medusa. About 300 B.C. Scale 2/1. (b) Nicolo cameo, portrait of Mithridates VI, King of Pontus, 120–63 B.C. Scale 2/1. Both in the Jacqueline Chittenden Collection. *G.A.,C.C.*, Pl. 76. (c) Amethyst intaglio, portrait of Demosthenes. Signed by Dioskourides. About 25 B.C. Scale 3/1. Formerly Sir Arthur Evans Collection.
Pl. 93	Mosaic. After a painting by the late-fourth-century artist, Philoxenus of Eretria. About 100 B.C. From Pompeii. In Naples.
Pl. 94	Marble. Antinous as a god. About A.D. 135. Life-size. From Rome. In Naples.
Pl. 95	Small marble relief. Antinous as Silvanus. Signed by the artist Antonianos of Aphrodisias. About A.D. 135. Height 56·5 in. From Lanuvium. In Rome. *A.P.*, Pl. 44.
Pl. 96	(a) Black sard intaglio. Portrait of Antinous, signed by Anto(nianos). About A.D. 135. Scale 3/2. (b) Sardonyx cameo. Portrait of Julia Paula. A.D. 219. Scale 1/1. Both formerly Duke of Marlborough Collection. (c) Gold prize medal with bust of emperor Severus Alexander. Reverse, emperor between Roma and Nike. Scale 2/1. Struck about A.D. 230. From Tarsus. In Paris. Photograph, Bibliothèque Nationale.

Pl. 97 (a, b) Two gold prize medals with heads of Philip II of Macedon and Alexander the Great. Diameter 2·5 in. Struck about A.D. 230. Made in Alexandria. From Tarsus. In Bibliothèque Nationale, Paris. Photographs, Roubier.

Pl. 98 (a) Gold prize medal with head of Alexander the Great in lion-scalp. Diameter 2·5 in. Struck about A.D. 230. Made in Alexandria. From Tarsus. In Bibliothèque Nationale, Paris. Photograph, Roubier. (b) Centre of silver dish, head like (a). About A.D. 230. Scale 1/1. Alexandrian work. From Egypt. In Berlin.

Pls. 99, 100 Bronze. Portrait of Claudius II, Conqueror of the Goths, A.D. 268 to 270. Made in the reign of Constantine the Great, about A.D. 310. Life-size. In Munich. A.P., Pl. 52.

Pl. 101 Bronze. Gigantic statue of an emperor, probably Valentinian I, A.D. 364–375. In Barletta. Looted from Constantinople by Crusaders in 1204; salvaged from a shipwreck. The original hands and legs melted down by Charles of Anjou, 1226–1285, King of Naples and Sicily, to make a church-bell. Restored by Fabio Alfano in 1491. Photograph, F. Bruckmann.

Pl. 102 Portraits in gold leaf on glass. (a) A mother and two children, signed by Bounneris. Diameter 4 in. About A.D. 230. In Brescia. Photograph, Aréthuse. (b) A man. Diameter 2·7 in. About A.D. 240. In the Vatican. Photograph, Vatican Museum.

Pl. 103 (a) Gold medal of Diocletian A.D. 284–305, struck at Ticinum (Pavia). Scale 2/1. About A.D. 295. In Vienna. (b) Silver medal of Constantine the Great, A.D. 306–337. Struck in Constantinople about A.D. 330. Reverse, enthroned goddess personifying the city of Constantinople. Scale 2/1. In Milan.

Pl. 104 Ivory leaf, one-half of a diptych. A girl putting incense on an altar. Height 11·7 in. A.D. 392 or 400. Made in Alexandria. In London. V. & A.I., frontispiece. Photograph, Victoria and Albert Museum.

Pls. 105, 106 Silver tray. In the centre Okeanos, four dolphins in hair and beard; compare dolphins on Pls. 3 and 55a; zone of ocean nymphs, tritons, sea-monsters. Main zone, Dionysos, Pan, maenads, satyrs. Weight 18 lb. Diameter 27 in. About A.D. 340. Made in Alexandria. Found 1942 at Mildenhall, Suffolk. Photographs, British Museum.

Pl. 107 (a) Bronze disk made from worn coin of Nero. The reverse a chariot inlaid in gold, silver and niello. Scale 5/2. About A.D. 350. Formerly wrongly attributed to the first century. Charles Seltman Collection. (b) Gold medallion in heavy contemporary gold triple frame. The Empress Galla Placidia. Scale 2/1. Made A.D. 423. In Bibliothèque Nationale, Paris.

| Pl. 108 | Ivory casket with traces of gilding. (a) On the front Helen, Paris, Bellerophon, Pegasus, Goddess of Corinth, and Iphigeneia decked for sacrifice. (b) On the back, Aphrodite, Ares, Europa on bull, children with a mare. Length of box 15·8 in. About A.D. 850–950. Made in Constantinople. In London. *V. & A.I.*, Pl. 12. Photographs, Victoria and Albert Museum. |

SUPPLEMENTARY

Pl. I	Painting in oils on aluminium by Uzelac. Formerly in London. See p. 86.
Pl. II	(a) A sibyl. Painting made about 1510 by Michelangelo on the ceiling of the Sistine Chapel in the Vatican. (b) Engraving of the same made in 1540 by Giorgio of Mantua. (c) Engraving of the same, late eighteenth century, by Tomaso Piroli. See p. 87 f.
Pl. III	Canvas by Domenikos Theotokopoulos (El Greco), painted about 1606. Laocoon. Photograph, Munich. See p. 97.

VIGNETTES

Page 11	A coppersmith riveting a handle on to a large bronze jar. Engraving on a prism-seal from Pedhiadha (central Crete). About 2000 B.C.
Page 24	A geometric bronze tripod, about 800 B.C., from Olympia. In Olympia.
Page 33	Apollo with lyre and flower on a silver two-drachma coin of Tarentum of about 530 B.C. In Berlin.
Page 42	Owl on the reverse of a silver four-drachma coin of Athens struck about 500 B.C. In Berlin.
Page 53	Nymph and Seilenos, from a wine-cup by the Sotades painter. About 460 B.C. Formerly in Castle Goluchow, Poland.
Page 65	Under-sketch drawn with a point on the surface of a large vase by a painter in the group of Polygnotos. About 450 B.C.
Page 76	Apollo on a four-drachma coin of Amphipolis. About 380 B.C. In Berlin.
Page 87	Head of Alexander the Great, diademed, a ram's horn springing from his temple. On a silver four-drachma coin struck by King Lysimachus. About 300 B.C. In Berlin.
Page 94	An African elephant, on the back of which a man is sitting, after a silver four-drachma coin issued by a Hellenised North-African Prince. About 200 B.C.
Page 110	Drawing, about A.D. 1750, by George Ogle. The Three Graces. Design after a late Hellenistic statue-group or coin.

INDEX

i

iv

PLATES

a

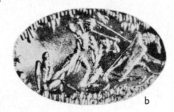

b

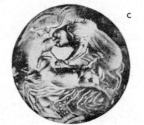

c

PLATE .I

Minoan art: (a) Bronze double-axe engraved with lion recumbent on rocky ground. From Crete; about 1550 B.C. (b) Intaglio bezel of a gold ring; a King, in tasselled cap and armed with dagger, in battle with three foes: about 1650 B.C. from Mycenae. (c) Large dark agate intaglio engraved with lion on the back of a plunging bull: from the Royal Tomb at Dendra: about 1500 B.C., and found with the cups on Pls. 3, 4. Minoan art: (d) Dagger blade, bronze inlaid with gold, silver and alloy; one of three galloping lions; from Mycenae: about 1550 B.C.

d

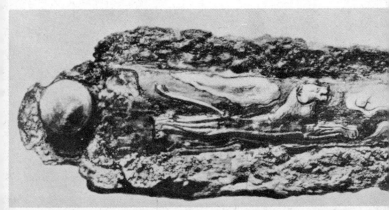

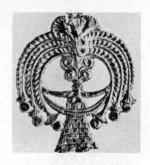

b

PLATE 2

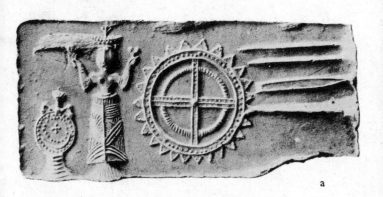

a

(a) *Stone matrix in which are cut intaglio moulds for the making of embossed metal objects. From Crete: about 1600 B.C. (b, c) Two gold ornaments, embossed and chased, made from moulds similar to (a). Both from Mycenae: about 1550 B.C.*

c

PLATE 3

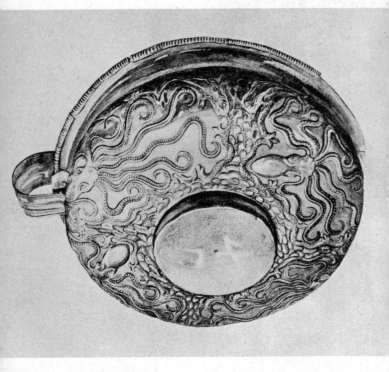

Minoan Gold Cup embossed and chased: four octopods among rocks, seaweed and diving dolphins. There is an inner lining of smooth gold. From the Royal Tomb at Dendra: about 1500 B.C.

PLATE 4

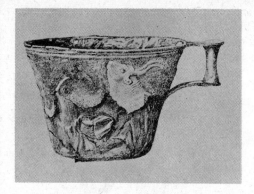

a

Minoan cup of silver and gold. The outer embossed and
chased portion with galloping bulls is of silver, and the smooth
inner lining is gold. From the Royal Tomb at Dendra:
about 1500 B.C.

b

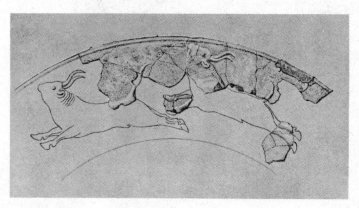

PLATES 5 & 6

Minoan ivory figure 6·3 inches high, ornamented with gold. This is the famous Boston "Goddess" who may be a young priestess with a pair of sacred snakes. From Crete: about 1550 B.C. This and the two following figures are the earliest examples, from Greek lands, of gold and ivory used together for statues.

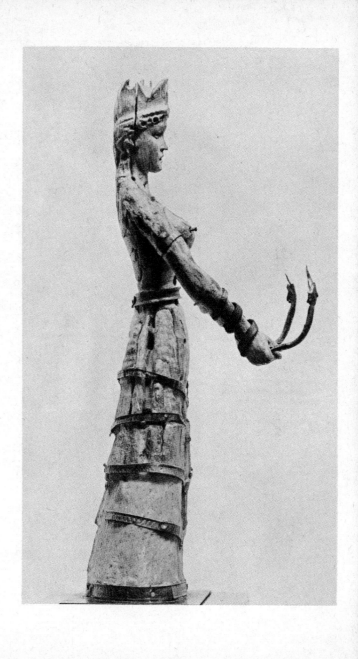

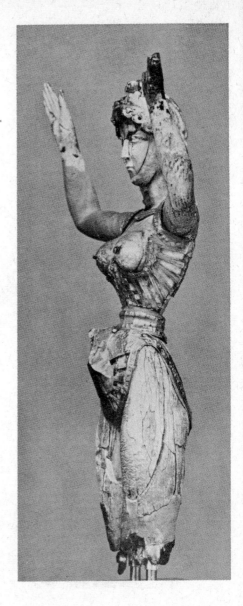

PLATES 7 & 8

Minoan ivory figure 7 inches high ornamented with gold. The right arm is restored but the right hand is ancient. Collar, nipples, corsage and apron are of gold. A girl Toreador from Crete: about 1550 B.C.

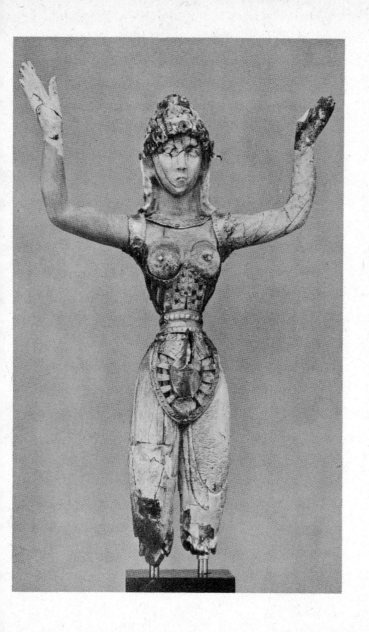

PLATE 9

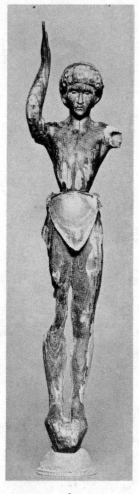

a

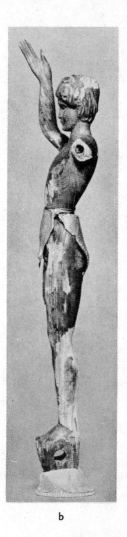

b

Minoan ivory figure, 5·2 inches high. A boy Toreador with a golden loin-cloth. From Crete: about 1550 B.C.

PLATE 10

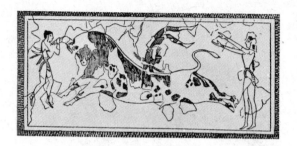

a

Minoan art: (a) Drawing of a fragmentary fresco from the Palace of Knossos. Athletes in the Bull-ring: about 1550 B.C. (b) Bronze group. Toreador somersaulting over bull. From Crete: about 1600 B.C.

b

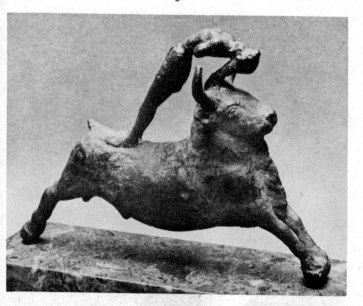

PLATE 11

Minoan painting. Fresco from Southern Crete. A cat on rocky ground stalking a bird, perhaps a pheasant. About 1600 B.C.

a

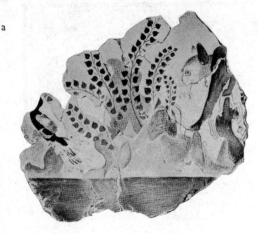

Minoan painting. Fresco from Melos. Flying fish, shells and sponges; a study in blues, whites and yellows. About 1600 B.C.

b

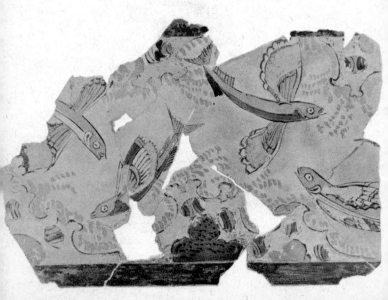

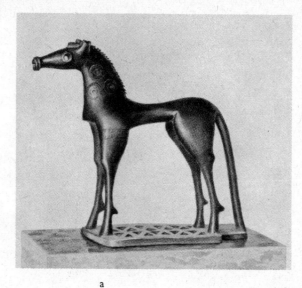

a

PLATE 12

Geometric bronze horse, complete but for ear-tips: eyes perhaps of amber were once inserted. Openwork bronze stand.

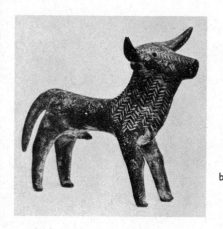

b

Geometric bronze bull, remarkably lively for so simple a carving. Both from Olympia: both about 800 B.C.

PLATE 13

Geometric ivory brooch of spectacle
shape. In the drawing it is restored and
the amber beads, now only fragments, are
added. From Sparta: about 820 B.C.

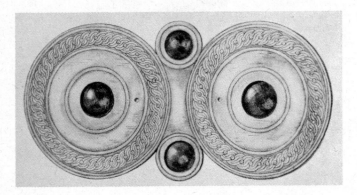

a

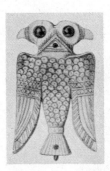

b

Another, shaped as a double-
headed hawk with amber eyes
(restored). From Sparta: about
820 B.C.

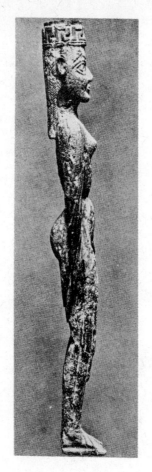 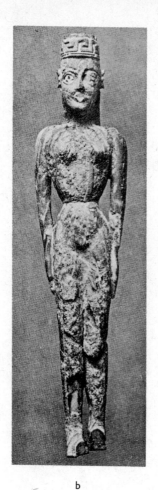

<div align="center">a b</div>

<div align="center">PLATE 14</div>

*Geometric ivory figure of a girl, 6 inches high, wearing a drum-like
cap with meander pattern. From a tomb in Attica: about 820 B.C.*

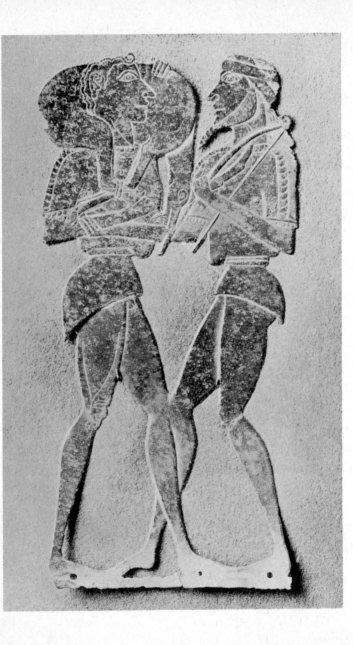

PLATE 15

Opposite: Cretan bronze sheet, cut out and engraved with two hunters, one of whom carries a trussed ibex. 7·3 inches high. From Crete: about 700 B.C.

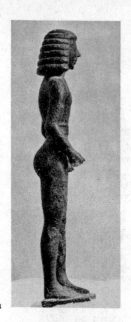

a

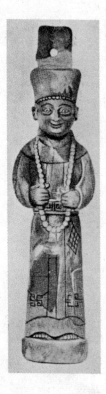

c

PLATE 16

(a, b) Bronze youth from Delphi: about 650 B.C. Height 7·8 inches. (c) Ivory Eunuch priest, 4·4 inches high, on his robe are patterns common on Greek geometric pottery, round neck a rosary. From Ephesus: about 650 B.C.

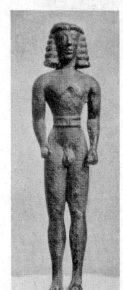

b

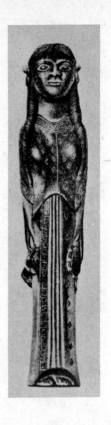
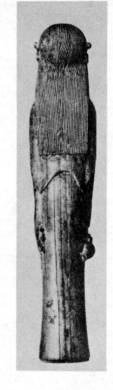

PLATE 17

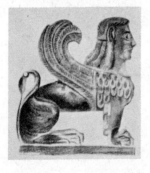

Ivories from Ephesus. (a, b) A girl priestess, 3·8 inches high, in geometric patterned robe. (c) Sphinx with curled wings and feather-pattern on chest. Height 1·8 inches. Both about 650 B.C.

a

b

c

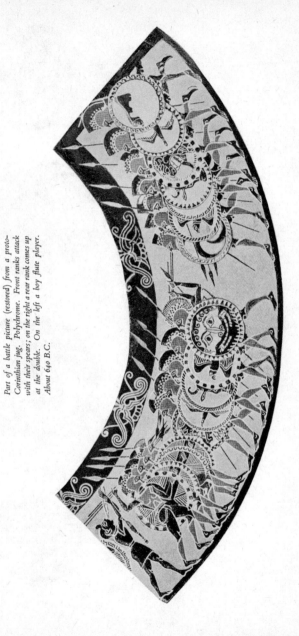

PLATE 18

Part of a battle picture (restored) from a proto-Corinthian jug. Polychrome. Front ranks attack with their spears; on the right a rear rank comes up at the double. On the left a boy flute player. About 640 B.C.

PLATE 19

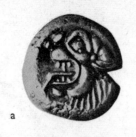

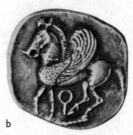

Early Greek coins. (a) Ionia.
White gold. Head of a laughing
or roaring lion: about 650 B.C.
(b) Corinth. Silver. Pegasus and
letter Q: about 625 B.C. (c)
Acanthus. Silver. Lioness on bull:
about 540 B.C. (d) Thasos.
Silver. Satyr carrying off a nymph:
about 550 B.C. All scale 2/1.

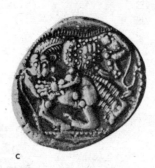

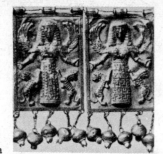

PLATE 20

(a) Gold plaques: on each, winged Artemis between panther-cubs. From Rhodes: about 625 B.C. (b) Large bowl of solid gold dedicated by family of Cypselus, despot of Corinth from 657 to 625 B.C. From Olympia. Weight 30 ounces.

a

b

PLATE 21

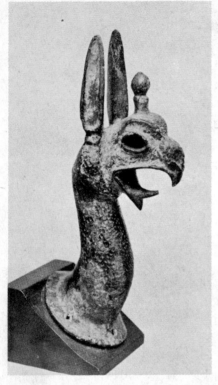

a

b

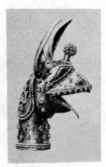

Heads of Griffins. (a) Bronze, height 5·9 inches. From Greece: about 600 B.C. (b) Gold, height 1 inch, Eastern Greek: about 600 B.C. Both may have been attached to the rims of cauldrons.

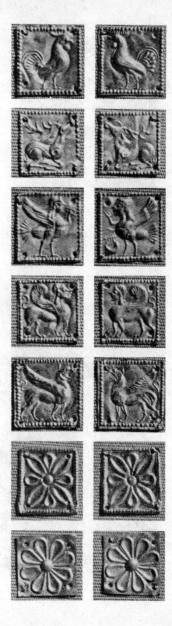

Miniature plaques of gold from a necklace with figures of cocks, stags, harpies, sphinxes, griffins and flowers. Scale 2/1. Ionian work from Anatolia: about 550 B.C.

PLATE 22

(a) *Translucent sard scarab, scale 5/2, engraved with sphinx on bull. Ionian work: about 550 B.C.* (b) *Panel in répousé silver with white gold additions. Height 8·4 inches. Two amazons on horseback, a third below. Ionian work: about 550 B.C.*

a

PLATE 23

b

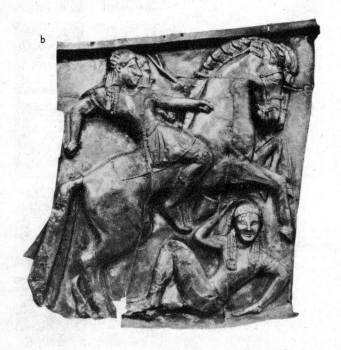

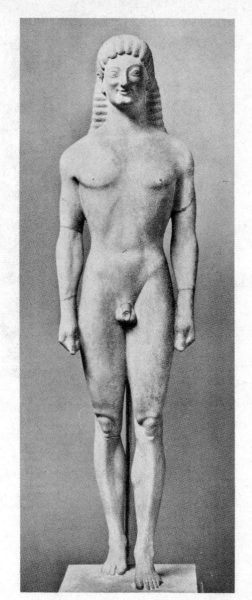

PLATE 24

Marble youth, about life-size. From Tenea near Corinth: about 565 B.C.

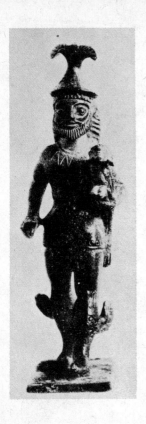

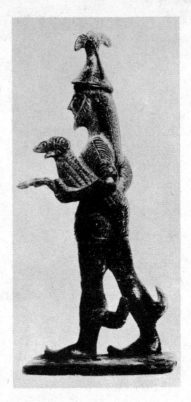

PLATE 25

Spartan bronzes. *Hermes wearing conical winged hat and large winged boots, carrying a ram. Height 4·7 inches. From Arcadia: about 560 B.C. Opposite: (a) Horseman wearing engraved helmet of Corinthian type. Height 9·9 inches. From Lucania: about 540 B.C. (b) For comparison with the bronze: the interior of a Laconian cup by the Rider painter: about 540 B.C.*

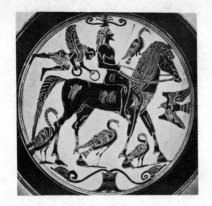

PLATE 26

b

a

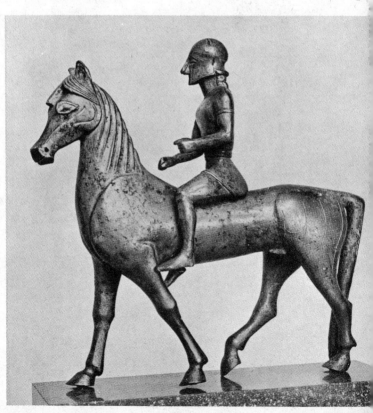

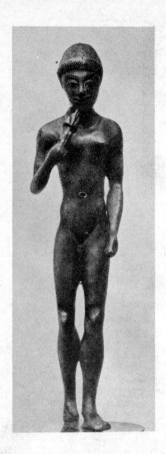

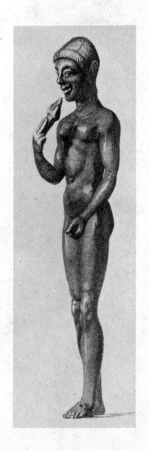

Spartan bronze. Young girl holding a flower. Height 6·8 inches. From Sparta: about 530 B.C.

PLATE 27

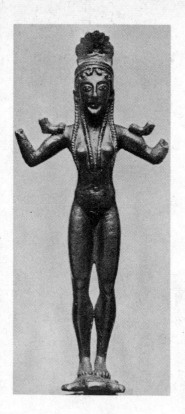

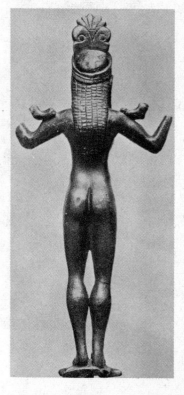

PLATE 28

Spartan bronze. Young girl, serving as a mirror support. She stands on a tortoise, the paws of cats rest on her shoulders. Height 6 inches. From Sparta: about 530 B.C.

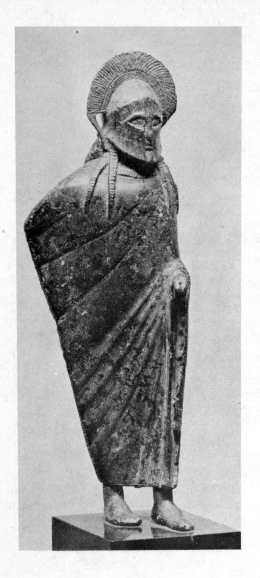

PLATE 29

Bronze: A Spartan Soldier wrapped in a cloak and wearing a Corinthian helmet with double crest. Height 4·3 inches. From Sparta: about 490 B.C.

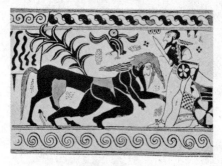

a

Two scenes from Athenian vases (both restored): (a) Herakles, his chariot behind him, has given a death-blow to a centaur. The target-headed bird is perhaps the centaur's soul. Decoration is orientalising. (b) From a vase by the Nessos painter. Herakles killing Nessos. The first about 630, the second about 610 B.C.

b

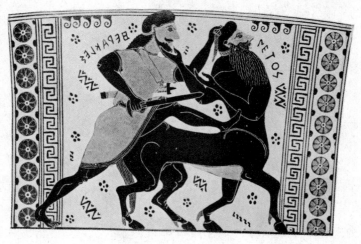

PLATE 30

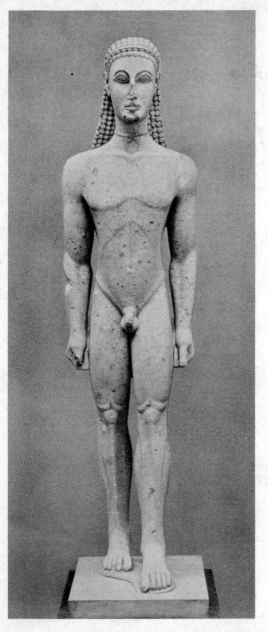

PLATE 31

Marble youth, about life-size, by the Master of the "Sounion" group. Attic work: about 615 B.C.

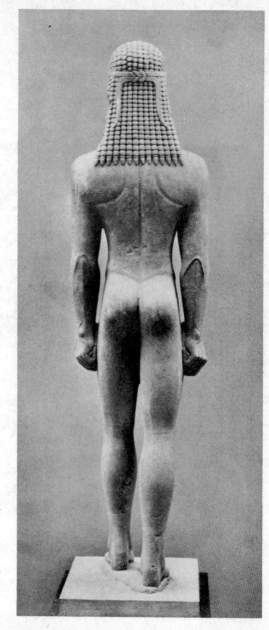

PLATE 32

The same figure, back view. Everything about this admirable figure shows it to be the work of a man trained to carve ivory and experimenting in marble.

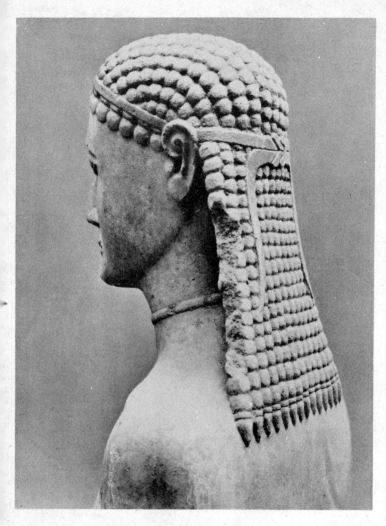

PLATES 33 & 34

Above: Head of the marble youth on Plates 31, 32, now in New York. The odd-angle view of an early figure can please.

Opposite: A bronze figure, 5·3 inches high, related to the New York youth. The model, from which was made the mould to cast this bronze, was of wood, hence kinship with the ivory-like statue on Plate 31.

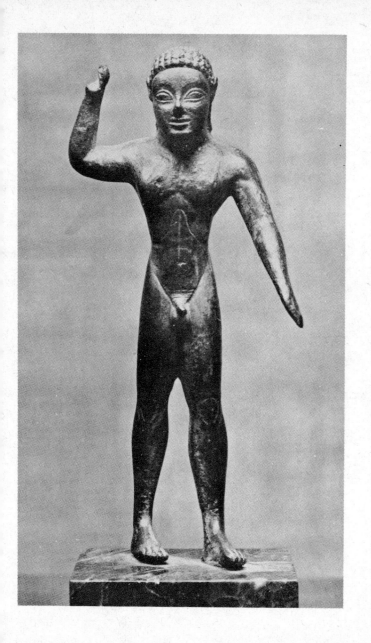

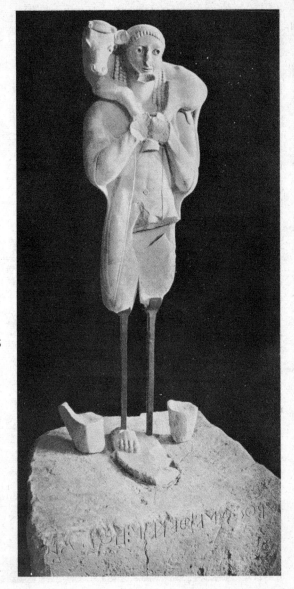

PLATE 35

PLATE 36

(a) *Silver coin, enlarged 2/1, of Athens: 566 B.C. Helmeted head of Athena and owl.* (b) *A plaque, apparently of gold heavily alloyed with bronze. Nike in a four-horse chariot facing. Height 2·7 inches. In Athens: about 550 B.C.*

Opposite: Marble statue, slightly under life-size, ivory-like in quality of carving; a bearded man wearing a cloak and carrying a calf. On its base is an inscription to say it was dedicated by Rhombos. Attic work, on the Acropolis: about 575 B.C.

a

b

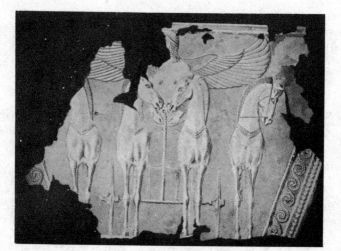

a

PLATE 37

Scenes from the main frieze of a big mixing-bowl painted by Kleitias about 560 B.C. with guests arriving at a wedding. Right to left above: Peleus, Chiron, Iris, Hestia, Chariclo, Dionysos. Below: The Hours, Calliope, Urania, Zeus and Hera.

b

a

PLATE 38

*Two panels on vases painted by Exekias: about 540 B.C.
(a) Left to right: Polydeukes and dog, Leda, Kastor off for
a ride, little boy with chair, oil flask and towel, Tyndareos
patting horse. (b) Ajax, his face furrowed with grief,
fixes his sword preparing to throw himself upon it.*

b

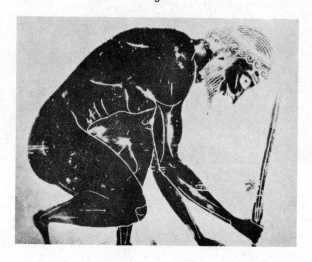

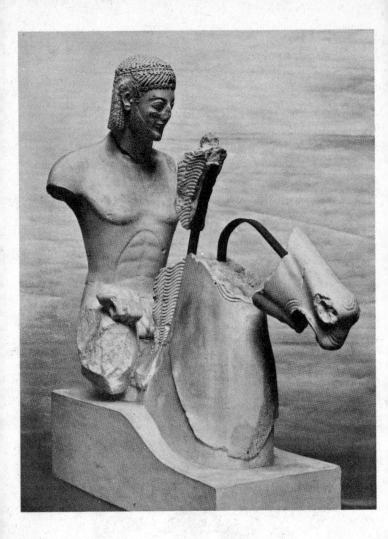

PLATE 39 *Marble horseman, about life-size, by the "Rampin Master", made just before 550 B.C. Here the ivory technique is applied to marble with a success that is complete. He is neither upright nor frontal like most contemporary figures. The head is in Paris, the rest in Athens.*

PLATE 40

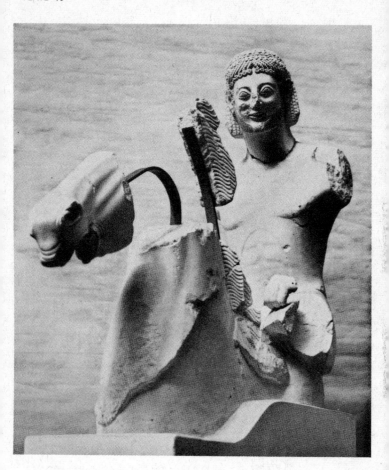

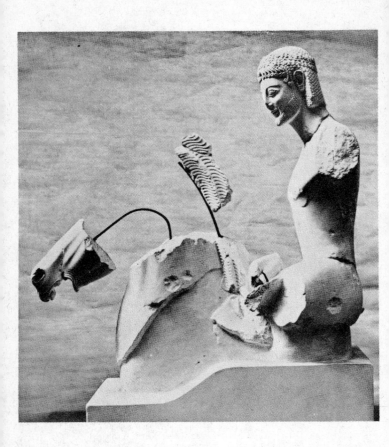

PLATE 41 *The profile of the horseman, made in Athens before 550*
B.C. by the "Rampin Master", shows well the putting
together of the scattered fragments to make the cast in
Cambridge.

PLATE 42

Head of marble horse, about half life-size, from the Acropolis in Athens,
made about 520 B.C. This glorious horse, like an ivory chess-board
knight, can help you to reconstruct the "Rampin Master's" horse.

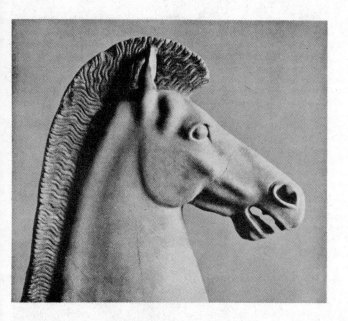

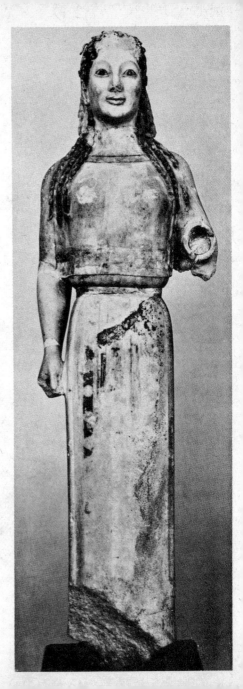

PLATE 43

Marble girl in Athens made by the "Rampin Master" about 540 B.C. She is about two-thirds life-size. Remains of colour upon the marble's ivory surface add to her charm.

PLATE 44

*Head and shoulders of the same girl. "In all Greek sculpture,"
wrote Humfry Payne, "there is no figure more intensely and
nervously alive. The sculptor was, indeed, one of the great
masters of his time . . . with a dexterity which would seem
miraculous in any artist but a Greek."*

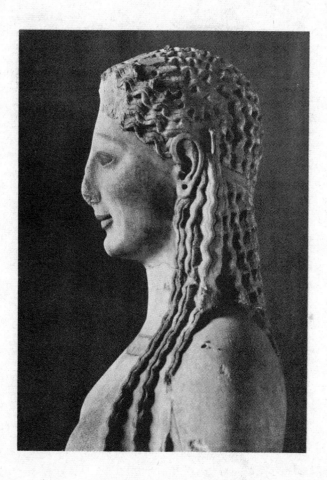

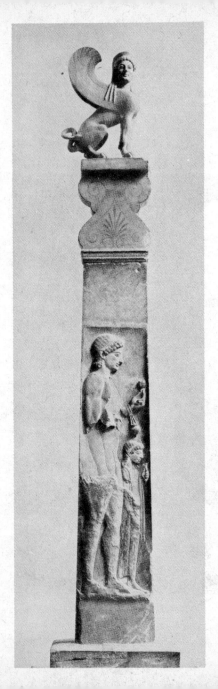

PLATE 45

Marble funeral monument made in Athens about 540 B.C. for a brother and sister, Megakles and Gorgo, by the "Sphinx Master". Here is, perhaps, the most tasteful tombstone in the world, for all the proportions appear right.

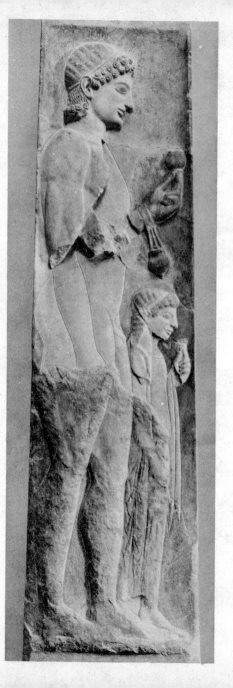

PLATE 46

A detail of Plate 45. The figures of Megakles and Gorgo carved in low relief look like the panel of an ivory casket. Stain and wax on the flesh, gay colours for hair, eyes, lips, garment and other details increased the charm.

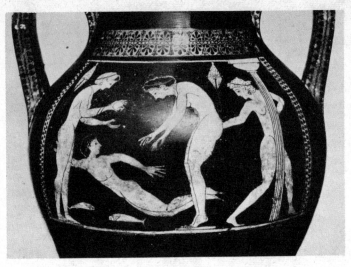

PLATE 47

*Both sides of an Attic vase by the Andokides painter about 530 B.C.
Naked bathing girls, fish, Amazons and a horse, all in white against a
black ground. This "light against dark" technique was the origin
of the red-figure manner.*

a

b

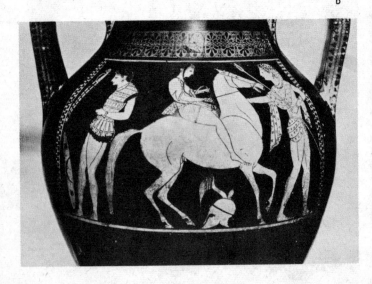

PLATE 48

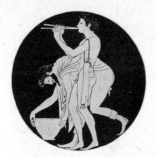

a

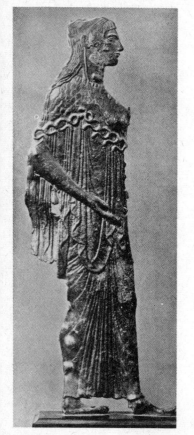

b

(a) *Figures on an Attic dinner-plate by Epiktetos I. Red figure: about 520 B.C. A bearded, cloaked and booted reveller stoops to raise a large bowl of wine. A boy plays double-flutes.* (b) *Fine thin plaque of bronze, 14 inches high. Athena wore a helmet (as on the coin, Plate 49c, but without a neckpiece), the scaly, snake-fringed aegis covers her shoulders, her garment is like that of the marble girl on Plate 50. From Athens: about 510 B.C.*

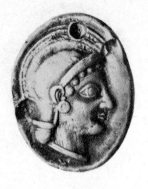

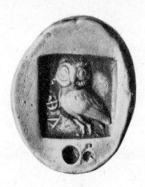

a

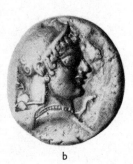

PLATE 49

Silver four-drachma coins of Athens. Scale 2/1. (a) About 524 B.C.; Athena has a splendid crested helmet: the "little owl" is very fine. (b) About 520 B.C.; the goddess has a helmet with tall crest (missing from the coin); before her chin is a snake from her aegis. (c) About 512 B.C.; both sides of this splendidly designed coin are the work of a gifted celator.

b

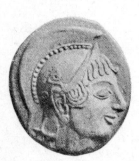

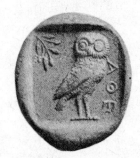

c

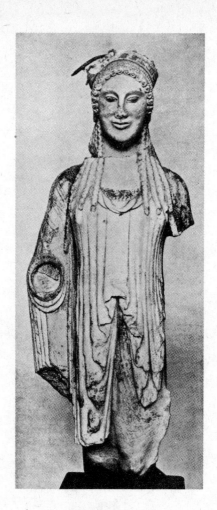

PLATE 50

Marble girl in Athens wearing an Ionic chiton with elaborate folds. Life-size, made about 510 B.C. Tight little curls and elaborate strands of hair are paralleled on coins and on Plate 48b—the bronze plaque. The technique is still ivory-like.

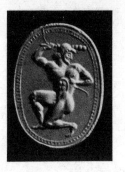

a

PLATE 51

*Translucent sard scarab. Scale 5/2. About 510 B.C.
Kneeling Herakles to be compared with the figure on the
left of (b): panel from Attic vase painted by Euthymides
about 510 B.C. Theseus carries off Korone whom Helen
tries to rescue: Peirithous follows.*

b

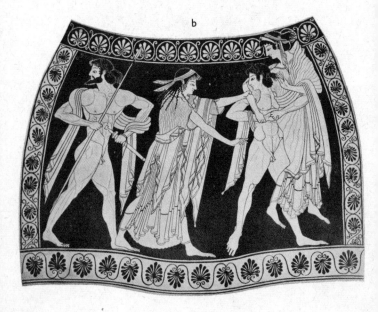

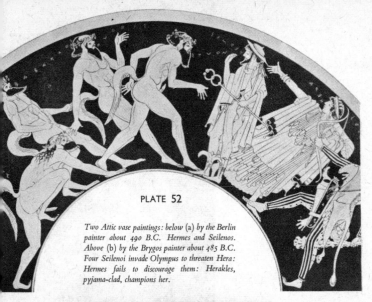

PLATE 52

Two Attic vase paintings: below (a) by the Berlin painter about 490 B.C. Hermes and Seilenos. Above (b) by the Brygos painter about 485 B.C. Four Seilenoi invade Olympus to threaten Hera: Hermes fails to discourage them: Herakles, pyjama-clad, champions her.

b

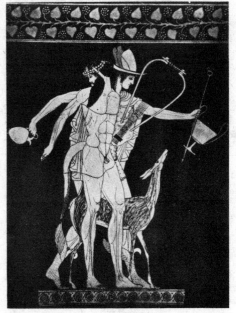

a

PLATE 53

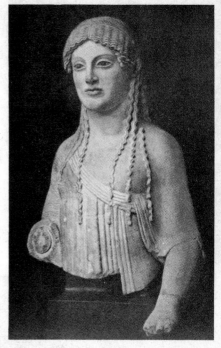

a

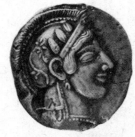

b

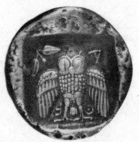

(a) *Marble girl dedicated by Euthydikos, about 2/3 life-size, made about 480 B.C., elegant and still ivory-like; but after this you no longer find marble treated with that delicacy which a celator always applied to ivory.* (b) *Silver ten-drachma coin of Athens, minted 486 B.C. Scale 2/1. Head of Athena, three olive-leaves on helmet. On the reverse a "little owl" flapping its wings, facing; an olive twig above left: all in a hollow square.*

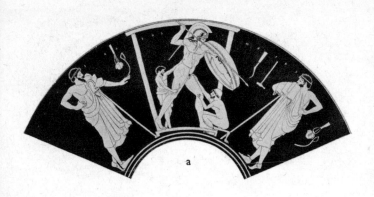

a

PLATE 54

Scenes painted on a cup by the Foundry painter, about 475 B.C. (a) Above: two workmen finish off a large bronze statue while the owners look on. (b) Below: the same two workmen are in the foundry; a handsome youth named "Diogenes" toys with a hammer while he watches operations.

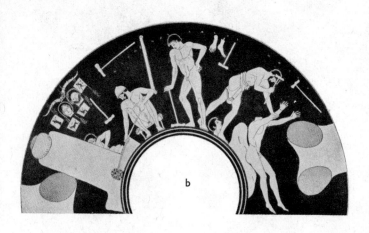

b

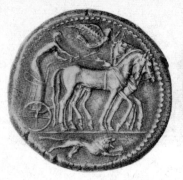

a

PLATE 55

b

Silver coins. Scale 2/1. (a) Ten-drachma piece of Syracuse. Victorious chariot: head of goddess olive-wreathed, and dolphins: 479 B.C. (b) Four-drachma piece of Aetna. Head of Seilenos and Zeus seated: 470 B.C. (c) Another of Naxos. Dionysos and Seilenos squatting. about 460 B.C.

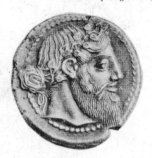
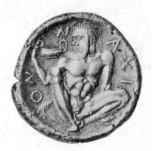

c

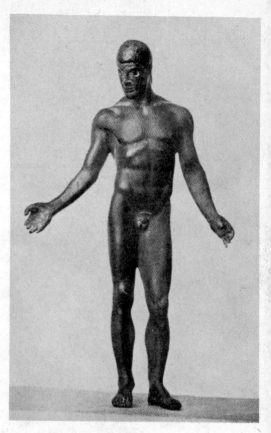

PLATE 56

a

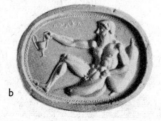

b

(a) *Bronze: youthful athlete, 7·9 inches high, who once held a bowl for libation; about 460 B.C.* (b) *Black jasper seal-stone, scale 4/1, signed by Anakles. Reclining Seilenos (compare Plate 55c): about 460 B.C. All these five works are part of a panhellenic art movement following on the victory over Persia.*

PLATE 58

Opposite: a winged goat made of silver and white gold, 10·8 inches high, hind hooves rest on palmette and head of a Greek Seilenos: about 470 B.C. From Persia. Work of a Greek artist of whom many were captives or exiles in the Persian Empire.

PLATE 57

Bronze. Statuette of a horse, 16·5 inches high, with hogged mane; one of four horses from a chariot group: about 470 B.C. Compare other horses, especially Plates 36b, 39 to 42, and 55a.

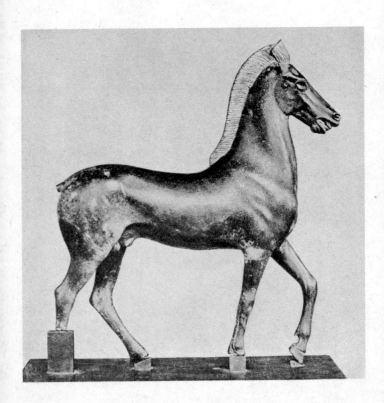

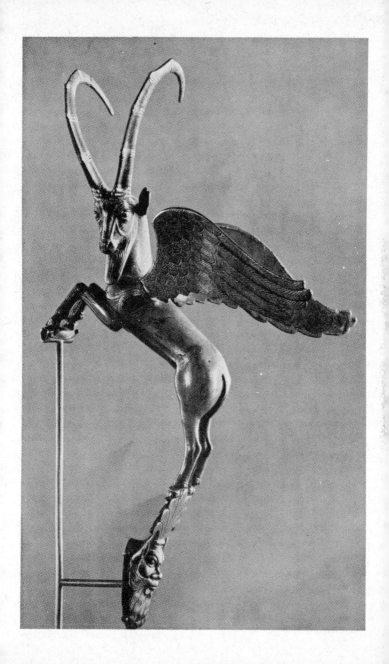

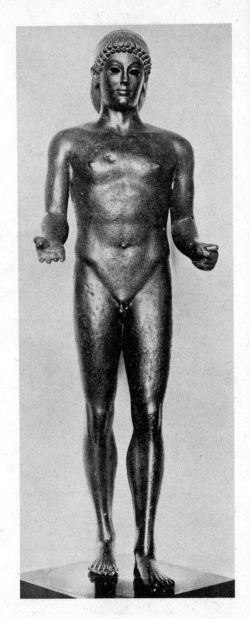

PLATE 59

Bronze: Apollo, hollow cast, about half life-size; lips and nipples of copper. He probably held a bowl in his right and a bow in his left hand. About 490 B.C.

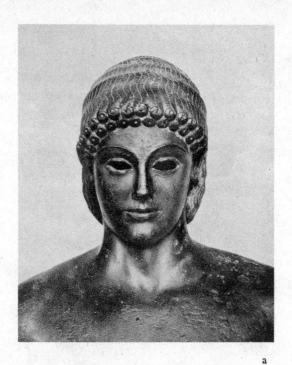

a

PLATE 60

(a) *Head of statue on Plate 59.* (b) *Bronze head of Apollo, height 12·7 inches, from a cult statue found at Tamassos in Cyprus. Probably Attic work of about 470 B.C.*

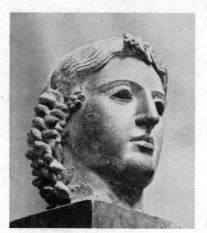

b

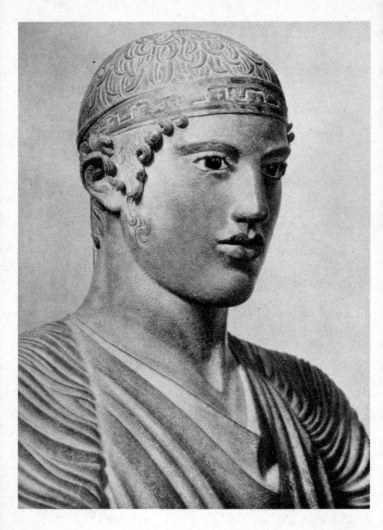

PLATE 61

Bronze: Charioteer, life-size; eyelashes of bronze, eyes of onyx and enamel, lips inlaid with copper, silver damascening on diadem. Dedicated in 476 B.C. at Delphi by Polyzalos. The figure originally stood in a chariot drawn by four bronze horses, which resembled the horse on Plate 57.

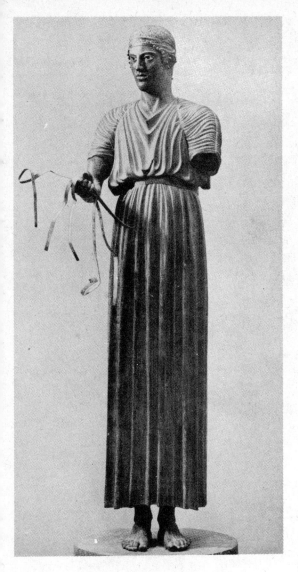

PLATE 62

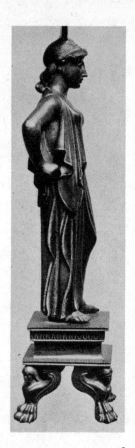

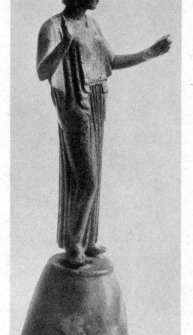

Opposite: two marble figures by the Olympia master, from the Temple of Zeus. (a) From east gable, figure of river-god, Kladeos. (b) From west gable, Lapith girl pulled to her knees by centaur whose hand holds her hair. The patterns for such marbles as these were carved in wood: about 460 B.C.

a

PLATE 63

Bronze figures of young girls: (a) wearing doric peplos. She is a mirror-support. Height about 6 inches. Date about 460 B.C. (b) Girl in the act of spinning; also wearing doric peplos. Height 8·5 inches. About 450 B.C.

b

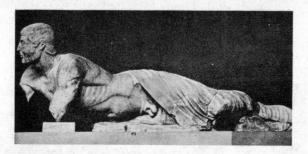

a

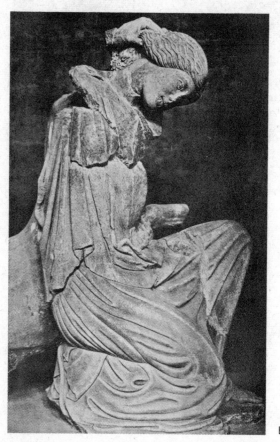

PLATE 64

b

PLATE 65

Marble group by the Olympia master from western gable of Temple of Zeus. The king of the Centaurs seizes the Bride. She seems like some dryad carved from a living tree. About 460 B.C.

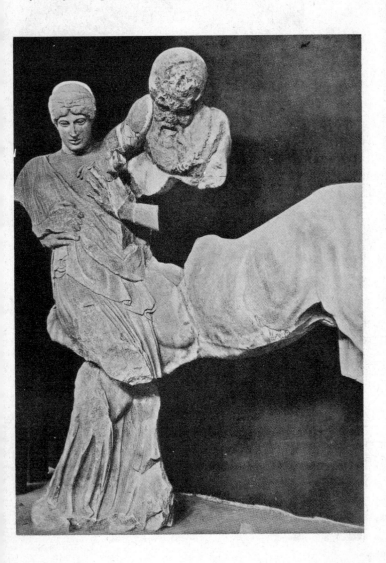

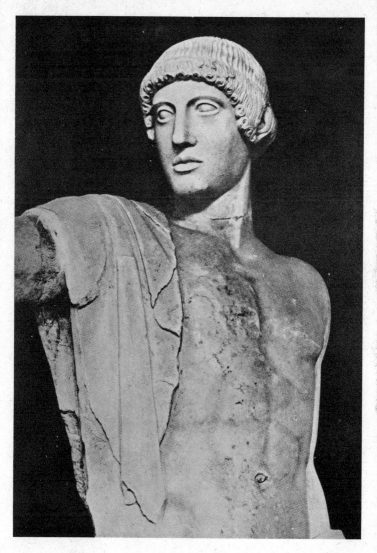

PLATE 66 *Apollo, central figure of the western gable of the Temple of Zeus at Olympia, his right arm stretched to quell the turmoil. The effect of tranquil divinity is overwhelming. Marble: about 460 B.C.*

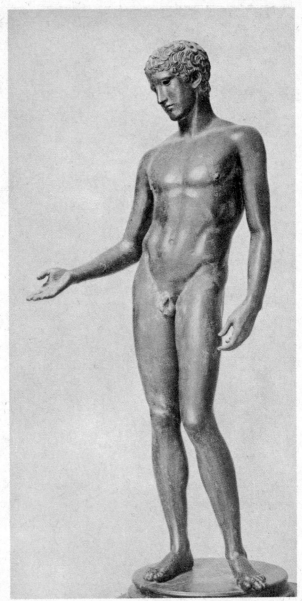

PLATE 67

PLATE 68

Bronze girl, a heavy scarf tied round her head. Height about 12 inches. From Macedonia: about 420 B.C.

Opposite: bronze boy pouring a libation. Almost life-size. Found A.D. 1530 at Pesaro; known as the "Idolino". About 440 B.C.

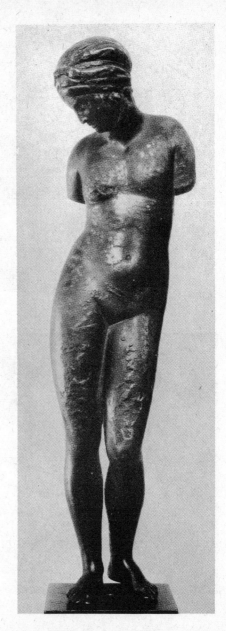

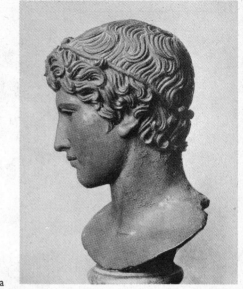

PLATE 69

(a) *Bronze. Head of young athlete, life-size. From Beneventum: about 440 B.C.* (b) *Marble figure from the east gable of the Parthenon in Athens. Over life-size. Known as "Theseus" or "Dionysos". The Parthenon was completed in 432 B.C.*

a

b

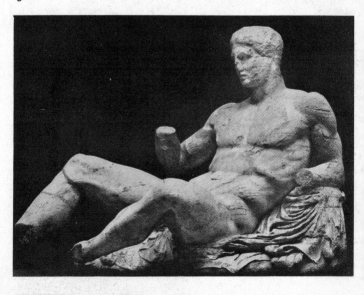

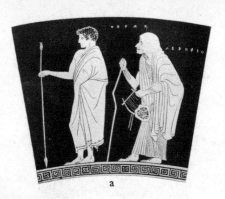

a

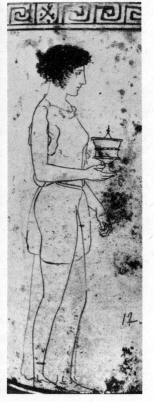

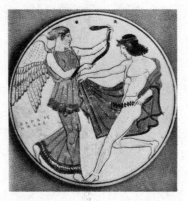

b

PLATE 70

Paintings on Attic vases: (a) from a cup by the Pistoxenos painter: the boy Herakles and his nurse, Geropso: about 470 B.C. (b) On a clay bobbin by the Penthesileia painter: Nike and boy athlete: about 470 B.C. (c) On a white vase drawn by the Achilles painter: girl with jar of ointment: about 440 B.C.

c

PLATE 71

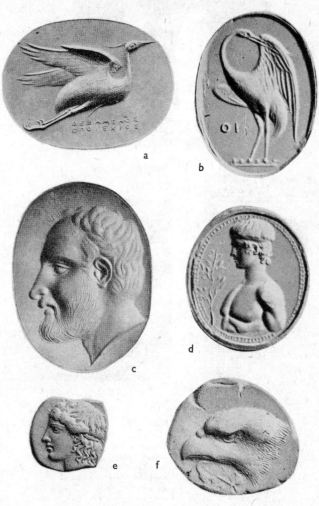

Four sealstones and two coins. (a, b. c) By Dexamenos of Chios. Herons and a portrait head: all about 440 B.C. (d) Sard sliced from scaraboid and mounted. Boy with laurel branch. (e) Silver coin, drachma of Troizen. Head of Athena: about 460 B.C. (f) Two-drachma coin of Olympia signed by engraver Da—— Eagle's head and white poplar leaf. 420 B.C. Scale of stones 3/1; of coins 2/1.

PLATE 72

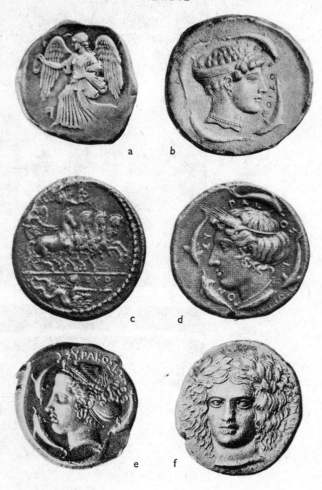

Silver coins: all scale 2/1. (a) Two-drachma piece of Olympia: running Nike: about 450 B.C. (b–e) Four-drachma coins of Syracuse with heads of a goddess, and one with a chariot; (b) about 450 B.C., (c) by Euthymos, (d) by Phrygillos, (e) by Euainetos. (f) Four-drachma piece of Catana by Herakleidas: all about 415 B.C.

PLATE 73

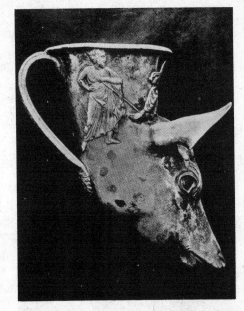

(a) *Silver drinking horn, parcel-gilt and enamelled, shaped as the head of a doe. Length 10·6 inches. Figures in relief above. Found near Taranto. Date about 420 B.C.*

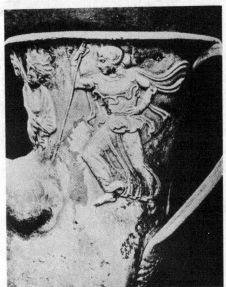

(b) *Detail of a figure on the silver horn above. Athena armed, the aegis over her chest, advancing to left.*

PLATE 74

*Silver coins: all scale 2/1. (a) Two-drachma piece of Terina by Phrygillos:
about 420 B.C. Head and seated figure of Nike. (b) Ten-drachma coin of
Syracuse by Kimon: about 405 B.C. with head of goddess. (c) Two-drachma coin
of Achaia: about 366 B.C. Head of Artemis. (d) Drachma of Larissa: about
380 B.C. Head of a nymph.*

PLATES 75 & 76 *Marble. Hermes with the child Dionysos, by Praxiteles of Athens. Over life-size. Modern the right shank, the left shank and foot. About 343 B.C.; found at Olympia. In Olympia.*

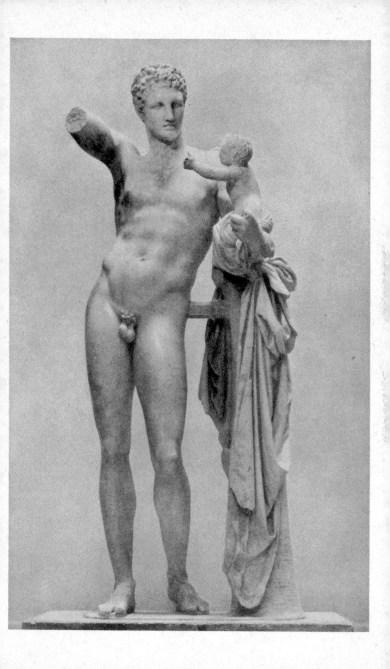

PLATE 77

Bronze mirror cover, diameter 7·3 inches, engraved. Girl in cap and shoes seated on bench playing the game of "five stones" with Pan. Eros behind her; below is a goose. From Corinth: about 380 B.C.

PLATE 78

Bronze mirror cover similar to that opposite. Aphrodite and her son Eros. She wears only slippers, and leans on a rock. Eros learns the use of bow and arrow. From Corinth: about 350 B.C.

PLATE 79

a

Gold work. (a) A pair of earrings, dolphin-headed. Scale 2/1: about 350 B.C. (b) Large bracelet. Scale 1/1. The snakes' eyes of garnet, uncut emeralds in their jaws: about 350 B.C.

(c) Eros, scale 2/1, leans on a pillar and holds out a quince, large stylised wings; a cloak tucked into his quiver-strap. Delicate work: about 320 B.C. From Athens.

c

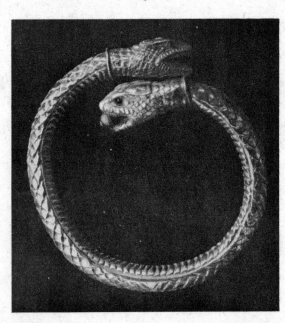

b

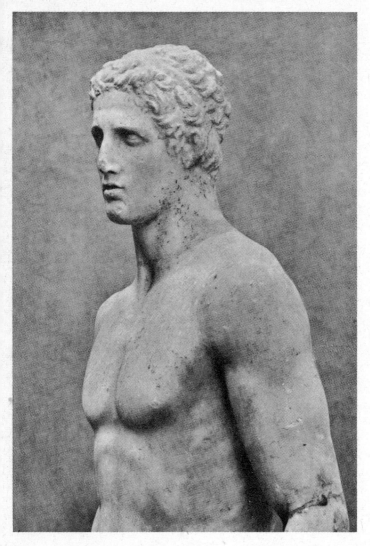

PLATE 80

Marble. Ideal portrait of Agias, a boxer. Life-size: about 330 B.C. Found at Delphi. In Delphi.

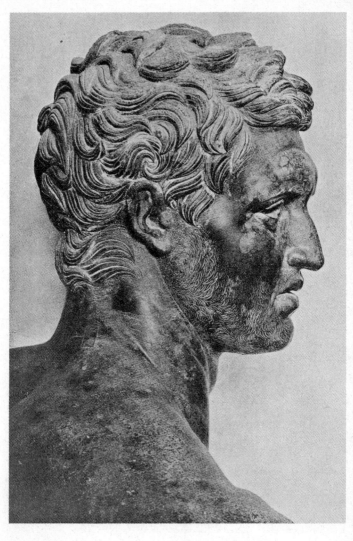

PLATE 81 *Bronze. Head of portrait statue of Demetrius I, King of Syria 162 to 150 B.C. Life-size. Made by a Greek artist and found in Rome where Demetrius resided for some time.*

a

PLATE 82

*Marble portraits. Life-
size. (a) Euthydemus,
Greek King of Bactria,
wearing a sun-helmet. A
portrait in his old age.
From Asia Minor: about
200 B.C. (b) Pompey
the Great, portrait by a
Greek sculptor from the
tomb of the Licinii in
Rome. About 50 B.C.*

b

PLATE 83 *It is improbable that any other island has produced a contrast so violent as that between these marbles of Rhodian origin: one the most vulgar, the other the most sublime product of the Hellenistic age. Laocoon, his sons and snakes, about life-size, by Agesander, Polydorus and Athenodorus of Rhodes: about 25 B.C. In Rome.*

PLATE 84 *Opposite: A giant Nike on the prow of a warship made by Pythocritus of Rhodes and set up about 190 B.C. on Samothrace. In Paris.*

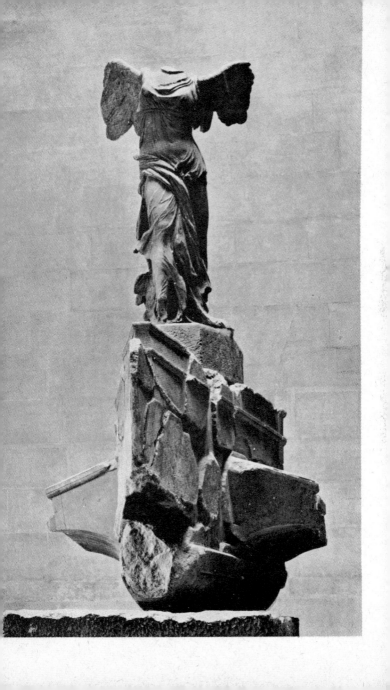

PLATE 85

Revival of formal art. Marble girl acting as a pillar, or caryatid. Hair, garments and stance recall older models. From Tralles: about 270 B.C.

PLATE 86

Opposite: Marble boy in a cloak, life-size; the revival of an older manner like that of the Olympia master. From Tralles: about 270 B.C.

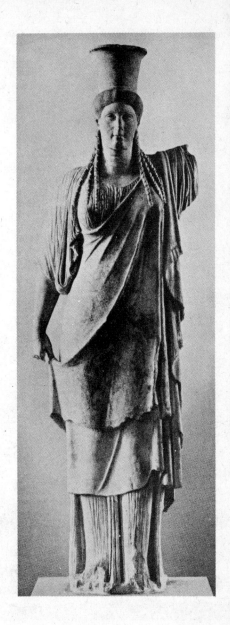

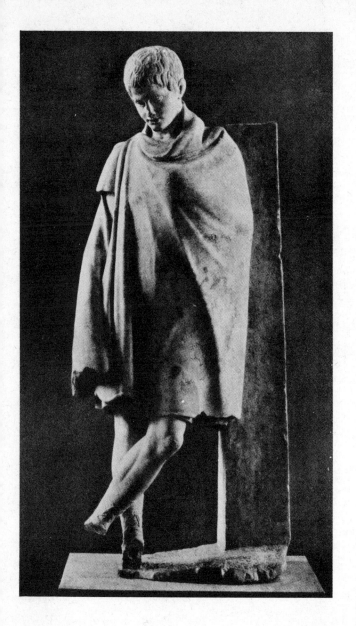

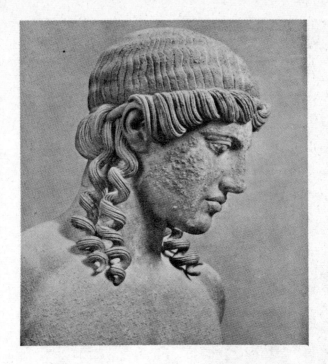

a

PLATE 87

*Formal art recast. Head of a bronze
statue of Apollo, three-quarter life-size:
about 25 B.C. From Pompeii.*

*Marble head of a goddess or a girl in the
manner of statues of the sixth century
B.C. Life-size and made about 25
B.C.*

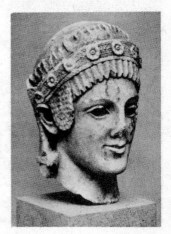

b

PLATE 88

Brutal realism in bronze. Head of a life-size statue of a boxer made and signed by Apollonius, son of Nestor of Athens, for a Roman client: about 100 B.C. In Rome.

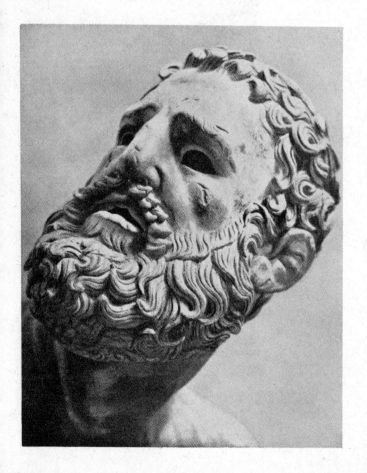

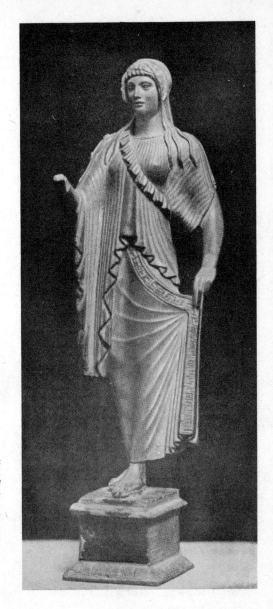

PLATE 89

Bronze statuette, 6 inches high. The sixth-century manner revived under Claudius. Silver damascening on the border of the garment. The eyes are inlaid diamonds. Greek work: about A.D. 50.

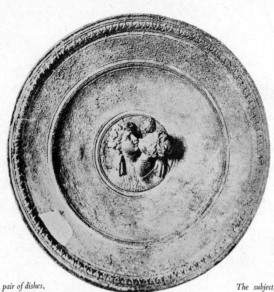

Silver. A pair of dishes,
each with diameter of 6·8
inches: each has a central
boss.

PLATE 90

The subject, a pair of
lovers, or Dionysos and
Ariadne. About 250
B.C. Found near
Taranto.

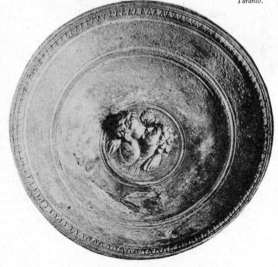

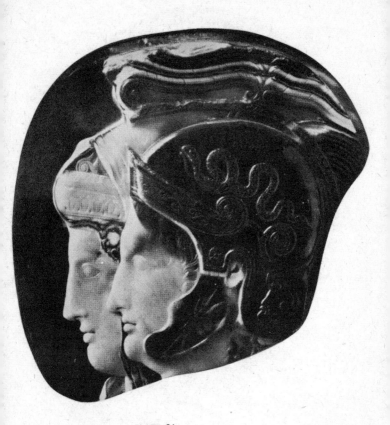

PLATE 91

The great Vienna cameo: a sardonyx of nine layers. Height 4·5 inches. Alexander the Great in helmet ornamented with serpent, head of Zeus Ammon and thunderbolt. Beyond him Roxane, diademed and veiled. The cameo made in honour of their infant son, Alexander IV, in Alexandria: about 315 B.C.

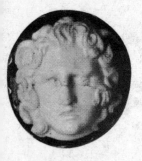

PLATE 92

(a) Cameo in two layers, opaque cream and translucent claret. The earliest and best of a long series of cameos with Medusa racked by pain: close in style to Scopaic heads of half a century before. The cameo, scale 2/1, is of about 300 B.C.

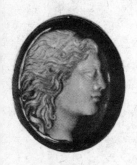

(b) Cameo. Nicolo of three colours. A contemporary portrait of Mithridates the Great, King of Pontus 120 to 63 B.C. Scale 2/1. Mithridates was himself a collector of gems.

(c) Intaglio amethyst, scale 3/1, with a portrait of Demosthenes carved and signed by Dioskourides, celator in chief to Augustus: about A.D. 25. Photograph direct from the stone.

PLATE 93 *Philoxenus of Eretria before 300 B.C. painted a mighty battle picture of Alexander's victory at Issus over Darius. A mosaic-maker copied it in coloured pebbles for a rich man's house at Pompeii.*

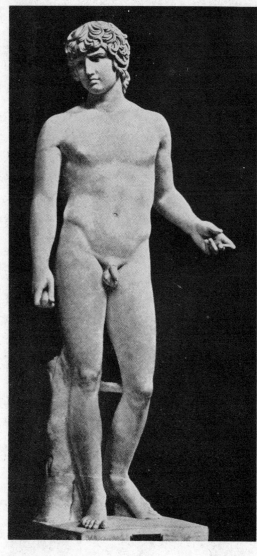

PLATE 94

Marble. *Antinous as a god.* Life-size. *A new form, though derived from athletic prototypes of long ago. In Naples: made about A.D. 135.*

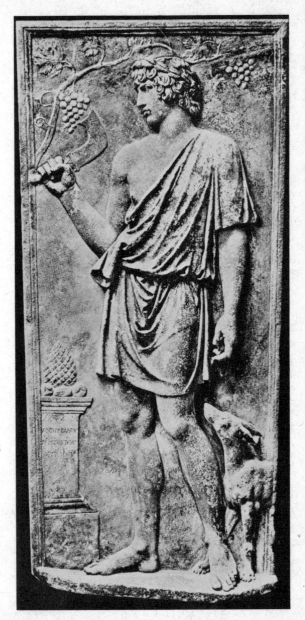

PLATE 95

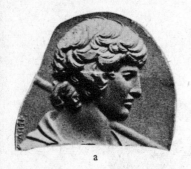

a

Opposite: Small marble relief, 56·5
inches high. Antinous as Silvanus,
signed by the artist Antonianos of
Aphrodisias: about A.D. 135.

PLATE 96

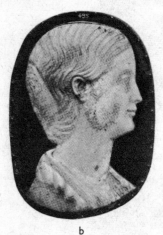

b

(a) Black sard intaglio, scale 3/2: signed
by Anto(nianos) and having portrait of
Antinous. About A.D. 135.

(b) Sardonyx cameo, scale 1/1. Por-
trait of Julia Paula, wife of the Syrian
Emperor Elagabalus, in A.D. 219.

(c) Gold prize medal. Scale 2/1. Bust
of the Emperor Severus Alexander. On
the reverse the Emperor between Roma
and Nike. Perhaps made in Alexan-
dria. Found at Tarsus with the medals
on Plates 97 and 98. Struck about
A.D. 230.

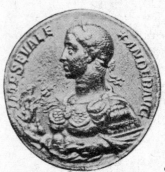

c

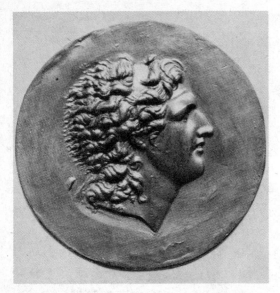

a
b

PLATE 97

Two gold prize medals, both of diameter 2·5 inches. Struck about A.D. 230, made in Alexandria and found at Tarsus. (a) Idealised head of Alexander the Great diademed. (b) Bust of his father, Philip of Macedon, diademed and wearing armour.

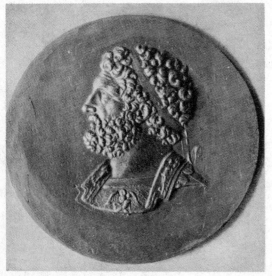

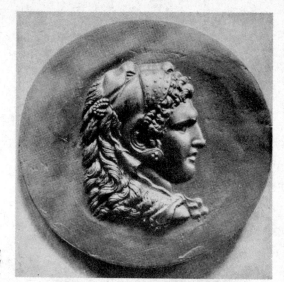

PLATE 98

a
b

(a) *Gold prize medal same size, date and origin as the two on Plate 97. Alexander the Great wearing the lion-skin of Herakles.*
(b) *Central boss of a silver dish with similar bust of Alexander. Scale 1/1. Alexandrian work: about A.D. 230.*

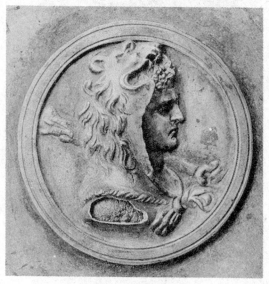

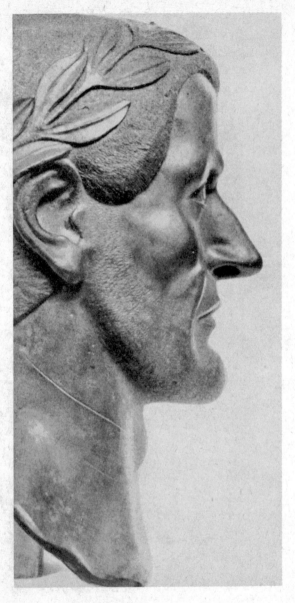

PLATE 99

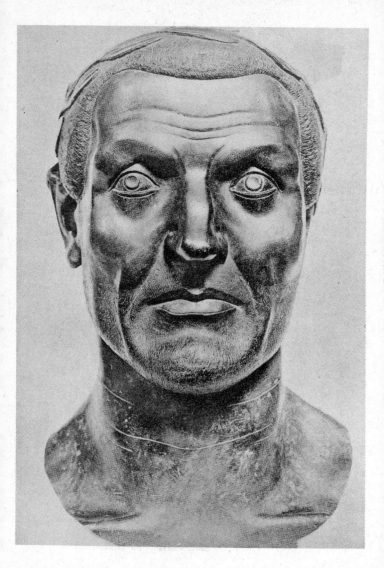

Bronze. Portrait, profile and full-face, of Claudius II, Conqueror of the Goths, Emperor from A.D. 268 to 270. There is still red paint on the lips of this life-size head, which was not made under Claudius, but in the reign of Constantine the Great, about A.D. 310.

PLATE 100

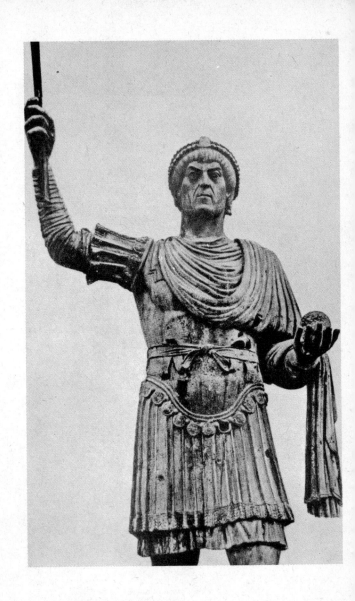

PLATE 101

PLATE 102

Opposite: bronze gigantic statue of an Emperor, probably Valentinian I, A.D. 364 to 375; once in Constantinople, looted by Crusaders. Portraits in gold-leaf on glass. (a) A mother and two children; diameter 4 inches, signed in Greek by Bounneris: about A.D. 230. (b) A man; diameter 2·7 inches: about A.D. 240. This art was to give rise later to that of illumination on vellum.

PLATE 103

Magnificent medals were a feature of the age of Diocletian
and Constantine. (a) A gold medal, scale 2/1, minted at
Ticinum with a head of Diocletian on the obverse and
an enthroned Zeus, or Jupiter, on the reverse; its date
about A.D. 295. (b) A silver medal, scale 2/1, minted
in Constantinople about A.D. 330, has on one side the
head of Constantine and on the other an enthroned goddess
personifying the city. Opposite: ivory leaf, one-half of a
diptych, made about A.D. 392 or 400 for a girl of the
Greek family of the Symmachoi. Height 11·7 inches. A
girl putting incense on an altar. Made in Alexandria.

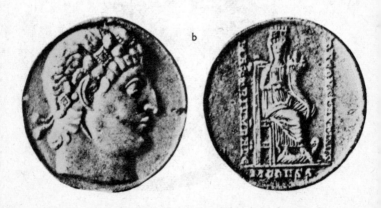

PLATE 104

PLATE 105

Silver tray: in centre Okeanos, four dolphins in hair and beard; zone of ocean nymphs, tritons, sea-monsters. Main zone, Dionysos, Pan, maenads, satyrs. Weight 11 lb., diameter 27 inches. About A.D. 340. Made in Alexandria. Found 1942 at Mildenhall, Suffolk.

Opposite: Details of tray. The concept of male vigour, which seemed to attain momentary perfection in the art of the Aetna master (Plate 55c), suddenly, eight centuries later, reappears on the noblest work of Greek art ever found in England. Pan dances, refuting the croaker who had said Great Pan was dead; and sadness is banished by Dionysos.